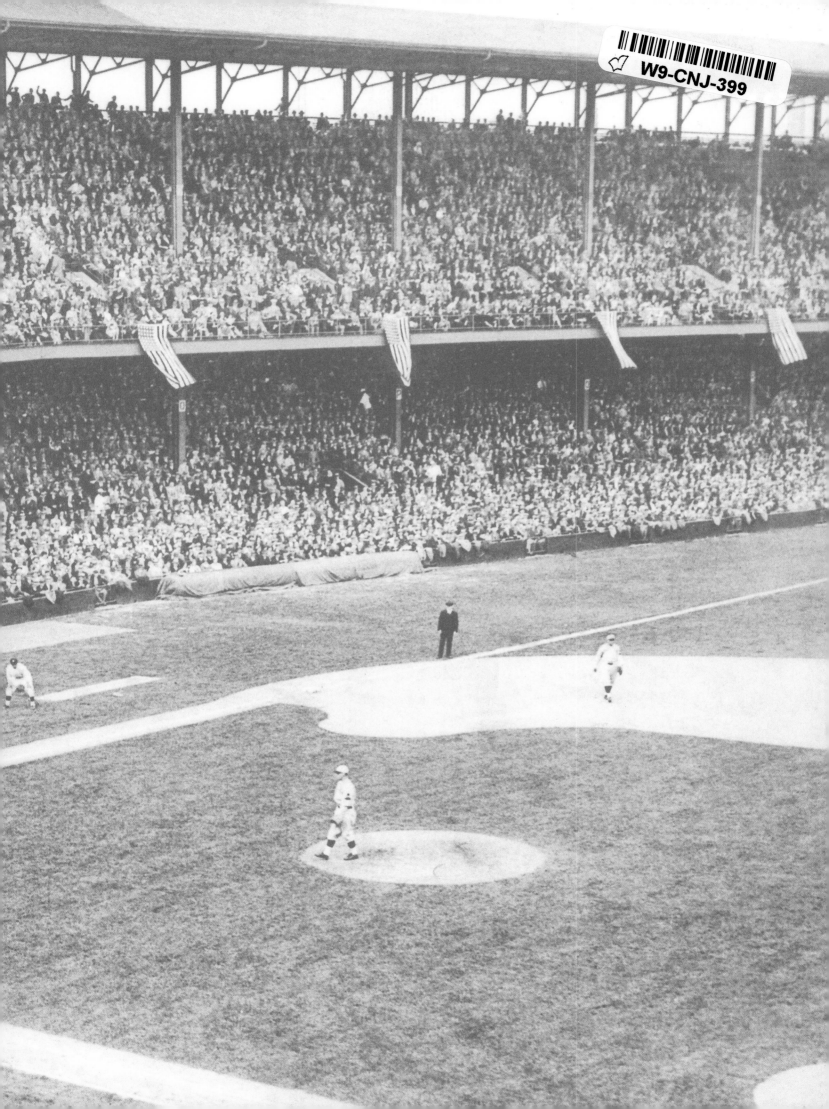

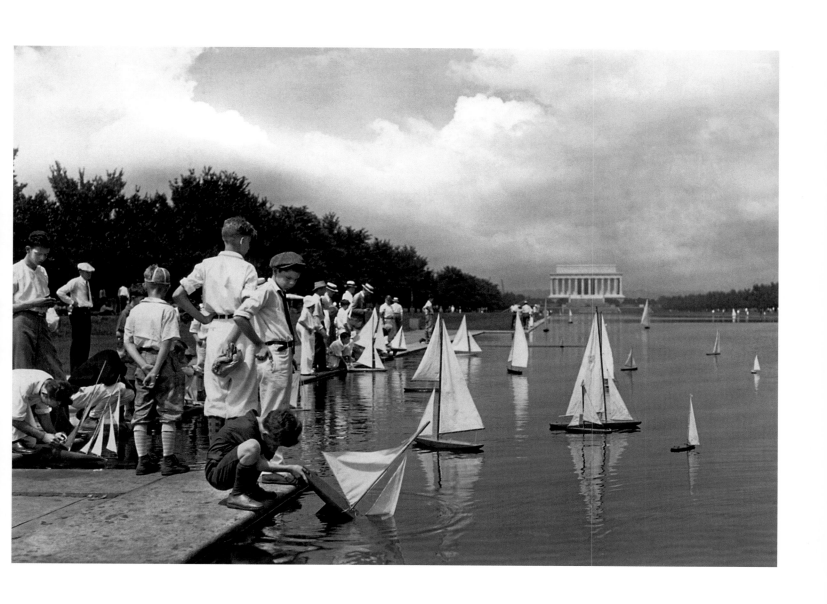

# CAPITAL VIEWS

Historic Photographs of Washington, D.C.,
Alexandria and Loudoun County, Virginia,
and Frederick County, Maryland

## JAMES M. GOODE

SMITHSONIAN BOOKS
WASHINGTON, DC

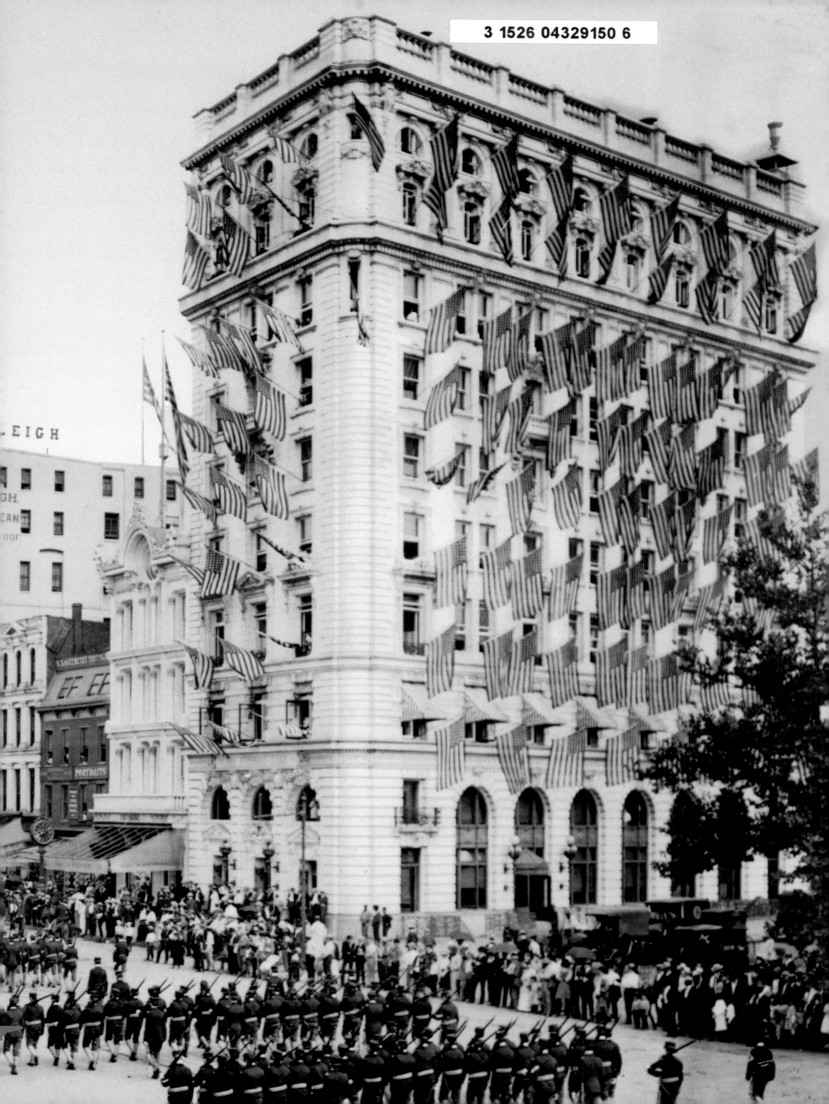

Funding for this book was provided in part by the B. F. Saul Company.

Produced by Smithsonian Books
Carolyn Gleason, Director
Christina Wiginton, Project Editor

Text by James M. Goode

Photography and archival photograph research by Peter R. Penczer

Edited by Lise Sajewski

Designed by Robert L. Wiser

Library of Congress Cataloging-in-Publication Data

Goode, James M.
    Capital views : historic photographs of Washington, D.C., Alexandria and Loudoun County, Virginia, and Frederick County, Maryland / James M. Goode.
        p.      cm.
    Includes index.
    ISBN 978-1-58834-331-4 (cloth : alk. paper) 1. Washington (D.C.)—History—Pictorial works.  2. Historic buildings—Washington (D.C.)—Pictorial works. 3. Architecture—Washington (D.C.)—History—Pictorial works.  4. Neighborhoods—Washington (D.C.)—History—Pictorial works.  5. Washington (D.C.)—Buildings, structures, etc.—Pictorial works. 6. Washington (D.C.)—Biography—Pictorial works. 7. Alexandria (Va.)—History—Pictorial works.  8. Loudoun County (Va.)—History—Pictorial works. 9. Frederick County (Md.)—History—Pictorial works.  I. Title.
    F195.G63  2012
    975.30022'2—dc23                                    2012006208

First Edition

17  16  15  14  13  12      5  4  3  2  1

Printed in China through Oceanic Graphic Printing, Inc.

Smithsonian Books titles may be purchased for educational, business, or sales promotional use. For information, please write: Special Markets Department, Smithsonian Books, P.O. Box 37012, MRC 513, Washington, DC 20013-7012.

**Display Illustrations**

Front endsheets. Griffith Stadium, about 1930 (see page 100).

Back endsheets. Leesburg tollgate, about 1915 (see page 148).

Page 1. During the Great Depression, model yachting was very popular with young and old alike, as this 1931 photograph attests. Here yachtsmen use the Rainbow Pool near the Lincoln Memorial (some other cities built pools expressly for model boating). Besides wind-powered vessels, steam- and gasoline-powered boats were popular as well. The Rainbow Pool was completed in 1922 as part of the landscape setting for the Lincoln Memorial, which included the more famous Reflecting Pool in the background. The Rainbow Pool was demolished in 2001 and rebuilt as part of the National World War II Memorial.

Pages 2–3. A dramatic 1903 photograph shows the annual Fourth of July parade passing down Pennsylvania Avenue at 11th Street, NW. The troops in the foreground are members of the District of Columbia National Guard. On the right is the recently built *Evening Star* building, which was designed by the local architectural firm of Marsh & Peter. The building has the typical Beaux-Arts formula of a tripartite division of its front façade into base, shaft, and capital.

Pages 4–5. Lucius Copeland, an engineer from Phoenix, Arizona, is shown in 1888 demonstrating his newly invented steam-powered tricycle in front of the Smithsonian Castle. Although two hundred of these early vehicles were manufactured in Camden, New Jersey, they could not compete with the new gasoline-powered cars of the mid-1890s, which could start immediately and travel faster. By 1899 America had produced over four thousand gasoline-powered cars, and the steam tricycle had become obsolete.

Pages 6–7. Miniature golf was invented in 1930 at a resort hotel near Chattanooga, Tennessee. Originally intended for children, it became a fad among adults that spread across the country like wildfire. This course in East Potomac Park, near Hains Point, opened in 1931. Seen here in a rare view from the 1930s, it is still in use today, although the White House, Capitol, and Mount Vernon obstacles have long since disappeared. It is believed to be the oldest miniature golf course in continuous operation in the country.

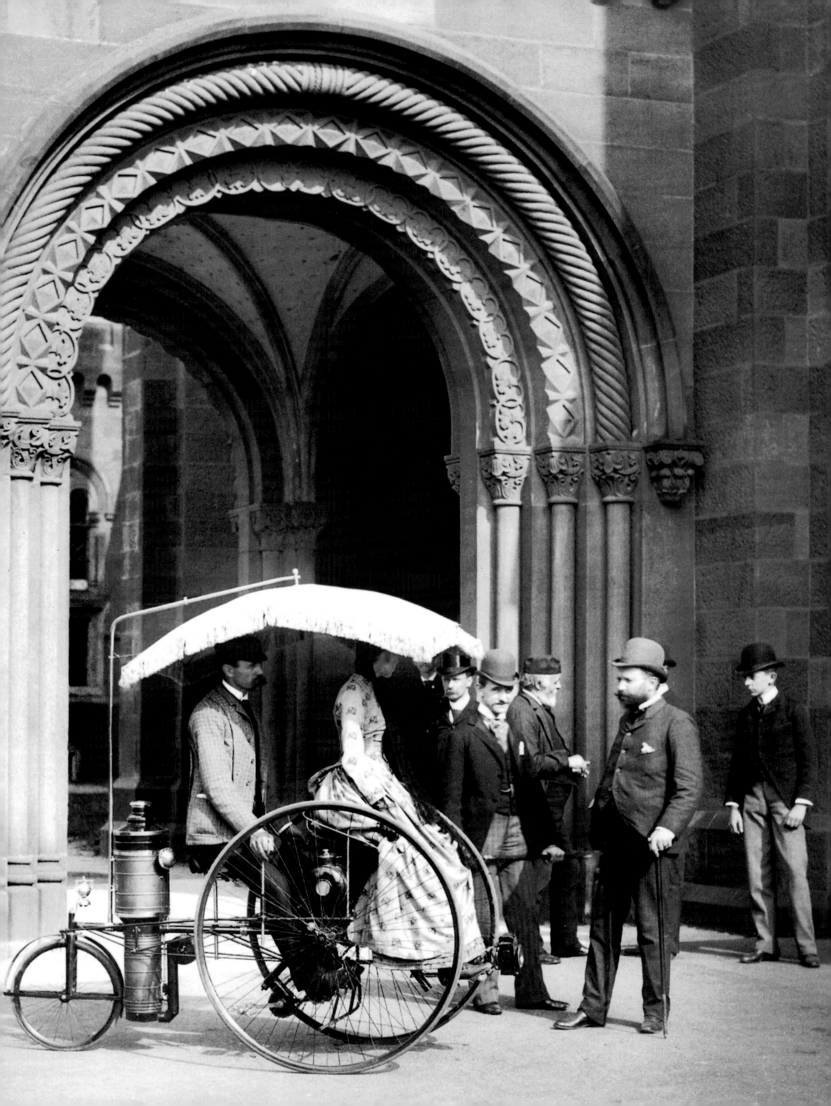

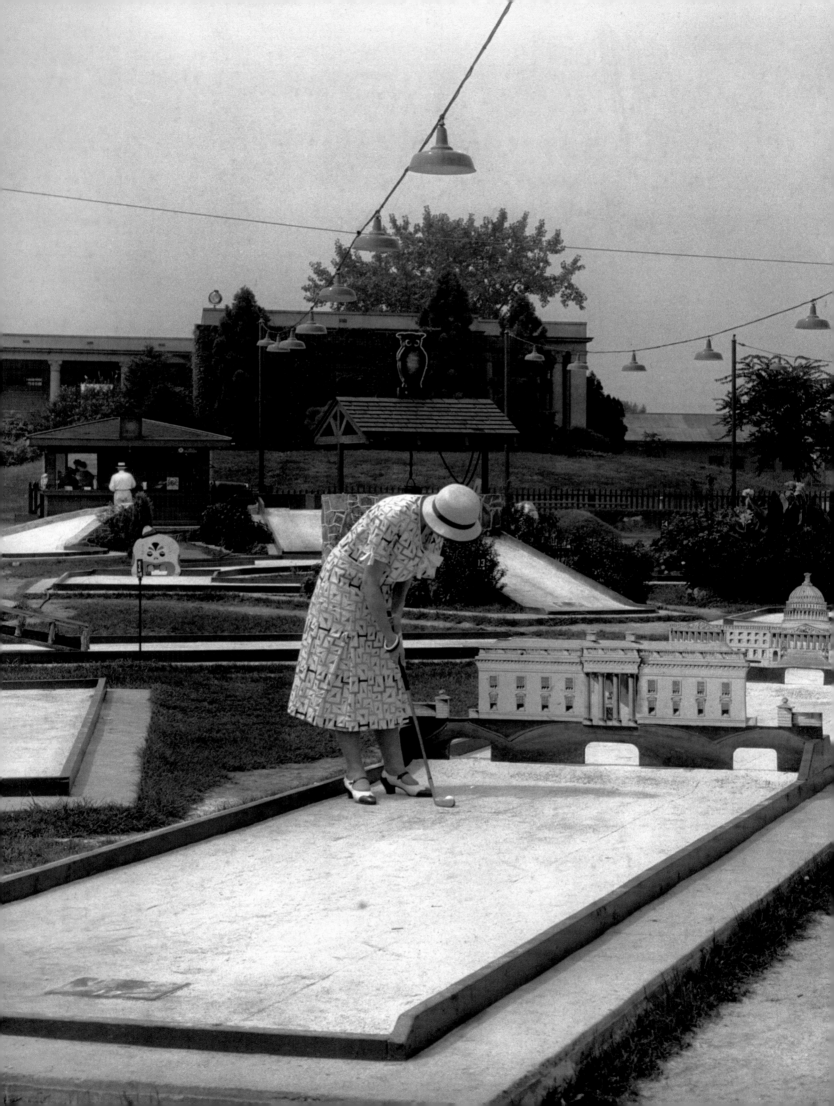

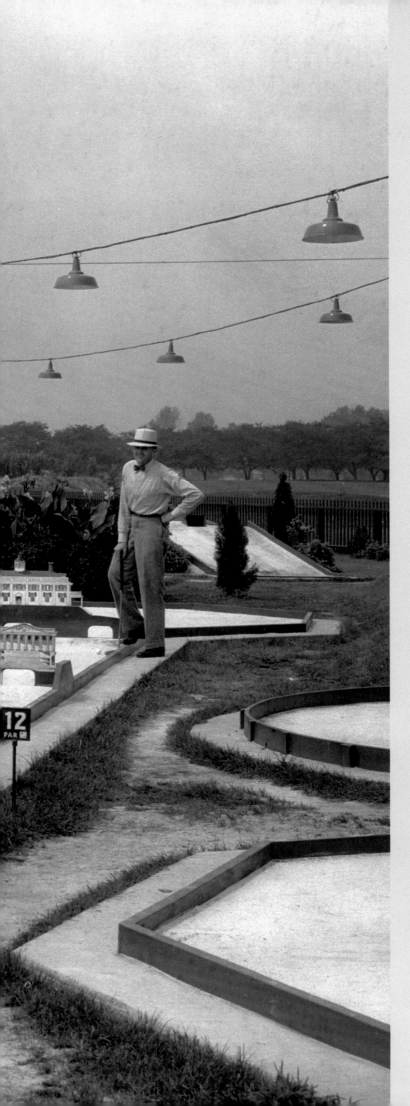

# CONTENTS

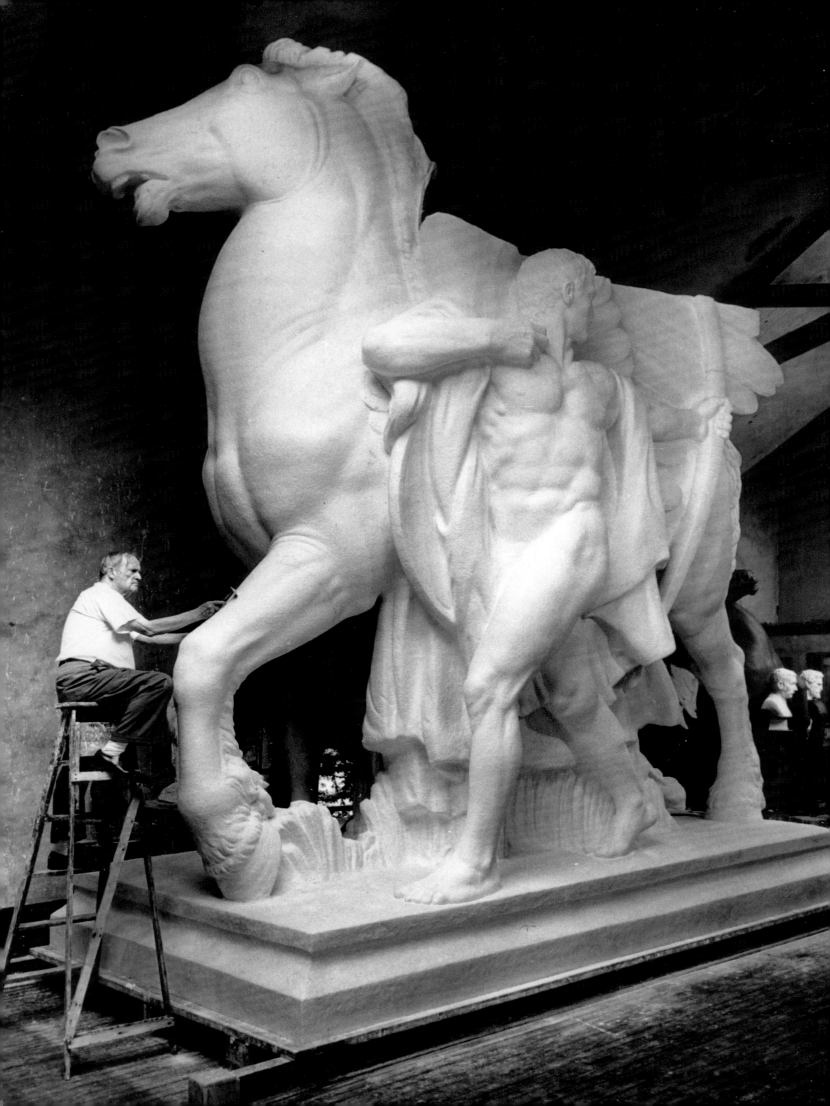

# PREFACE

As a historian of Washington, D.C., for over forty years, I have relied heavily on photographs, both historical and modern, to complement the text of my books and articles. Images are essential when discussing both architecture and sculpture. My serious interest in photographs of Washington, D.C., began in 1969 when I first worked as a reference librarian in the Prints and Photographs Division of the Library of Congress. My work there helping researchers on a wide range of photographic topics was a real education both in judging the quality of historical photographs and in the techniques used by many local professionals. These ranged from Mathew Brady and J. F. Jarvis from the nineteenth century to Theodore Horydczak and Frances Benjamin Johnston, who both worked in Washington as architectural photographers in the early twentieth century. While serving as curator of the Smithsonian Castle for many years, I relied heavily on historical photographs to prepare my work *Capital Losses: A Cultural History of Washington's Destroyed Buildings*, which was first published by the Smithsonian Institution Press in 1979 and reprinted as an enlarged second edition by Smithsonian Books in 2003. This work has helped gain wide public support for the preservation of historic buildings in the city then and today.

For the past eleven years, I have worked on the staff of the B. F. Saul Company in Bethesda, Maryland, as its historian, curator, and archivist. In addition to organizing the archives, curating the corporate art collection, and writing a privately published history of the company, which was established in 1892, I have organized exhibitions of mostly historical photographs in the

James Earle Fraser designed *The Arts of Peace,* a monumental pair of neoclassical equestrian statues, for the entrance to the Rock Creek Parkway adjacent to Memorial Bridge. The photograph opposite, taken in the 1930s, shows Fraser working on a plaster model of one of the pair, *Aspiration and Literature.*

lobbies of seven office buildings owned by the company as well as the Metropolitan Club. In several of these exhibitions, especially the one on Frederick County, my assistant Peter Penczer was very skillful in both locating historical photographs and taking photographs of landmarks of which no historical photograph in good condition could be found.

The B. F. Saul Company placed these historical exhibitions of enlarged photographs (in large frames, usually forty inches wide by thirty inches high, with labels inscribed by a calligrapher on their mattes) in the lobbies of buildings mostly located in Washington, D.C., but also in the suburbs of Alexandria and Leesburg, Virginia, and Frederick, Maryland. The tenants of many of these buildings asked to have a pamphlet printed with the historical photographs displayed in their buildings to give to clients and visitors. It occurred to me to produce a book with photographs from all eight exhibitions.

I wanted to preserve the long years of research that went into the brief but scholarly captions of the photographs and the historical photographs themselves, many never published before. These images provide a fascinating insight into a way of life in Washington and its environs that has disappeared. They were found in fifty-one sources, many of them from remote or rarely consulted depositories for Washington views such as the Hagley Museum and Library in Wilmington, Delaware, and the Massachusetts Historical Society in Boston, Massachusetts. Thanks should go to the many librarians who assisted me, as well as to B. Francis Saul II, the chairman of the board of the company, for his keen interest in and support of Washington, D.C.'s history.

By 1943 temporary wartime office buildings filled the Mall between the Washington Monument and the Lincoln Memorial (opposite). Those in the foreground were built during World War II and those in the background date from World War I. At that time, motorists were still allowed to park at the base of the monument.

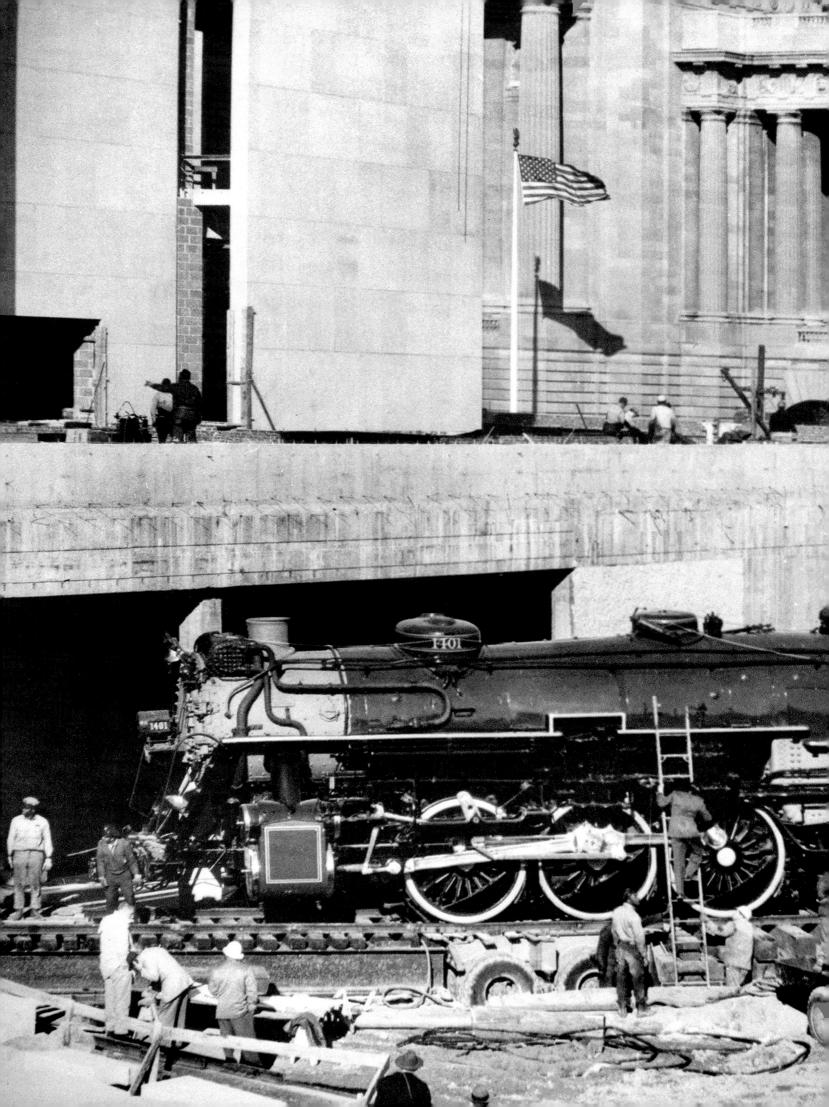

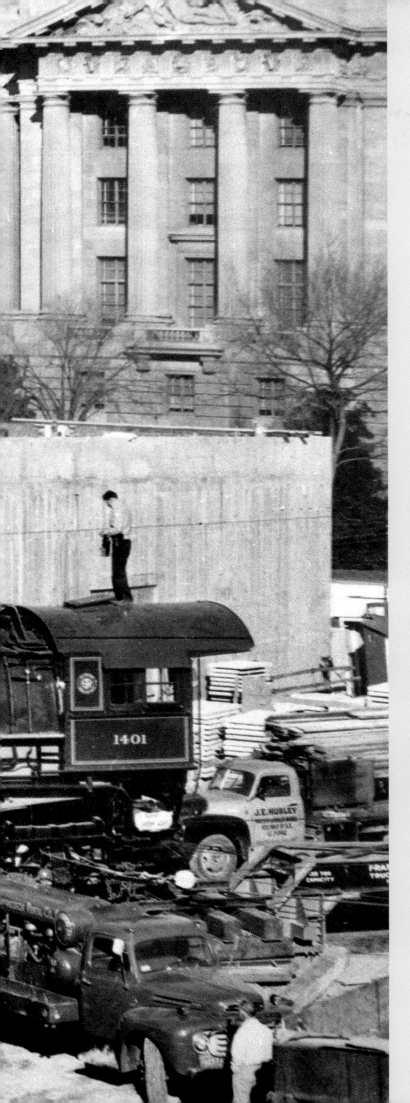

# THE NATIONAL MALL

This 1962 photograph shows the installation of the steam locomotive Number 1401 of the Southern Railway in the east end of the almost-completed National Museum of American History on the Mall. Number 1401 was built in Richmond, Virginia, in 1926 and hauled passenger trains between Washington, D.C., and Atlanta until diesel locomotives replaced it. Through the efforts of Robert V. Fleming, a Washington banker, Smithsonian regent, and Southern Railway director, 1401 was given to the Smithsonian.

THE CENTERPIECE of Pierre (Peter) L'Enfant's brilliant design of the nation's capital, Washington City, in 1791 was the Mall, a formal L-shaped park linking the Capitol with the White House. It was not until 1850, however, that the federal government acted to landscape this impressive space. Landscape architect Andrew Jackson Downing designed an informal asymmetrical plan of curved carriage drives and plantings of American trees—mostly evergreens. For this project, Downing persuaded nurseryman John Hennessy Saul, an Irishman then working in Bristol, England, to emigrate to Washington in 1851 to supervise the implementation of his plan.

By the time the Civil War broke out in 1861, only the landscaping of the Smithsonian grounds and Lafayette Park had been completed. Conditions improved in 1872 when the Washington Canal, then abandoned and essentially an open sewer, was filled in. It ran along what is now Constitution Avenue from the Washington Monument to Sixth Street, NW, then crossed the Mall, skirted Capitol Hill to the south, and connected to the Anacostia River. Three historical maps have been included in this chapter as "lost views" to help explain the changes in urban planning during the early years of Washington, D.C.'s development.

The U.S. Senate acted in 1901 to improve conditions on the Mall and monumental Washington by establishing the McMillan Commission to develop a master plan for restoration and future development. This body recommended demolishing four blocks of private houses and industrial buildings at the east end of the Mall, removing the train station and tracks which crossed the Mall

at Sixth Street, extending the Mall westward—through reclaimed land (which would provide a site for the future Lincoln Memorial) and replacing the overgrown Victorian landscaping with an open, formal greensward flanked by parallel rows of elms. It was not until the 1930s, however, that the National Park Service, with New Deal funds, completed the landscaping project by grading the Mall, planting trees, and laying out two pairs of parallel drives.

Overzealous city planners proposed in 1929 to extend the Mall eastward from the Capitol to the Anacostia River, between Independence and Constitution Avenues. More than five thousand Victorian houses would have been demolished in the process. Fortunately this plan and another proposed in 1946, for two elevated highways on the Mall, were dropped by 1958.

Enormous improvements have been made to the Mall since 1970 with the building of five new museum buildings. Other important projects include the Capitol Reflecting Pool, Constitution Gardens, Hirshhorn Sculpture Garden, the National Gallery's Sculpture Garden, and conversion of the two inner streets to pedestrian paths. Three new memorials—to the Korean War, Vietnam War, and World War II—serve to unify the country by their patriotic appeal. Even though restrictions have been placed on future uses of the Mall, it continues to evolve. The Franklin Delano Roosevelt Memorial and the Martin Luther King, Jr. Memorial have been built by the nearby Tidal Basin. The National Museum for African American History and Culture is scheduled to open on the National Mall in 2015 at 14th Street and Constitution Avenue, NW.

The National Mall in Washington, D.C., was the first great urban park in the country and is truly a proper setting for memorials to America's greatest heroes.

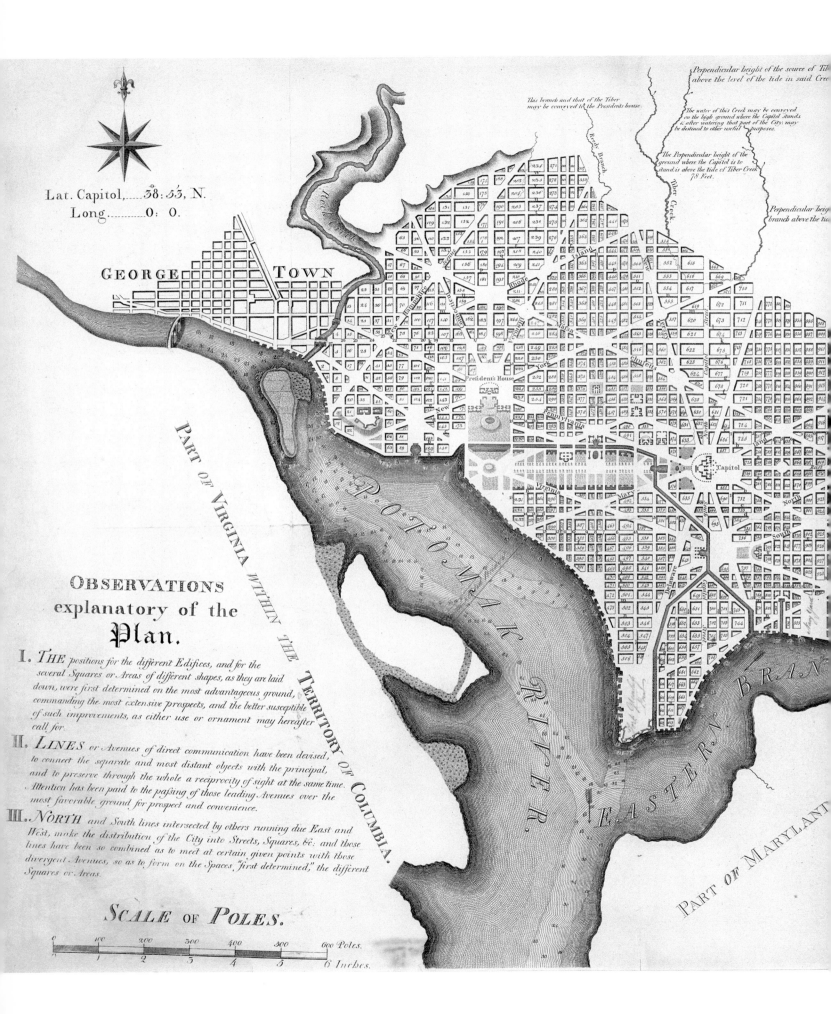

GEORGE TOWN

Lat. Capitol, 38:53, N.
Long. 0: 0.

PART OF VIRGINIA WITHIN THE TERRITORY OF COLUMBIA.

This branch and that of the Tiber
may be conveyed to the Presidents house.

Perpendicular height of the source of Tib
above the level of the tide in said Cree

The water of this Creek may be conveyed
on the high ground where the Capitol stands
& after watering that part of the City, may
be destined to other useful purposes.

The Perpendicular height of the
ground where the Capitol is to
stand is above the tide of Tiber Creek
78 Feet.

Perpendicular heigh
branch above the tid

President's House

Capitol

POTOMAK RIVER.

EASTERN BRANCH

PART OF MARYLAND

OBSERVATIONS
explanatory of the
Plan.

I. THE positions for the different Edifices, and for the
several Squares or Areas of different shapes, as they are laid
down, were first determined on the most advantageous ground,
commanding the most extensive prospects, and the better susceptible
of such improvements, as either use or ornament may hereafter
call for.

II. LINES or Avenues of direct communication have been devised,
to connect the separate and most distant objects with the principal,
and to preserve through the whole a reciprocity of sight at the same time.
Attention has been paid to the passing of those leading Avenues over the
most favorable ground for prospect and convenience.

III. NORTH and South lines intersected by others running due East and
West, make the distribution of the City into Streets, Squares, &c: and those
lines have been so combined as to meet at certain given points with those
divergent Avenues, so as to form on the Spaces "first determined," the different
Squares or Areas.

SCALE OF POLES.

0        100        200        300        400        500        600 Poles.
    1         2         3         4         5         6 Inches.

16

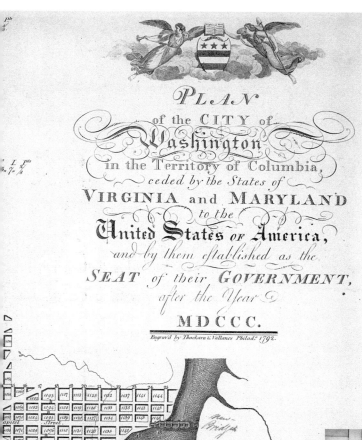

The first large detailed map of Washington, D.C., (left) was engraved and printed in Philadelphia by James Thackara and John Vallance in late 1792. Most copies of the first printing were cut into squares and glued to canvas so that they could be folded for the overcoat pockets of investors. This map depicts Peter L'Enfant's 1791 plan for the city, but it bears the name of Andrew Ellicott. The plan is unrivaled in its imagination and scale, but its author, temperamental and eccentric, had trouble working under the supervision of the District of Columbia commissioners. Charged with insubordination, L'Enfant resigned in early 1792. Ellicott, a surveyor who laid out L'Enfant's plan, worked with George Washington and Thomas Jefferson to make a number of changes to it.

The map below depicts architect Benjamin H. Latrobe's 1816 plan for a national university that would occupy thirty-four acres on the Mall between 13th and 15th Streets. Shown here are a freestanding church and a large U-shaped complex that provided for professors' houses, dormitories, a library, lecture halls, a dining hall, and an observatory. Although never built, Latrobe's plan influenced Thomas Jefferson's design for the University of Virginia several years later. The Washington Monument now occupies the site.

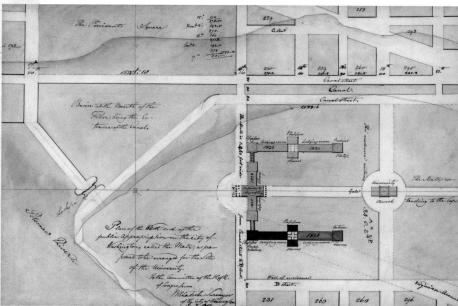

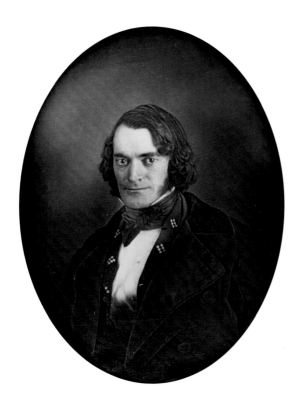

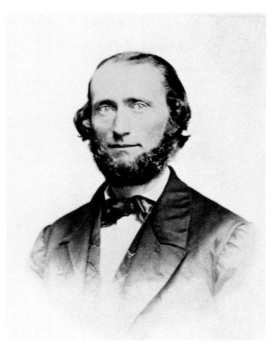

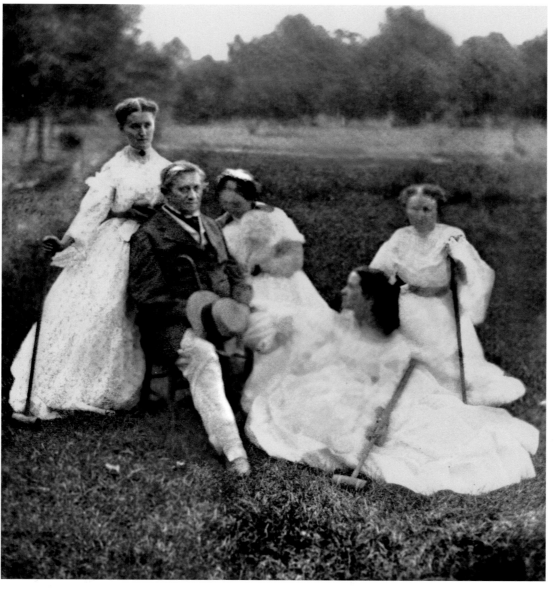

Andrew Jackson Downing (1815–1852) (opposite, top left) was considered the father of landscape architecture in the United States. He not only operated an important nursery in Newburgh, New York, but he also published three influential books on landscape architecture and edited a popular journal, the *Horticulturist*. One of Downing's most important contributions was the preparation of a master plan for landscaping the National Mall in 1850. Downing brought John Hennessy Saul (opposite, top right), a native of Ireland, to the United States in 1851 to supervise the implementation of the plan. After Downing died in the burning of a steamship on the Hudson River, the project faltered, and the only portion of the Mall to be completed before the Civil War was the grounds of the Smithsonian Castle (below). The Castle was designed in medieval revival style by James Renwick Jr. and was completed in 1855.

The first secretary of the Smithsonian Institution, Joseph Henry, and his family (opposite, bottom) lived in the east wing of the Castle. This bucolic 1862 portrait shows Henry and his wife, Harriet (standing), and their three daughters ready for croquet on the Mall before the Castle.

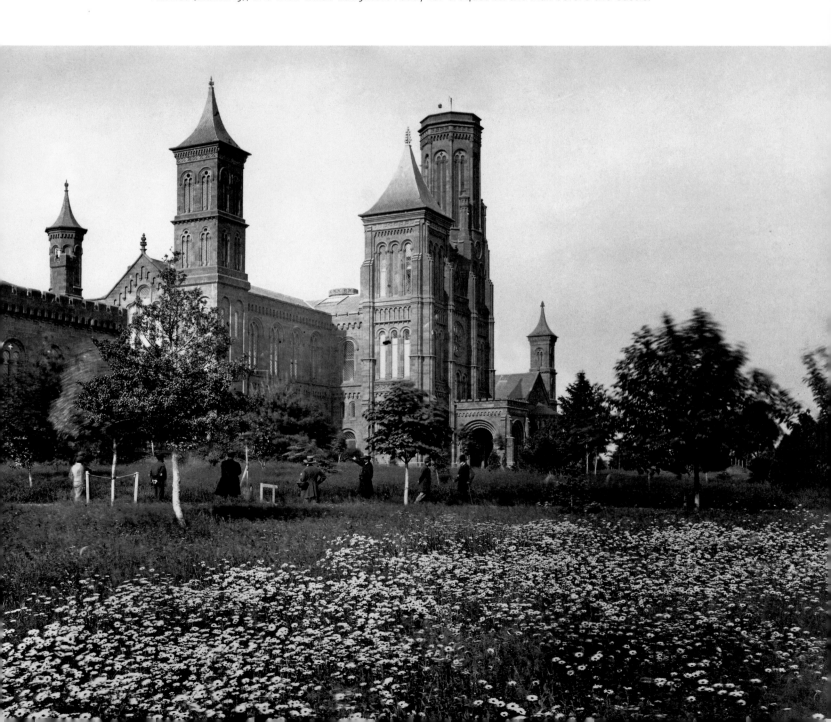

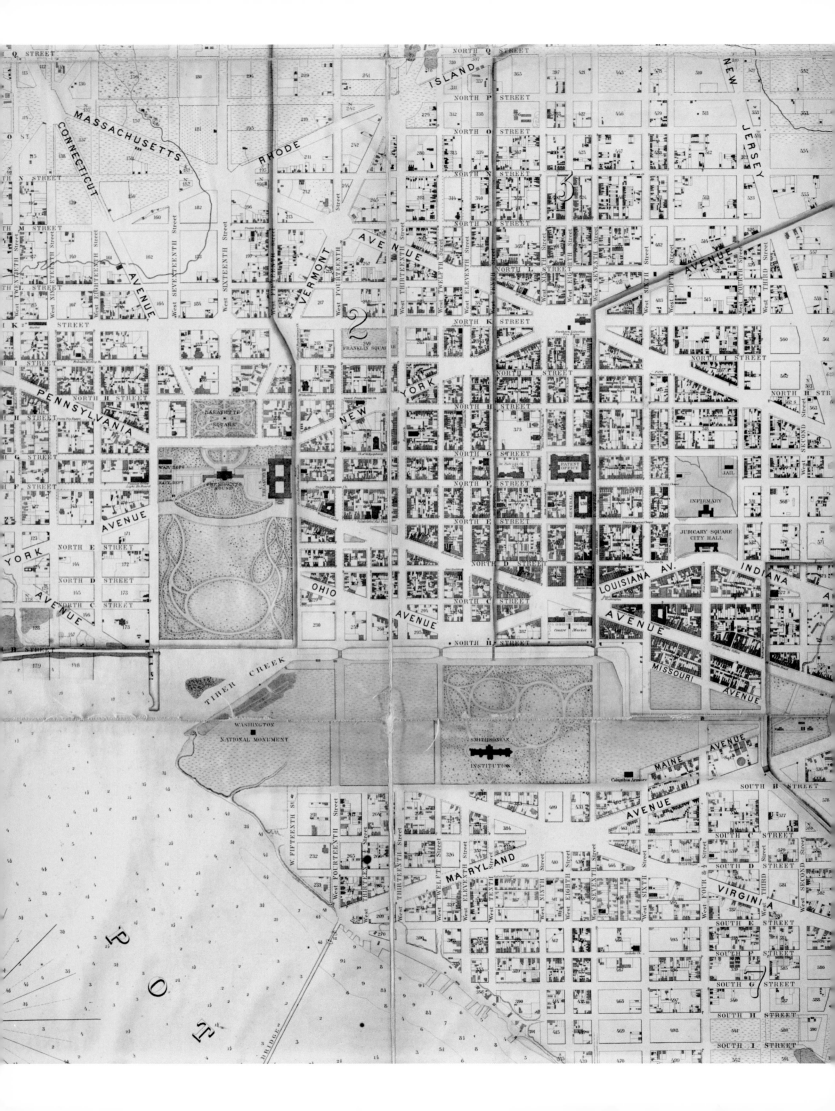

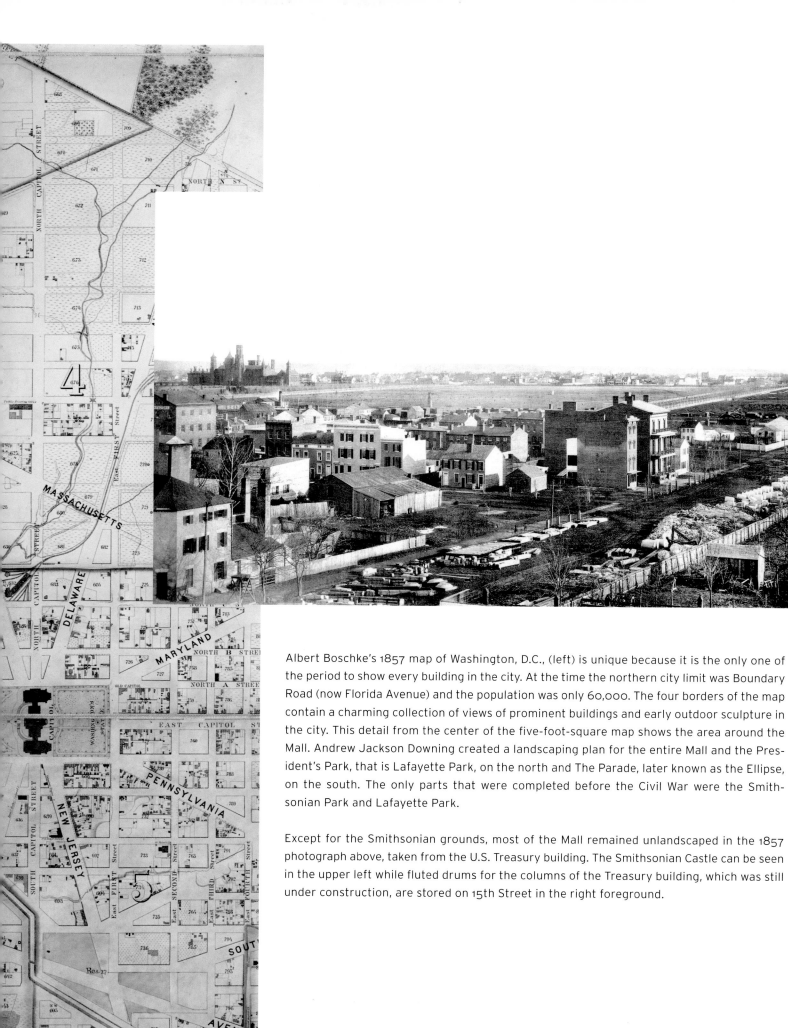

Albert Boschke's 1857 map of Washington, D.C., (left) is unique because it is the only one of the period to show every building in the city. At the time the northern city limit was Boundary Road (now Florida Avenue) and the population was only 60,000. The four borders of the map contain a charming collection of views of prominent buildings and early outdoor sculpture in the city. This detail from the center of the five-foot-square map shows the area around the Mall. Andrew Jackson Downing created a landscaping plan for the entire Mall and the President's Park, that is Lafayette Park, on the north and The Parade, later known as the Ellipse, on the south. The only parts that were completed before the Civil War were the Smithsonian Park and Lafayette Park.

Except for the Smithsonian grounds, most of the Mall remained unlandscaped in the 1857 photograph above, taken from the U.S. Treasury building. The Smithsonian Castle can be seen in the upper left while fluted drums for the columns of the Treasury building, which was still under construction, are stored on 15th Street in the right foreground.

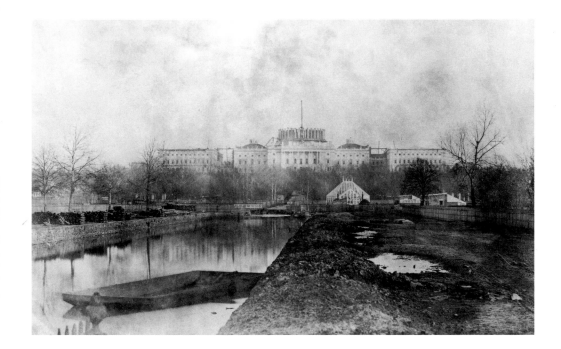

The photographer stood next to the Washington Canal in 1858 to capture the view above of the Capitol's iron dome during its first year of construction. The small glass conservatory of the U.S. Botanic Garden was built in 1850. The canal was covered over in 1872.

Before the Civil War, visitors to the eastern end of the National Mall would have seen the Tripoli Monument on the west terrace of the U. S. Capitol (right). It was erected in 1807 at the Navy Yard and moved to the Capitol grounds in 1830. The monument honors the American naval officers who lost their lives in the Tripolitan War between 1801 and 1805. This 1860 photograph shows the memorial shortly before it was removed to the Naval Academy in Annapolis. It is thought that the last move was made to free additional space on the Capitol grounds for storing the vast number of iron castings needed to construct the new dome.

In the foreground of the photograph below, taken about 1863, are the glass conservatory of the U.S. Botanic Garden and the Washington Canal. The white wooden wards of the Armory Square Hospital, where Walt Whitman volunteered as a nurse, were located along Sixth Street in the center. The Smithsonian Castle and the unfinished Washington Monument, barely visible here, dominate the background.

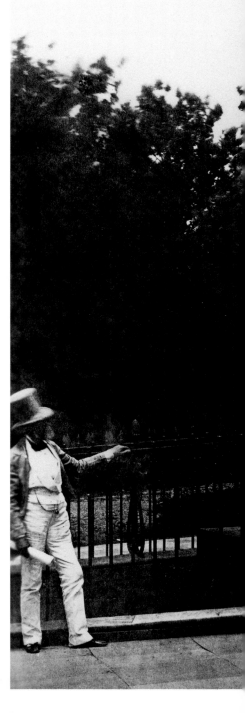

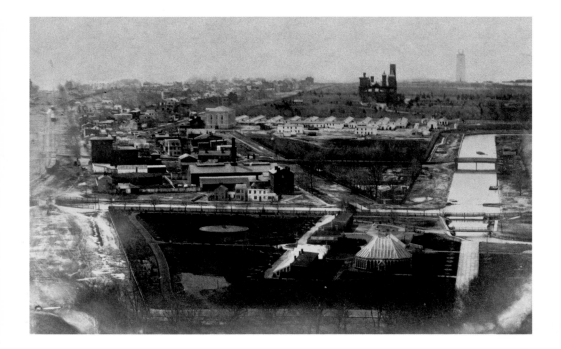

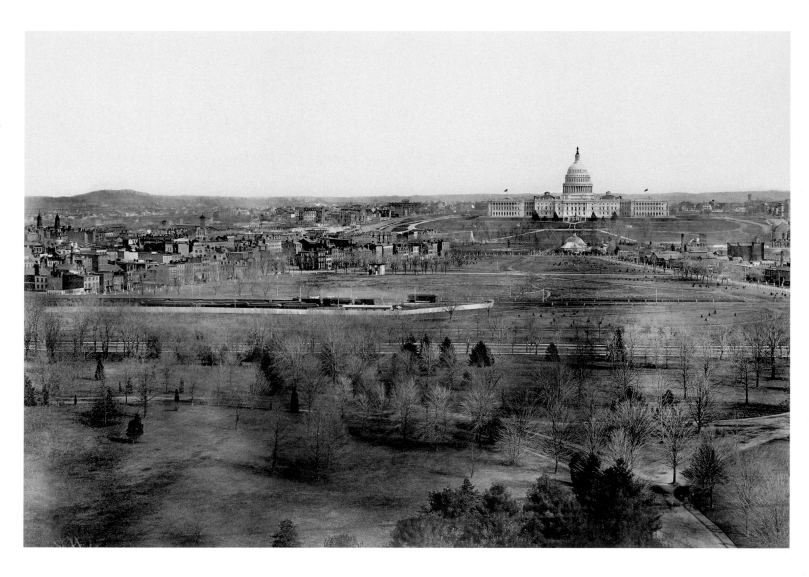

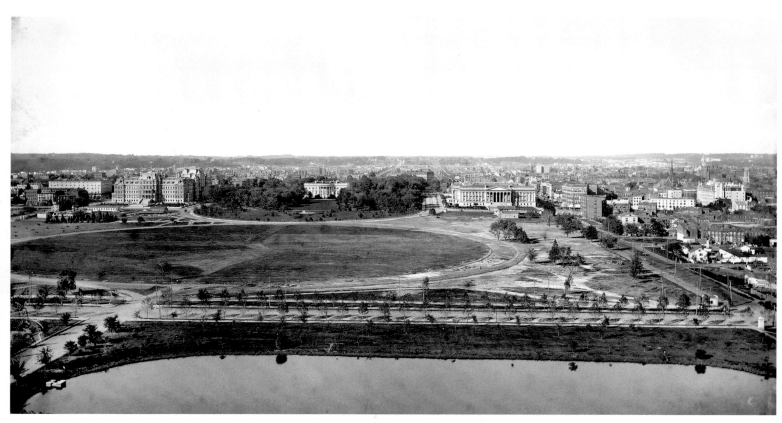

In 1872, the Baltimore & Potomac Railroad Station (opposite, top) opened at Sixth Street and B Street (now Constitution Avenue), NW. Its railroad cars, coal piles, and tracks marred the beauty of the east end of the Mall for many years. The station was finally demolished in 1908, shortly after Union Station opened. The mostly barren grounds of the Capitol, seen here in 1878, were landscaped by Frederick Law Olmsted between 1874 and 1892. The dark circular building at the upper right was constructed to store the gas for lighting the Capitol.

An 1885 photograph (opposite, bottom) shows one of the fish-breeding ponds on the Washington Monument grounds adjacent to B Street (now Constitution Avenue), NW, and the Ellipse. In the left background is the State, War, and Navy building; the White House is in the center; and on the right is the Treasury Department building.

Crowds converge on the Washington Monument at its dedication in February 1885 (below). The grounds were occupied by stonemasons' sheds and fish-breeding ponds, which had frozen over on this cold winter day.

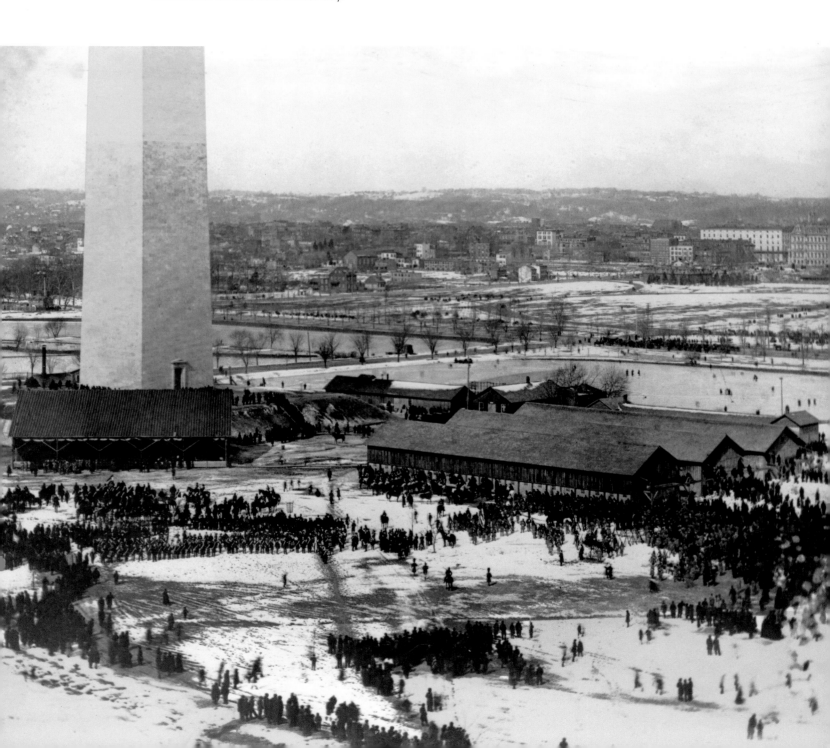

The National Zoological Park originated when William Hornaday, shown at right leading a buffalo calf on the Mall in 1889, placed animals in cages behind the Smithsonian Castle. Hornaday, the Smithsonian taxidermist, studied live animals in order to properly mount specimens for exhibition and urged the creation of a National Zoo to help save the buffalo from extinction. Influenced by Hornaday's ideas, the first building at the National Zoo, which opened in 1891 adjacent to Rock Creek Park, was the Buffalo House (below).

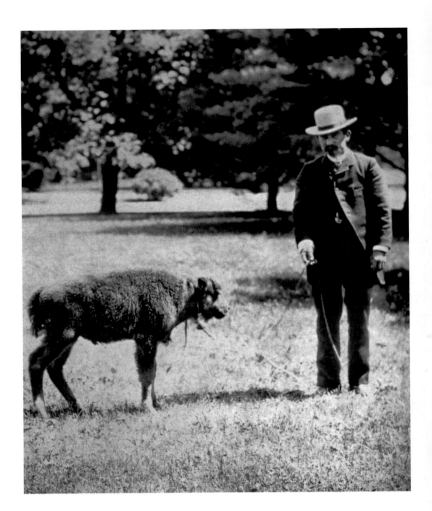

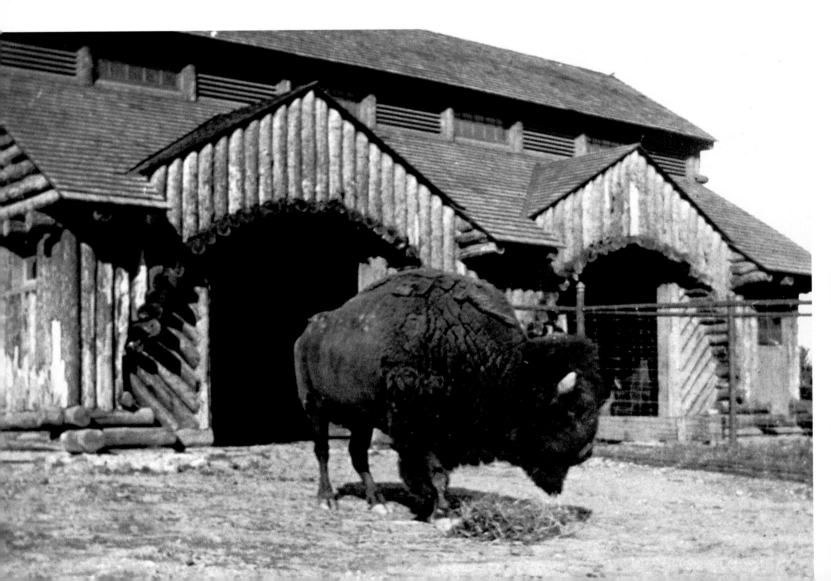

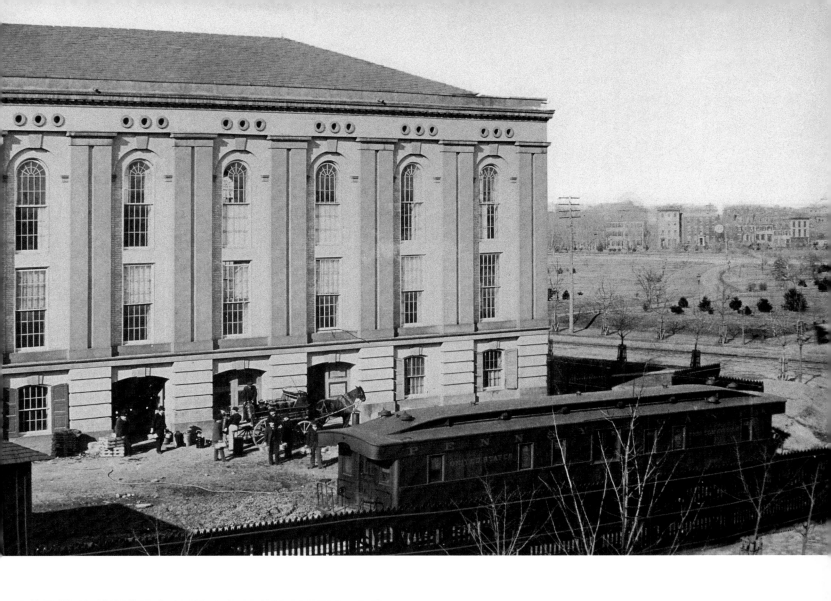

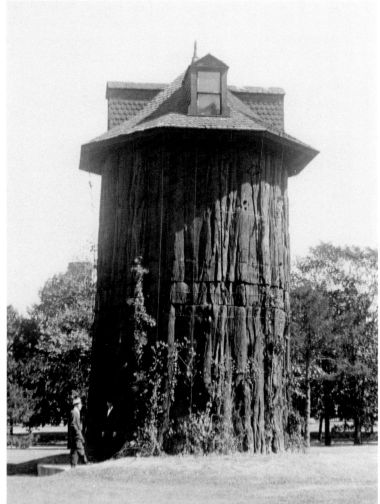

The Washington Armory (above) was built by the War Department in 1856 at Sixth Street and B Street (now Independence Avenue), SW, for the storage of weapons belonging to the militia companies of Washington, D.C. During the Civil War, the building became part of the Armory Square Hospital, which had a chapel and over a dozen wooden wards extending across the Mall. In 1877 the Smithsonian took over the Armory and used it to store exhibits from the 1876 Centennial Exhibition. Within a few years the U.S. Fish Commission moved into the building. Here the commission bred millions of fish in special tanks, then transported them across the country by railroad to replenish streams and rivers. After the commission moved out in 1932, the building was again used for storage until it was razed in 1964 to make way for the National Air and Space Museum.

Washington's oldest "building," the two-thousand-year-old General Noble Redwood Tree House (left), occupied the grounds of the Agriculture Department on the Mall from 1894 to 1932. A circular staircase allowed visitors to inspect the formal gardens below from the dormer windows. The tree was cut in General Grant National Park, Tulare, California, in 1892 for display at the World's Columbian Exposition in Chicago the following year and then given to the government when the fair ended. It was removed when the Mall was graded and restored to L'Enfant's design in the 1930s, and it subsequently disappeared.

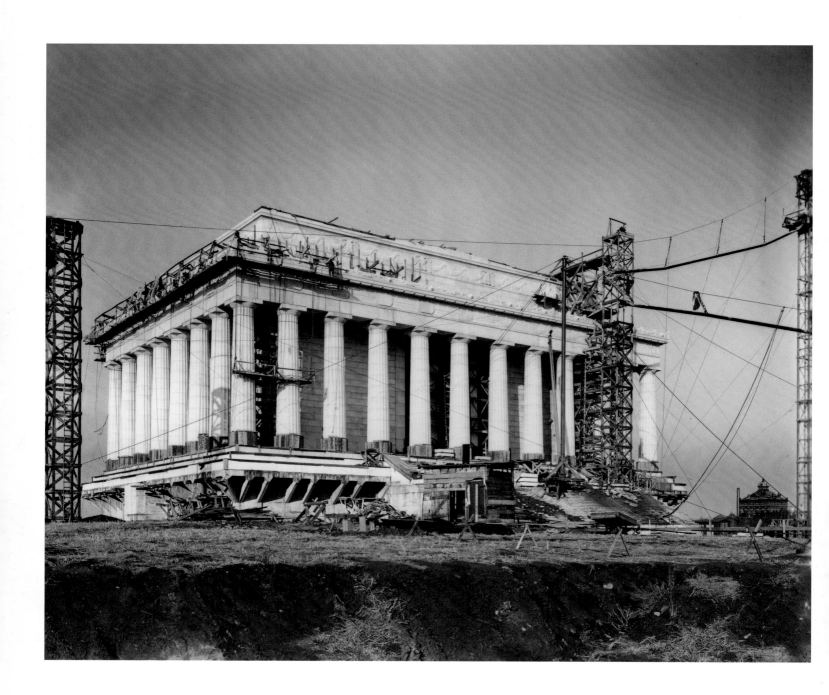

Work began on the Lincoln Memorial in 1914 in parkland recently reclaimed from the Potomac River. The memorial was elevated on a foundation of concrete so that the floor was even with the base of the Washington Monument. It is seen above about 1917, still under construction. In the photograph at right, workers apply finishing touches to *Abraham Lincoln,* shortly before the dedication of the memorial in 1922. Sculptor Daniel Chester French and architect Henry Bacon stand to the right. The statue, nineteen feet tall, was carved from twenty-eight separate blocks of marble by Piccirilli Brothers of New York City and carefully fitted together.

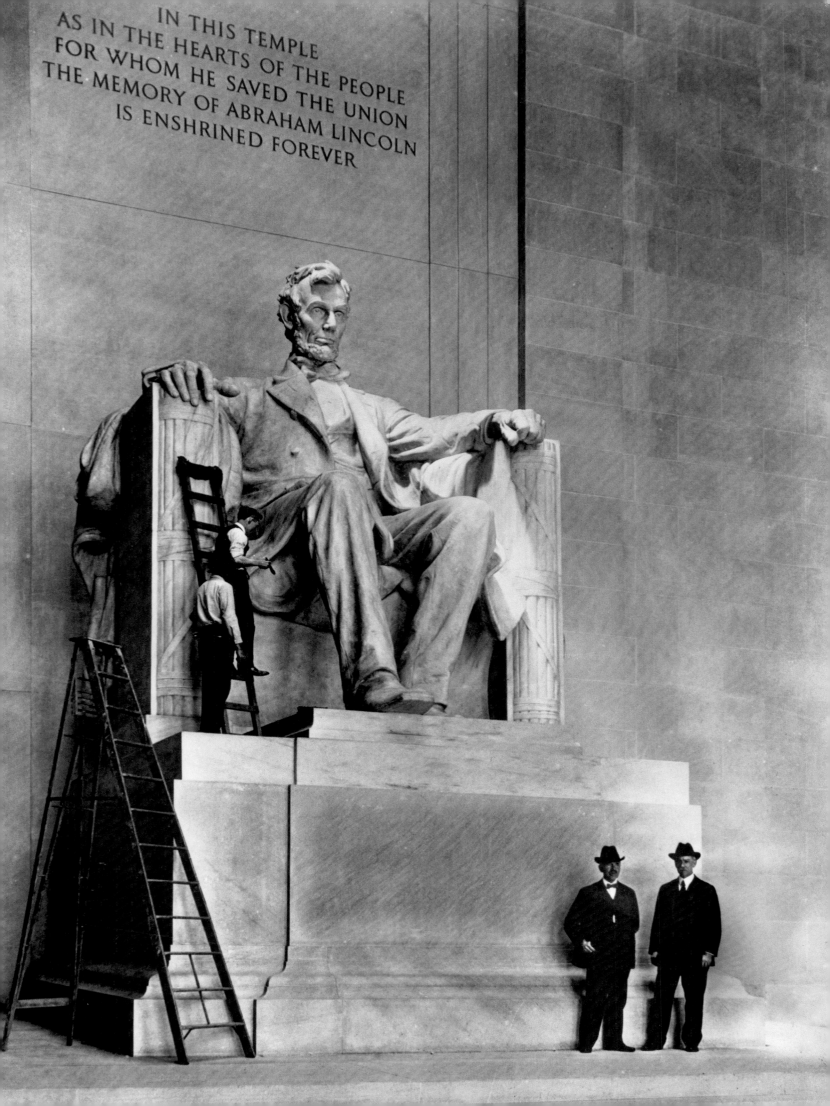

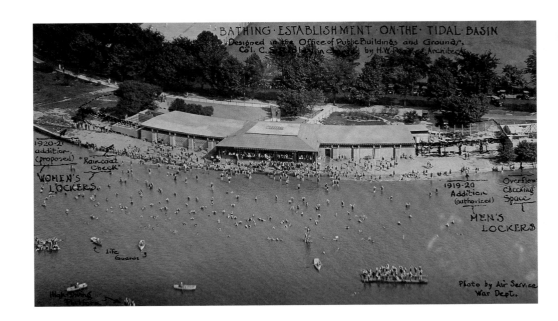

BATHING·ESTABLISHMENT·ON·THE·TIDAL·BASIN
Designed in the Office of Public Buildings and Grounds.
Col. C. S. Ridley in charge by H.W. Peaslee, Architect.

1920-21
addition
(proposed)
"Rain-coat
Check"

WOMEN'S
LOCKERS

1919-20
Addition
(authorized)

Overflow
Checking
Space

MEN'S
LOCKERS

Life
Guards

High-diving
Platform

Photo by Air Service
War Dept.

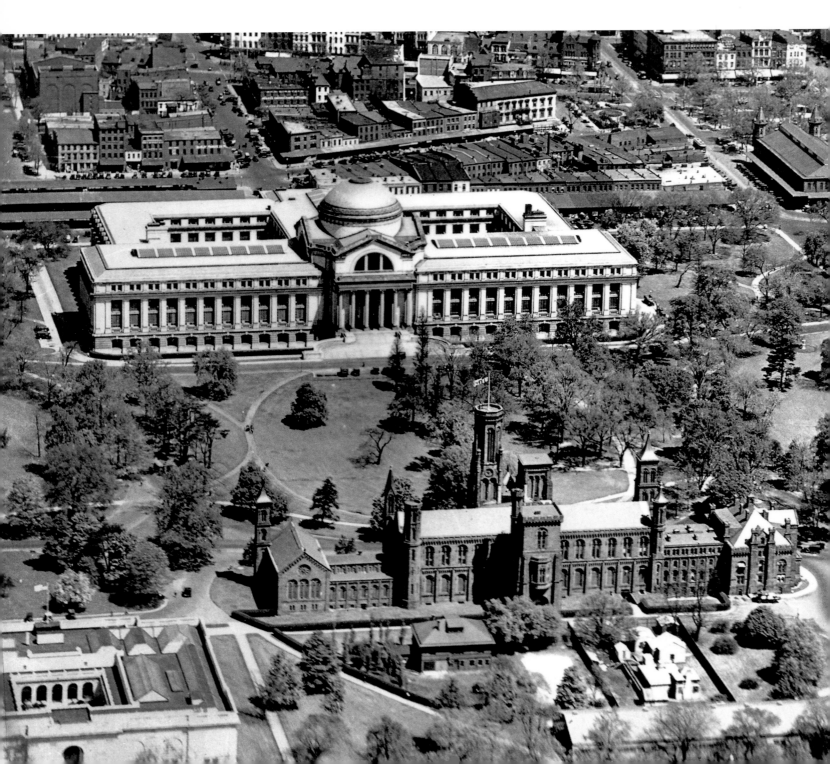

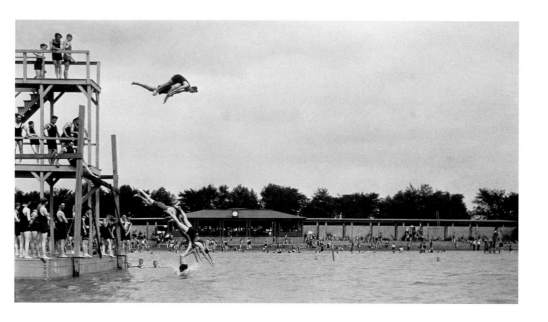

The bathhouse of the Tidal Basin Bathing Beach (opposite, top) occupied the present site of the Jefferson Memorial between 1918 and 1925. Several thousand swimmers enjoyed the 1,600-foot-long beach during the summer months. The bathing beach included a two-tiered diving platform (above). Criticism that the beach detracted from the beauty and quiet of Potomac Park and was unsanitary resulted in its closure.

Soon after the 1929 photograph at left was taken, the Mall was cleared of trees and restored to L'Enfant's original open formal design. The massive Center Market, seen in the upper right, was razed in 1931 for the National Archives building.

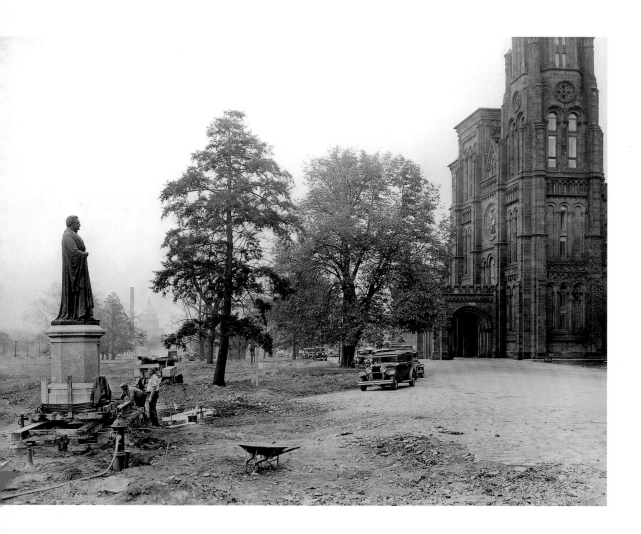

In the 1935 photograph above, workers move the statue of Joseph Henry to its present location in front of the main entrance of the Smithsonian Castle, while bulldozers grade the Mall. In 1902 the McMillan Commission recommended replacing the dense Victorian plantings on the Mall with an open greensward flanked by rows of elms, inspired by Peter L'Enfant's original vision for the park. Work began in 1929 under President Herbert Hoover but proceeded slowly until 1934, when President Franklin D. Roosevelt completed it in two years with New Deal funds.

The National Gallery of Art had been open for only a year when the aerial photograph at right was taken in 1942, showing a World War II military parade on Pennsylvania Avenue spearheaded by a "*V* for Victory" formation passing Sixth Street. The Atlantic Coast Line Railway building at 601 Pennsylvania Avenue, in the lower center foreground, still stands, but the historic National Hotel on the opposite corner had just been demolished for a parking lot. The majestic elms lining the Mall were still saplings.

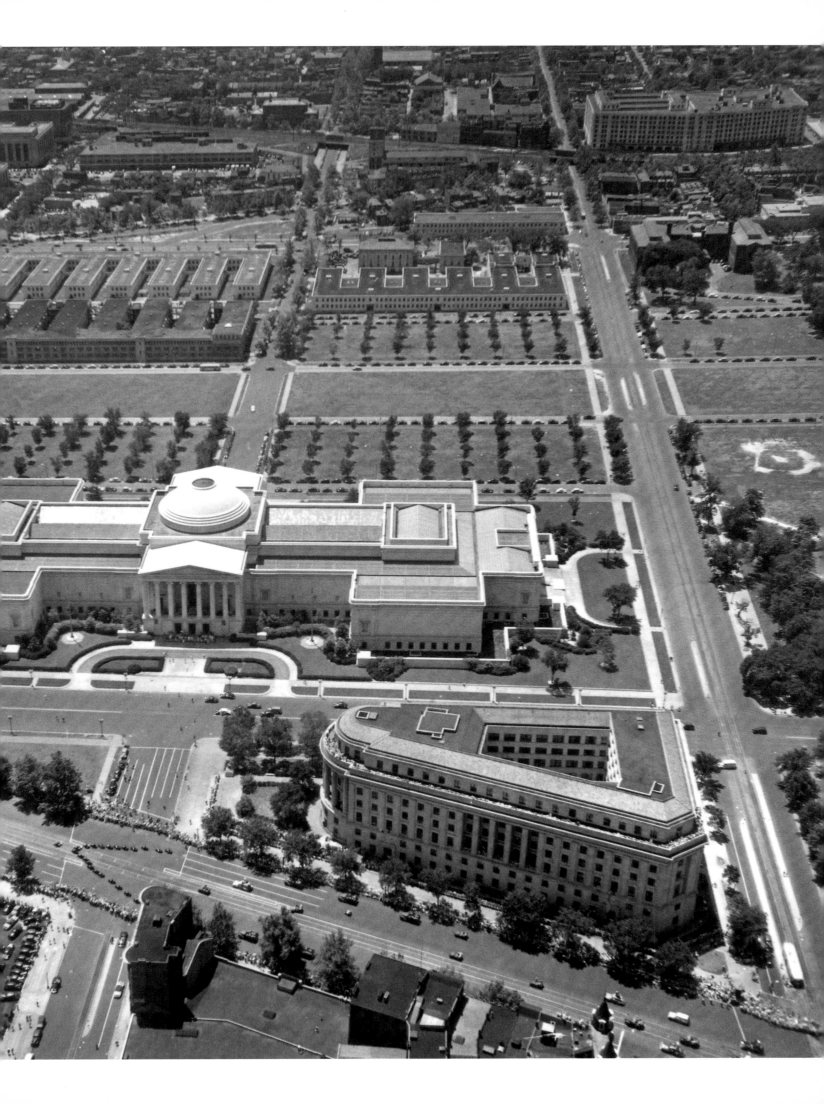

A twenty-five-foot-long fiberglass model of a triceratops, seen below in 1969, was built by the Sinclair Oil Company for a movie made at the National Zoo as part of a 1967 NBC-TV special on dinosaurs. Afterward, the model, named "Uncle Beazley," was donated to the Smithsonian Institution. Secretary S. Dillon Ripley placed it in front of the National Museum of Natural History in 1969 to help popularize the Mall. Uncle Beazley was moved in 1994 to the National Zoo, where it remains today.

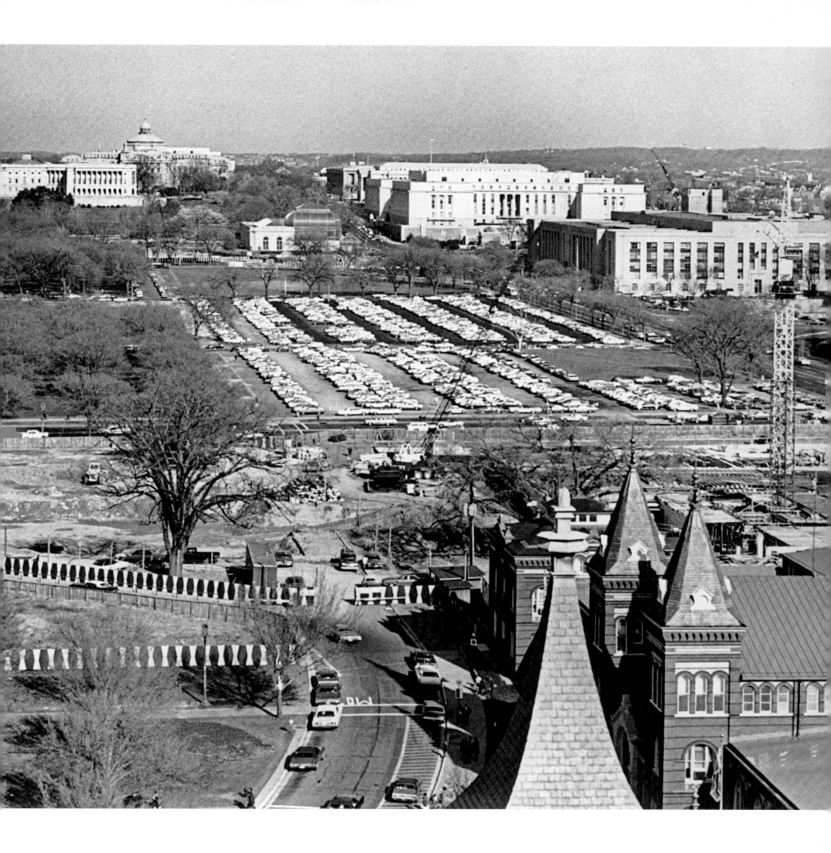

This 1971 photograph taken from the roof of the flag tower of the Smithsonian Castle, shows the Hirshhorn Museum and Sculpture Garden under construction. Excavation was then underway for the Ninth Street tunnel below the Mall as well. The original design for the Sculpture Garden would have severed the Mall in two, but public outcry put a stop to it and the plans were scaled back dramatically. Beyond, on the right, are large parking lots now occupied by the National Air and Space Museum and the Museum of the American Indian.

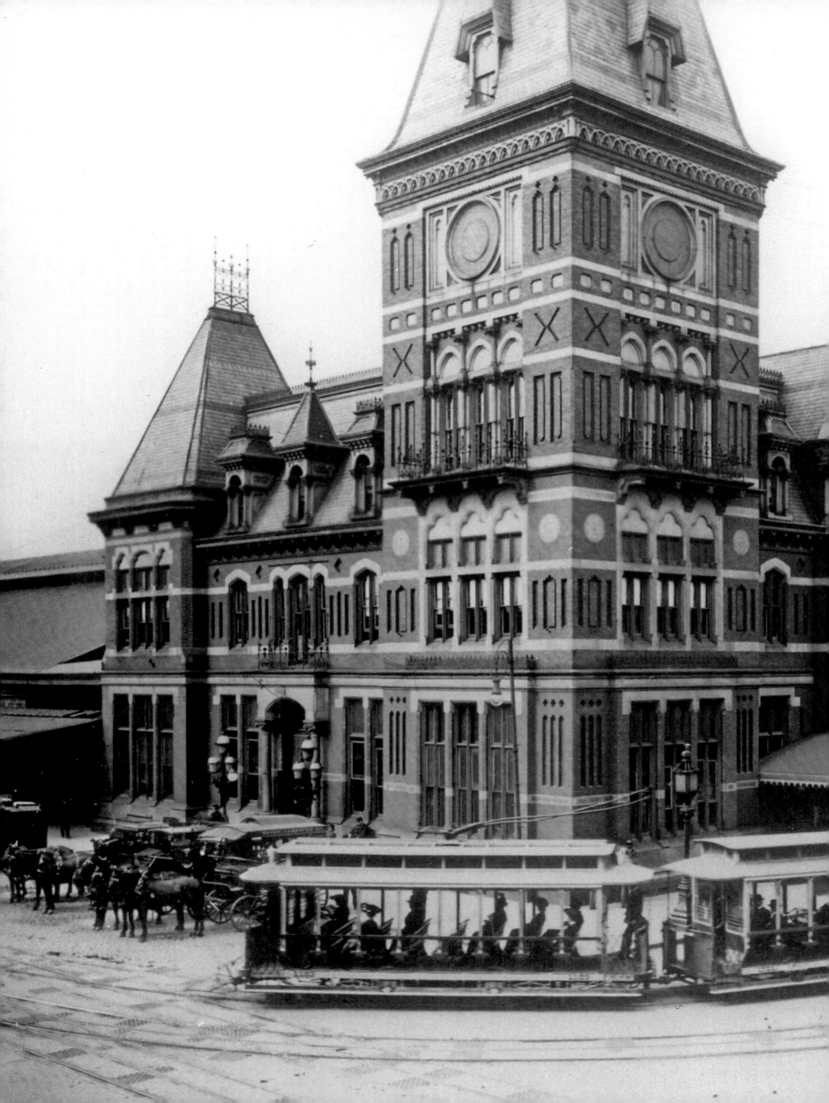

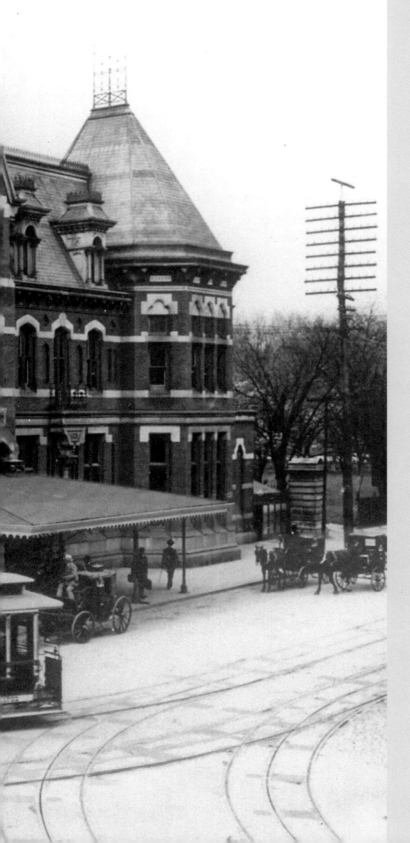

# MARKET SQUARE

Between 1873 and 1907, all railroad passengers arriving in Washington, D.C., from the south used the Baltimore & Potomac Railroad Station, located at Sixth Street and B Street (now Constitution Avenue), NW, the present site of the West Building of the National Gallery of Art. Although the old "B&P" station was picturesque, its unsightly 510-foot-long train shed and adjacent coal piles (not shown in this photograph) were eyesores. All were demolished in 1908, shortly after the completion of Union Station. The B&P station was the site of the assassination of President James Garfield in 1881, who was shot in the back as he walked through the ladies' waiting room on his way to a train.

WHEN WASHINGTON, D.C., was laid out in 1791, the widest street in the city was Pennsylvania Avenue, which Pierre (Peter) L'Enfant envisioned as a ceremonial way to connect the Capitol and the White House. This same route was, in a humbler past, the old Ferry Road connecting Georgetown with the Anacostia River. Its importance in crossing what was to become downtown Washington, D.C., was recognized by L'Enfant, who retained the road and renamed it Pennsylvania Avenue. By 1820 the avenue was lined with three-story Federal brick row houses. Soon business owners began to convert the row houses to shops, or joined them together on the north side of the avenue to create makeshift hotels. By the Civil War, these structures were replaced by much larger five-story hotels with unified neoclassical façades. As Pennsylvania Avenue became more commercial, the blocks to the north, including nearby F Street, evolved into a fashionable residential area.

During the 1850s the federal government instituted a massive building program, adding House and Senate wings and a prominent iron dome to the Capitol, and new wings to the Treasury building at Pennsylvania Avenue and 15th Street. In the Market Square neighborhood, wings were added to both the U.S. Patent Office building and the Post Office Department building, located opposite one another at F and Eighth Streets, NW.

Most members of Congress roomed in hotels on Pennsylvania Avenue; permanent residents of the city lived in houses downtown within walking distance of their work. Most did their grocery shopping at the massive Center Market, which occupied the south side of the avenue between Seventh and Ninth Streets, NW. Members of Congress and local residents found it convenient to use the Baltimore & Potomac Railroad Station located at Sixth Street and B Street (now Constitution Avenue), NW.

Immediately after the Civil War, Seventh Street between the Mall and Mount Vernon Square replaced the avenue as the city's main commercial corridor. By 1900 stores and offices began to replace the fashionable houses on

F Street, between 7th and 15th Streets, to form Washington's third commercial center. Commerce in Washington's old downtown along F Street began to fade in the 1960s with the development of large new suburban shopping centers and new office buildings on K Street.

The Senate's McMillan Commission Plan of 1902—meant to restore Washington to L'Enfant's 1791 design and to expand the city's monumental core—made a lasting mark on the Market Square neighborhood. The deteriorated industrial blocks to the south, in a triangle between Pennsylvania and Constitution Avenues, were razed to make way for monumental neoclassical federal office buildings. The seventy-acre "Federal Triangle" was essentially completed by 1938. After World War II, the north side of the avenue began to decline as businesses moved to the growing suburbs in Virginia and Maryland.

President John F. Kennedy determined to improve the appearance of Pennsylvania Avenue after observing its deteriorated state close at hand during his inaugural parade in 1961. It was not until 1972, however, that Congress established the Pennsylvania Avenue Development Corporation to rejuvenate the avenue and the adjacent blocks to the north. Its success today is evident in the dozens of restored historic buildings in the area, notably the Willard Hotel, the Warner Theatre, the *Evening Star* building, and Mathew Brady's photographic studio.

During the 1980s and 1990s, many new office buildings were built on the avenue between 6th and 15th Streets. These include the Willard at 1455, built in 1986 and designed by Vlastimil Koubek; National Place at 1331, built in 1984 and designed by Mitchell/Giurgola; the Heurich at 1201, built in 1981 and designed by Skidmore, Owings & Merrill; two monumental buildings designed by Hartman-Cox: 1001, completed in 1986, and Market Square at 701–801, completed in 1990; and 601, completed in 1986 and designed by Eisenman-Robertson. At the same time, the construction of a number of handsome new structures, including the East Building of the National Gallery of Art, the Canadian Embassy, and lastly the Newseum, enhanced the east end of the avenue.

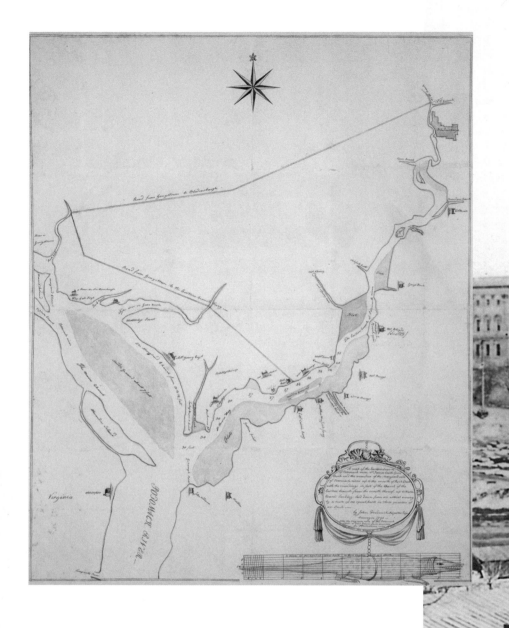

A rare 1790 manuscript map by local surveyor John F. A. Priggs (above) shows the future site of the capital city and the plantations in Prince George's County, Maryland, where the Eastern Branch (present Anacostia River) flows into the Potomac River. The map is important because it shows the early land owners as well as the Ferry Road between Georgetown and the Eastern Branch. This route was so important that Peter L'Enfant retained it when he designed Washington City in 1791. Ferry Road became Pennsylvania Avenue, which connected the Capitol with the Executive Mansion. The avenue became the focus of the present-day Market Square neighborhood.

At the time of this 1862 view (right), Gothic Revival Trinity Episcopal Church at the northeast corner of Third and C Streets, NW, was a hospital for wounded soldiers brought to Washington from Civil War battlefields. Rows of building supplies for the U.S. Capitol, including marble for the new House and Senate wings and ironwork for the new dome, littered the Capitol grounds in the background. The church, built in 1849 from a design by James Renwick Jr., was razed in 1936.

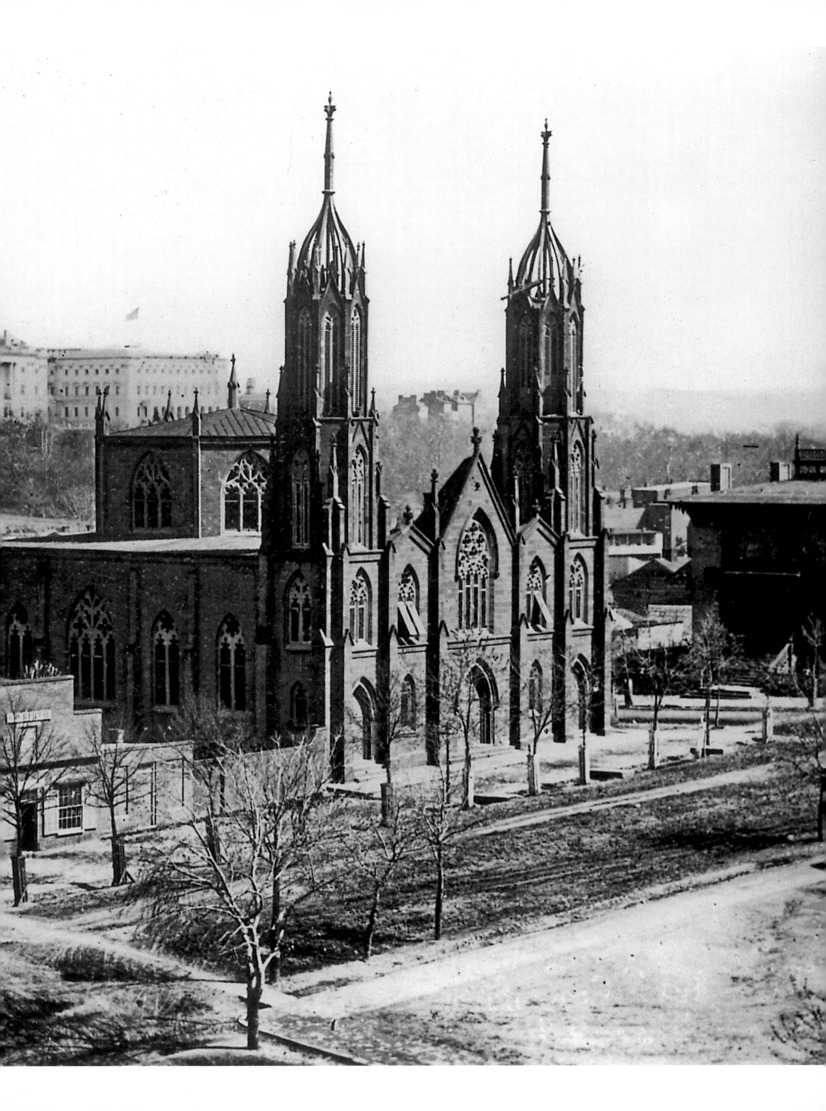

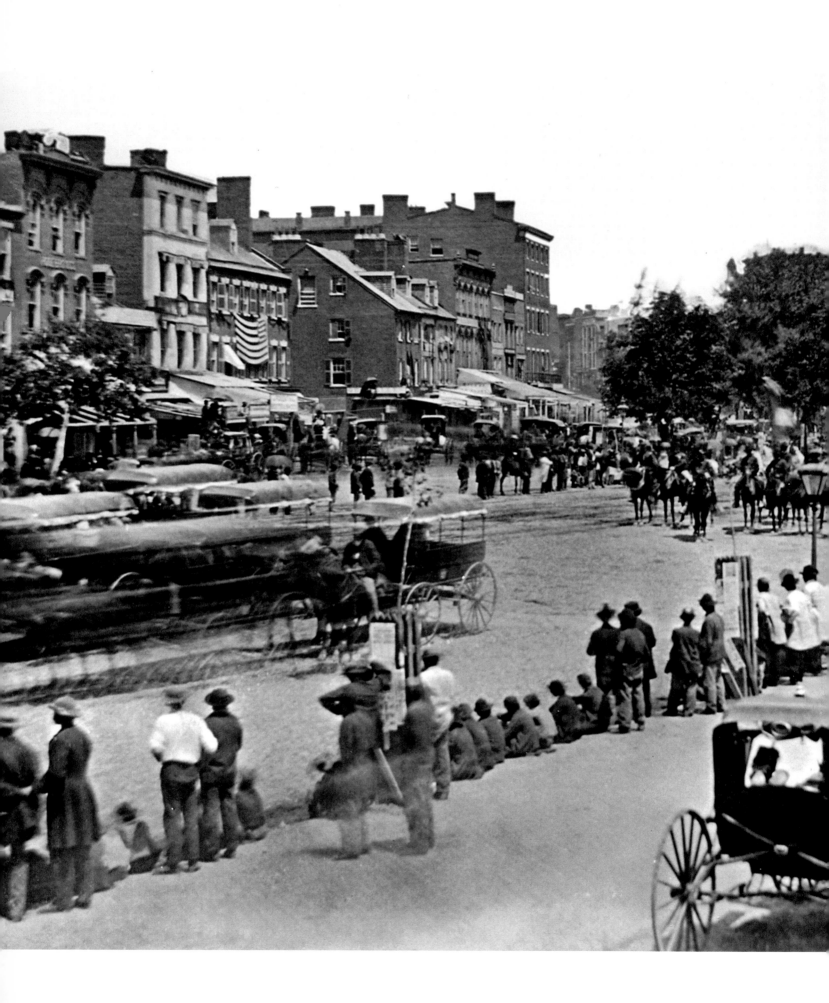

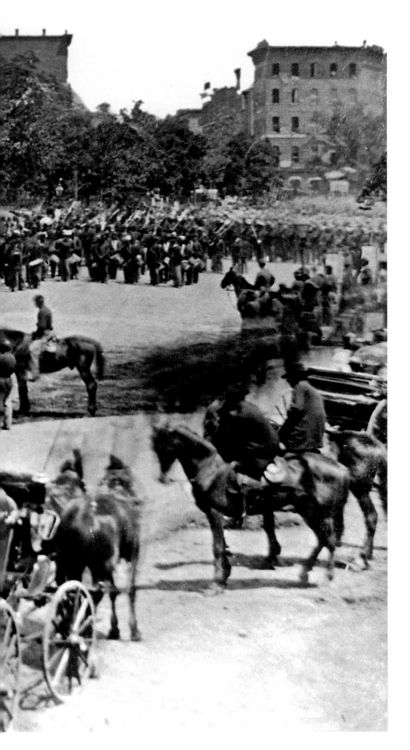

This view (left) toward the north side of Pennsylvania Avenue between Seventh and Ninth Streets was taken in May 1865, as troops of General Sherman and General Grant marched in review from the Capitol to the White House. The Avenue House, a prominent hotel at the northwest corner of Seventh Street and Pennsylvania Avenue, is the tall building just to the left of center. The U. S. Navy Memorial now occupies this location opposite the present National Archives building.

During the early years of Washington City, from 1792 to 1820, Pennsylvania Avenue between 1st and 15th Streets, NW, was lined with three-story Federal row houses. After 1820 these residences were rapidly converted into shops or joined together to create hotels. The 1867 photograph below shows 909 Pennsylvania Avenue, built in 1810, when it was occupied by the French & Richardson Book & Stationery Store. The building was razed in 1963 to clear the site for the J. Edgar Hoover FBI Building.

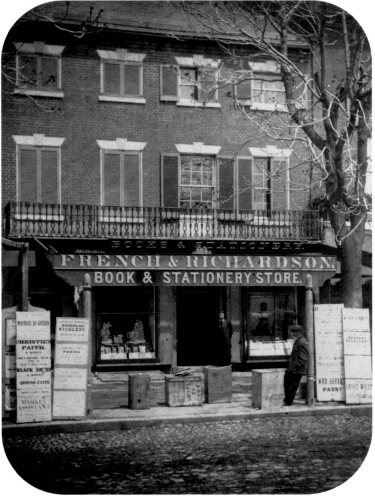

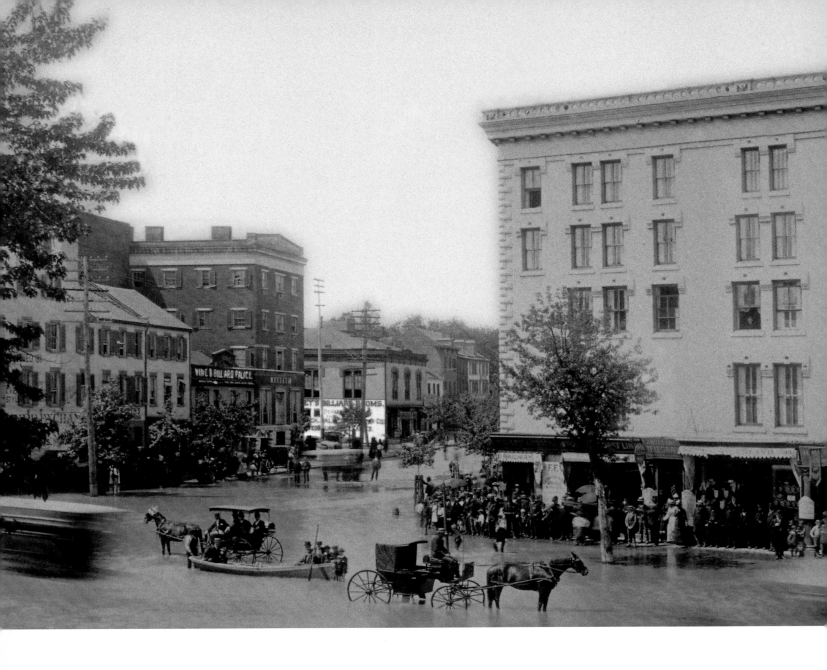

An 1889 photograph (above) shows the north side of Pennsylvania Avenue, NW, at Sixth Street during the worst flood in Washington history. Resulting from the same rains that led to the disastrous flood at Johnstown, Pennsylvania, the flood caused serious damage to the merchants on the Georgetown waterfront, to the adjacent Chesapeake & Ohio Canal (which never fully recovered), and to lower Pennsylvania Avenue, NW. This view shows the National Hotel (1826–1942) on the right and the early Federal row houses on the left. The latter were razed in 1892 to build the Atlantic Coast Line Railroad building, now part of 601 Pennsylvania Avenue, NW.

The electric lines pictured in a 1901 view up Seventh Street from D Street, NW, (opposite, top) are now underground. The large six-story office building on the corner still stands, as does the historic neoclassical Post Office Department building, now the Hotel Monaco, which can barely be seen one block north on Seventh Street.

Hoy's Hotel on the northeast corner of D and Eighth Streets, NW, stands in the foreground in this 1901 scene (opposite, bottom). In the distance is the Patent Office building, one of the most important Greek Revival buildings ever built in the United States. It was designed by Robert Mills and Thomas U. Walter and built between 1836 and 1868. This landmark now houses the Smithsonian American Art Museum and the National Portrait Gallery.

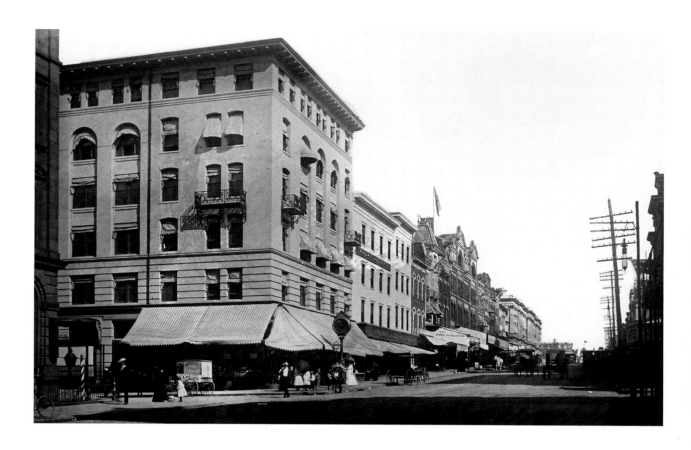

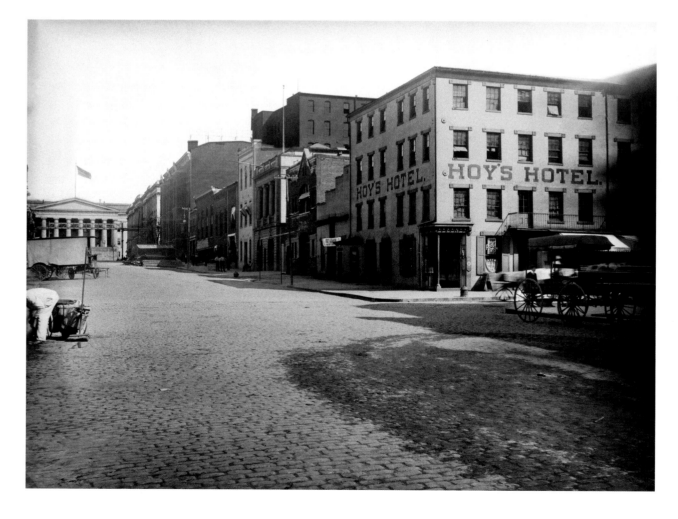

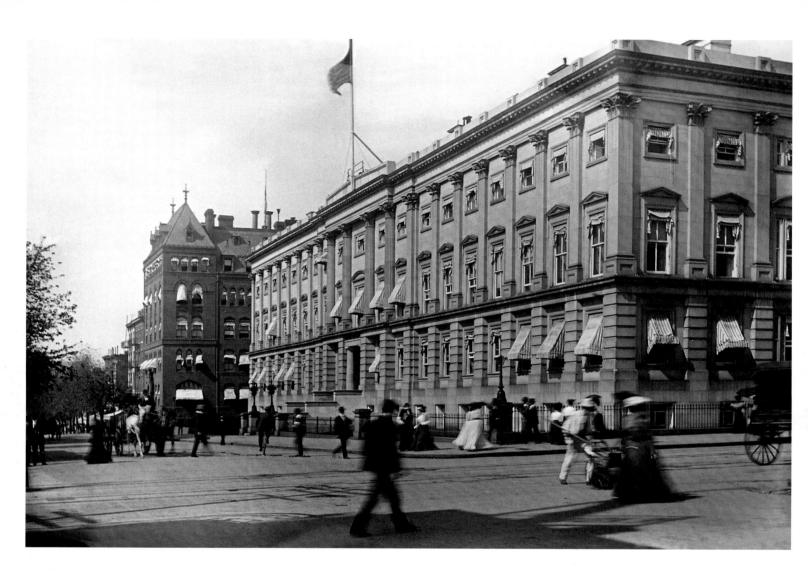

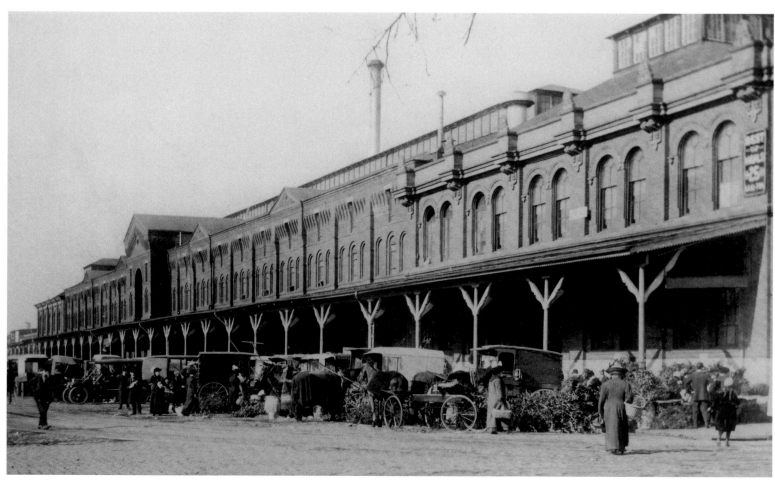

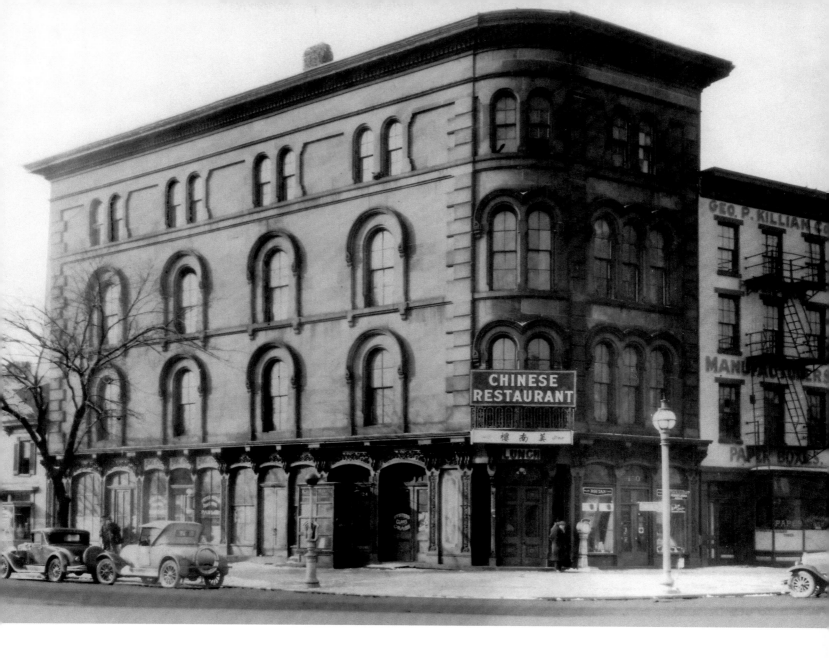

The original south wing of the Post Office Department building (opposite, top), on the northwest corner of Seventh and E Streets, NW, designed by architect Robert Mills in 1836, is pictured in 1901. The other wings of this monumental neoclassical landmark, the first marble building in Washington and now the Hotel Monaco, were designed by Thomas U. Walter and built in the 1850s. Walter is better known as the architect of the new wings and iron dome of the U.S. Capitol.

The massive Center Market (opposite, bottom), designed by Adolph Cluss in 1871, occupied four square blocks bounded by Pennsylvania Avenue, Constitution Avenue, and Seventh and Ninth Streets, NW, until it was razed in 1931 to clear the site for the National Archives building. The three-hundred-foot-long structure, which contained a thousand stalls for food vendors, was considered the largest and most modern food market in the country when it opened.

The imposing 1860 Italianate office building above once stood on the southwest corner of Pennsylvania Avenue and Fourth Street and housed the headquarters of the American Colonization Society. The ACS was founded in 1817 to raise funds to transport free blacks in the United States to Africa "where they could live a normal life in their own democracy." This photograph was taken shortly before the landmark was razed in 1931, when work began to clear the Mall for the restoration of L'Enfant's original design.

Brown's Hotel, renamed the Metropolitan (right), occupied most of the site of the present office building at 601 Pennsylvania Avenue, NW. This handsome five-story hotel, built in 1850 with a Greek Revival entrance portico and white marble façade, was designed by noted Philadelphia architect John Haviland. This photograph shows the landmark shortly before it was razed in 1936. A small section of the original hotel located at 621 Pennsylvania Avenue—two stories tall and two bays wide— remained standing until 1984. When it fell to the bulldozers of the Pennsylvania Avenue Development Corporation, it was in use as Barney's Restaurant. The façade of the 1892 Atlantic Coast Line Railroad building, a portion seen on far right, was dismantled and reerected as part of 601 when it was built between 1984 and 1986.

A 1968 photograph shows the deteriorated condition of the pair of Italianate commercial buildings at 625–627 Pennsylvania Avenue, NW (below). Gilman's drugstore occupied the first floor of 627 on the left from 1855, when the buildings were finished, until 1967. From 1858 to 1881, Mathew Brady's photographic studio and exhibition gallery occupied the three floors above, where Brady and his assistants took photographs of many important personalities. By the 1960s Pennsylvania Avenue was quite run-down and lined with parking lots, liquor stores, and souvenir shops. In 1972 an act of Congress established the Pennsylvania Avenue Development Corporation to revitalize the avenue through a public-private partnership. The corporation was highly successful during its twenty-four-year existence. Today 625–627 has been restored.

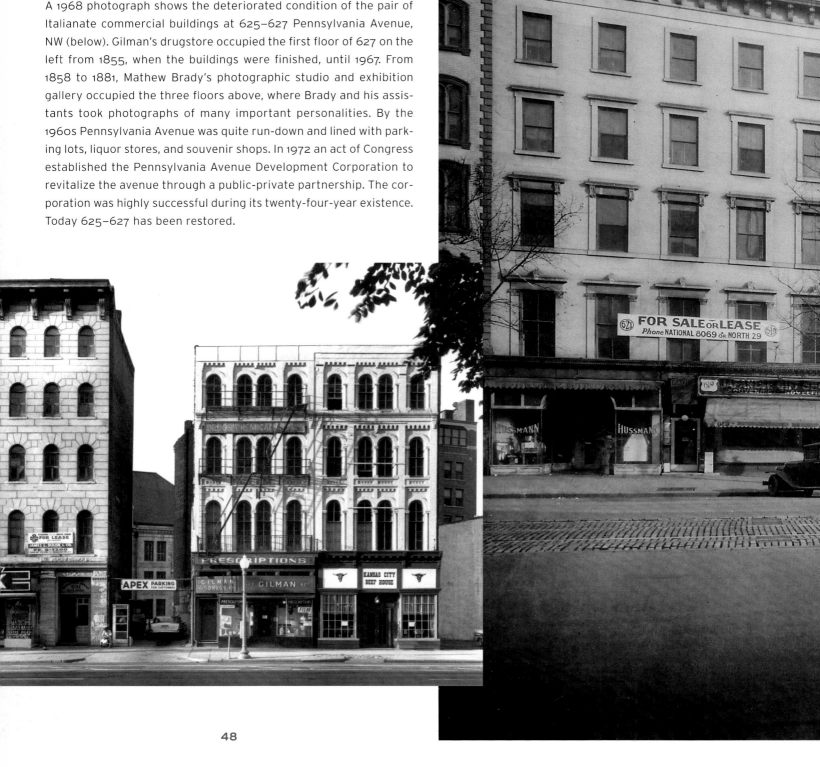

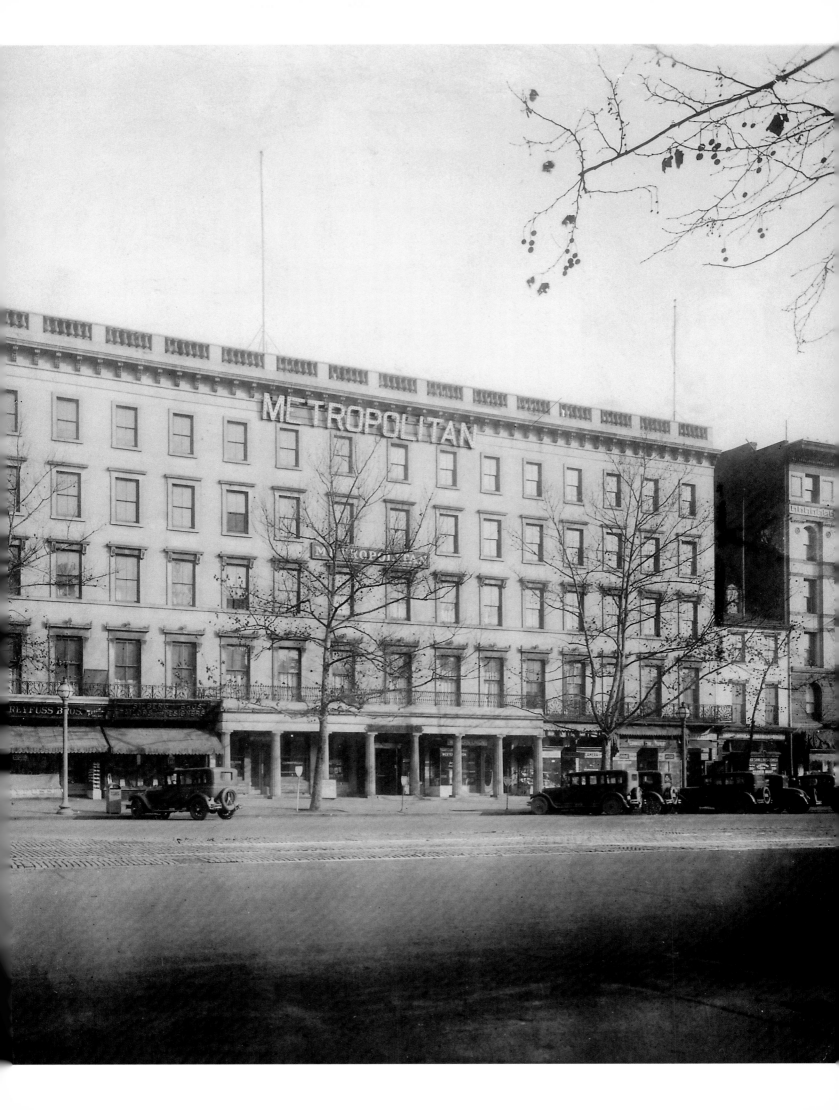

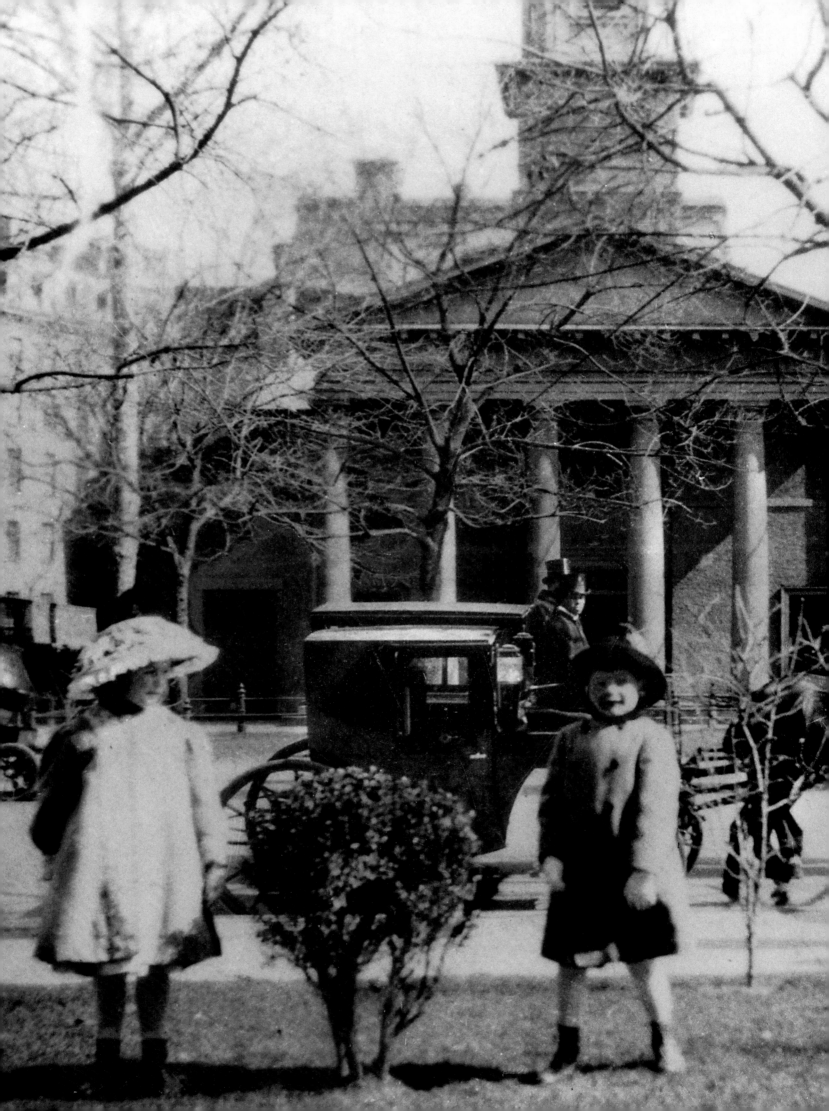

# THE HAY-ADAMS HOUSES

This view across 16th Street from the front steps of John Hay's house, dating from about 1904, is not altogether different from what a guest at The Hay-Adams would see today from the hotel's main entrance. Architect Benjamin Latrobe designed St. John's Church, in the background, in 1816. The portico was added in 1820, the steeple in 1822. In the foreground are two of John Hay's grandchildren.

THE HAY AND ADAMS HOUSES on the northwest corner of 16th and H Streets, NW, were designed by architect Henry Hobson Richardson in 1884. Richardson, one of America's greatest architects, produced just four houses in Washington, all in his signature Romanesque Revival style; only one house survives. Richardson and Henry Adams met when they were classmates at Harvard University and became lifelong friends. Adams tapped him to design the adjoining houses for himself and John Hay; as close friends the two men and their wives often entertained and traveled together. For more than four decades, the Hay-Adams Houses were a landmark on Lafayette Square, but the once-residential neighborhood became progressively commercial. Hay's daughter sold the two houses in 1927 to local developer Harry Wardman, who razed them to build The Hay-Adams hotel on the site.

John Milton Hay (1838–1905), a native of Warsaw, Illinois, studied law in Springfield where he met Abraham Lincoln. Hay and John G. Nicolay served as Lincoln's secretaries at the White House during the Civil War and later in life collaborated on a biography of Lincoln. Hay entered the foreign service, worked as a newspaper editor in New York, and is best remembered as secretary of state under presidents William McKinley and Theodore Roosevelt.

The owner of the smaller of the two houses was Henry Brooks Adams (1838–1918), a native of Boston, Massachusetts, who was descended from presidents John Adams and John Quincy Adams. He spent the Civil War in England, where his father was the American minister. Adams taught medieval history at Harvard University from 1870 until 1877, when he moved to Washington, D.C., with his wife, Clover Adams. There he worked as a journalist and historian and wrote a number of books. He traveled widely, in Europe, Egypt, Japan, the South Seas, and the American West. After Clover took her life in 1885, Adams commissioned Augustus Saint-Gaudens, the dean of American sculptors, to design a funerary statue. Popularly known as *Grief* in Rock Creek Cemetery, it is considered one of Saint-Gaudens's greatest works.

B. F. Saul Company installed this exhibition on the history of the Hay and Adams houses in The Hay-Adams shortly after it acquired the hotel in 2006.

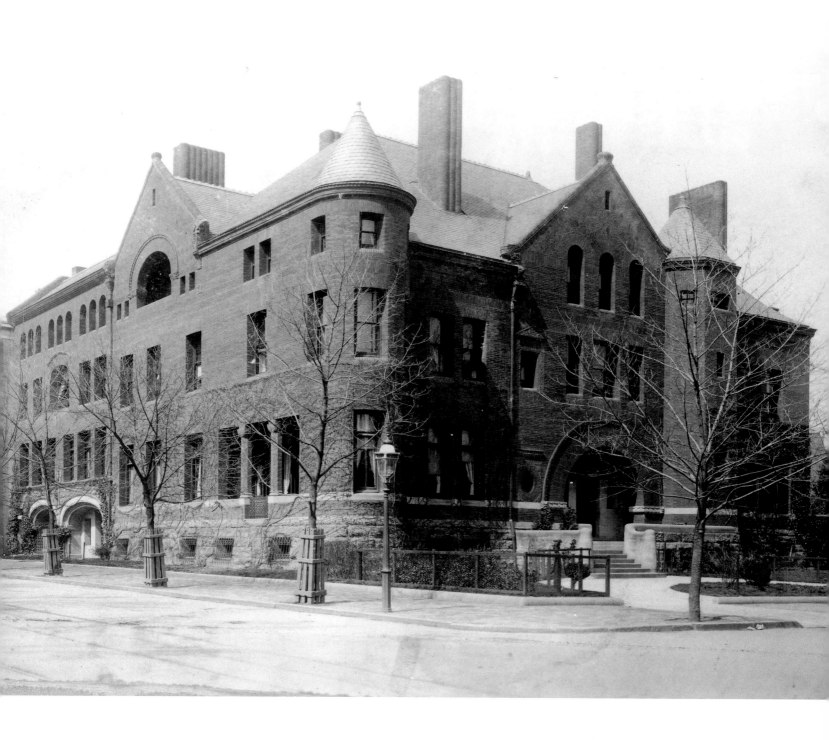

The Hay-Adams Houses were located on the northwest corner of 16th and H Streets, NW.

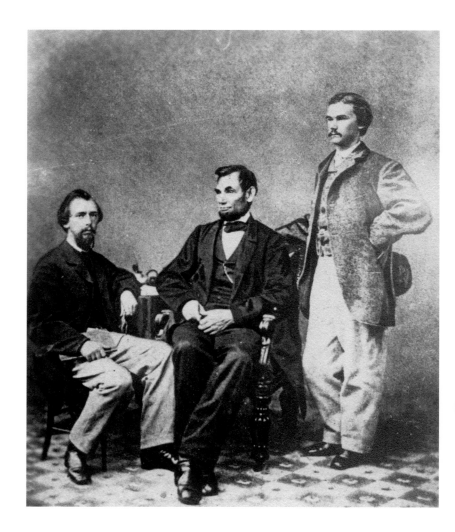

Henry Hobson Richardson (above, left) designed the Hay-Adams Houses for historian Henry Adams and statesman John Hay. A noted bon vivant, Richardson was one of the most important architects in American history. His signature style, known as Romanesque Revival, was an imaginative adaptation of the early medieval architecture of France. Clover Adams took this photograph of Richardson in 1884, the year that work began on the two houses.

In an 1863 photograph (above, right), President Abraham Lincoln appears with John G. Nicolay (left) and John Hay (right), his secretaries during the Civil War. Nicolay was responsible for Lincoln's official correspondence, the White House budget, and social functions; Hay, only twenty-five years old, functioned as Nicolay's assistant and managed Lincoln's private correspondence. Both men screened the president's visitors, served as his proxy on sensitive political missions, and stood by his side at receptions. Nicolay later served as a diplomat in Europe and as marshal of the Supreme Court. In 1890 both men collaborated on a ten-volume biography of Lincoln, which helped define Lincoln for the postwar generation.

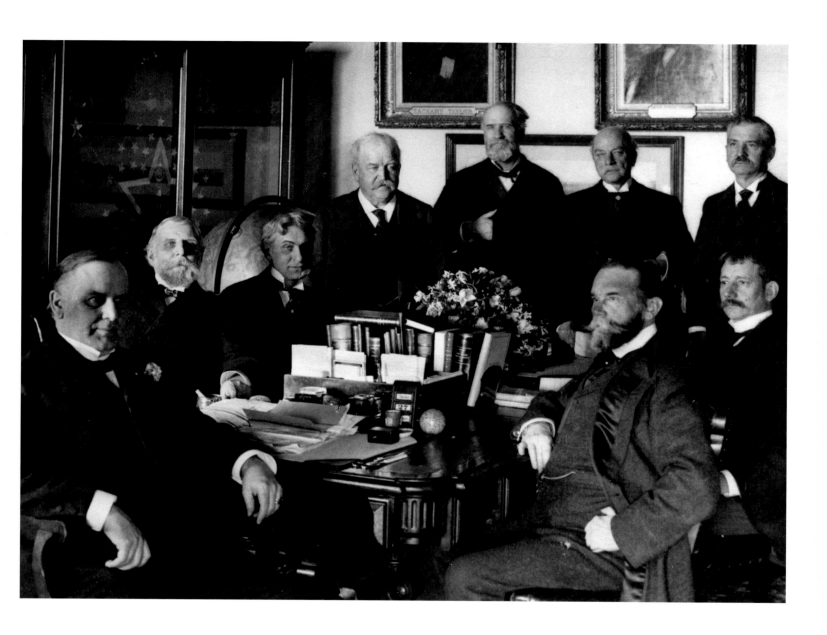

John Hay was secretary of state under presidents William McKinley and Theodore Roosevelt. Hay appears here about 1899, seated in the right foreground, with McKinley on the left, and the other members of the cabinet. One of Hay's most important achievements as secretary of state was to negotiate the 1903 treaty with Panama that paved the way for the Panama Canal. The men are posed in the Cabinet Room at the White House, known today as the Treaty Room.

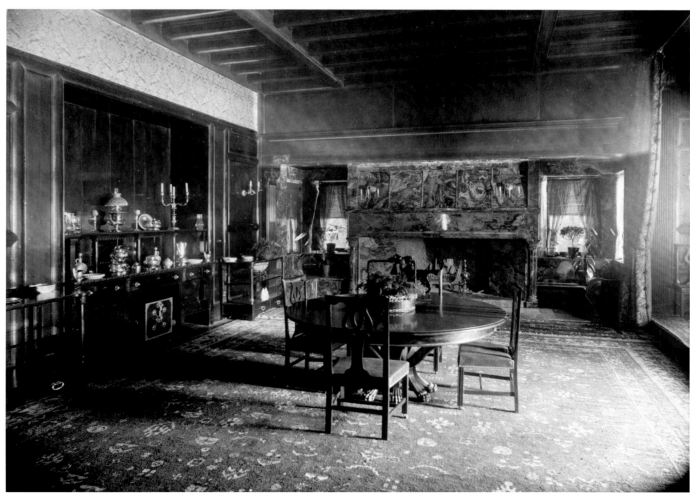

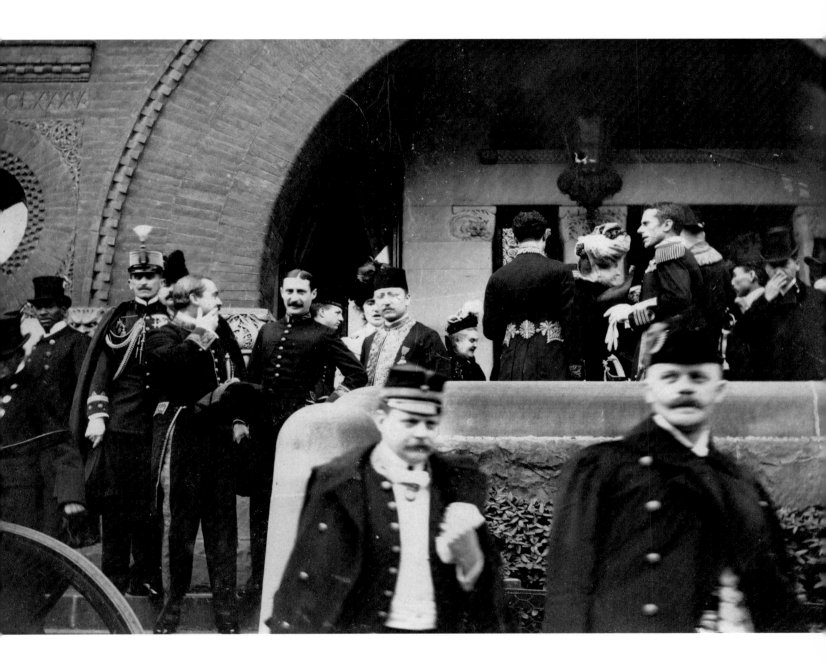

The entrance hall and staircase of John Hay's house (opposite, top) was richly decorated in walnut paneling and stamped leather friezes. His dining room (opposite, bottom) included a beamed ceiling, recessed sideboard, and massive fireplace.

An unusually candid view (above) of a diplomatic reception at John Hay's house was taken about 1900. The men include foreign ministers and military representatives, and on the left, two coachmen in top hats. Hay served as ambassador to Great Britain for a year, and then as secretary of state from 1898 to his death in 1905. Like many in the upper reaches of Washington society, Hay chose to live in close proximity to the White House. He acquired his great wealth through his marriage to Clara Stone, the daughter of Amasa Stone, a very successful industrialist in Cleveland, Ohio.

Marian "Clover" Hooper (right), daughter of a prominent Boston doctor, married Henry Adams in 1872 when she was 28 years old. In 1877 they moved to Washington, where she earned a reputation as a prominent socialite and intellectual. Headstrong and emotional, she entertained at her house on H Street almost nightly and is credited with writing a novel on the Washington political scene that was published anonymously. In 1885 she took her own life. Although she was an accomplished amateur photographer, this is one of the few images of her. It was taken at her father's summer house in Beverly Farms, Massachusetts.

During the Civil War, Henry Adams served in London as private secretary to his father, who was the American minister. He spent seven years there and formed many lasting friendships. Adams returned to Europe in 1872, with his new bride Marian "Clover" Adams, on a wedding trip that lasted more than a year. Below, Henry (standing at the far left) and Clover (partially hidden) visit the ruins of Wenlock Abbey in Shropshire with a group of English friends. Adams was a professor of medieval history at Harvard University, and during the trip he and his wife read European history voraciously and met many of the leading English and German historians.

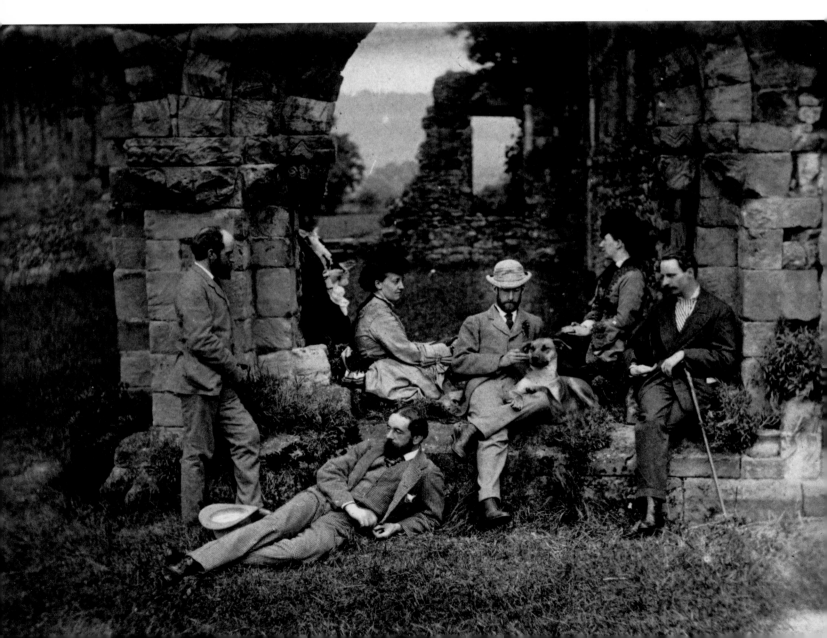

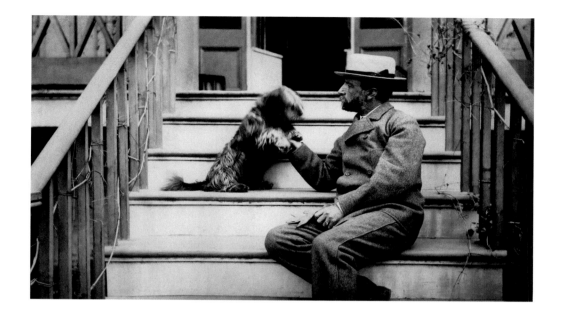

Henry Adams (above) was one of the notable American intellectuals of his time. A historian and descendant of two presidents, he wrote many books, but the best-known is his autobiography, *The Education of Henry Adams*. The book, which won the Pulitzer Prize, explores through his own experience the vast technological and social changes during his lifetime and how little his conventional education helped prepare him for them. His wife, Clover, took this photograph in 1883 on the back porch of their house at 1607 H Street, where they lived while the Hay-Adams Houses were under construction next door. The dog is Marquis, one of their three Skye terriers.

In 1894 Henry Adams and John Hay traveled to Wyoming to visit Yellowstone Park (below). Accompanied by five guides and twenty-five horses, the two men traveled through the park for four weeks and set up twenty-two camps. Adams read Roman literature and painted watercolors—and probably shot this photograph of John Hay seated by a campfire. Yellowstone National Park, formed in 1872, was the country's first national park.

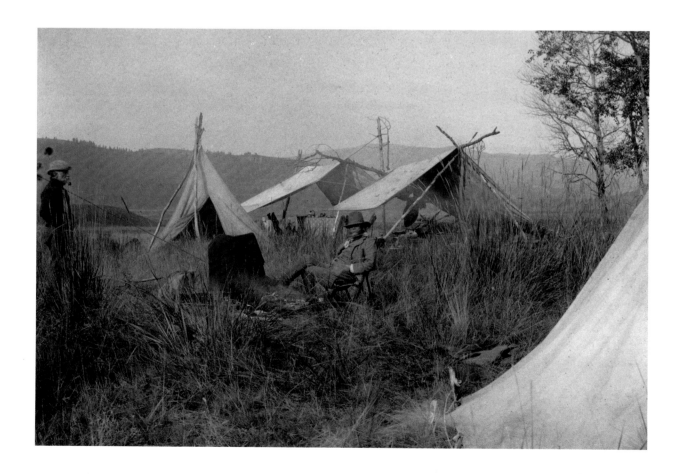

The façade of Henry and Clover Adams' house (opposite) faced H Street and was dominated by a pair of wide carved limestone arches which framed its simple entrance. Adams once complained that messengers delivering packages to Hay usually came to his smaller house on the left thinking that it was the servants' entrance. Fortunately, architect Horace W. Peaslee purchased the limestone arches when the Adams House was demolished in 1927 and incorporated them into a new house he was building at 2618 31st Street, NW.

The 1949 photograph above of The Hay-Adams hotel shows the English Renaissance façade, designed by developer Harry Wardman's talented architect, Mihran Mesrobian. A porte cochere was added in 1984 over the main entrance facing 16th Street, and a new ninth floor for banquet rooms was built in 2009.

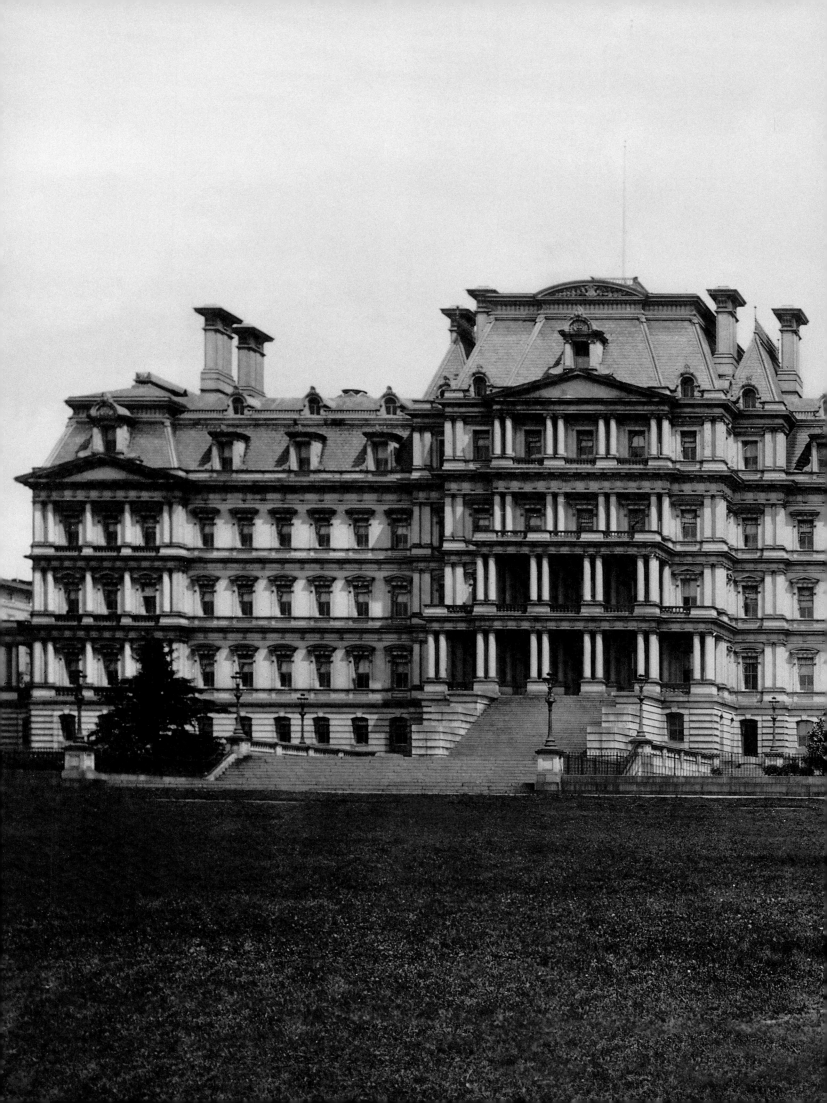

# WASHINGTON, D.C., IN 1908

Pauline Wayne, President William Howard Taft's pet cow, shown on the south side of the State, War, and Navy building, was the gift of a U.S. senator from Wisconsin in 1910. No ordinary cow, Pauline was a champion Holstein. She was said to produce sixty-four quarts a day, providing milk for the president and his family until Taft lost the election of 1912. Pauline then went home to Wisconsin.

IN 1908 THE POPULATION of Washington was 300,000. Much of the land in the northern portion of the city, on Georgia Avenue above Howard University and on Connecticut Avenue north of Cathedral Avenue, was being developed as streetcar lines expanded north from downtown. In business the Washington Stock Exchange recovered from the Panic of 1907, a crisis that led six years later to the establishment of the Federal Reserve System. Washingtonians normally worked six days a week, but in 1908 four national holidays fell on Saturdays—a cause for celebration, since those occasions allowed workers to take a "week-end" off.

The physical appearance of the city was improving as well. The Senate's McMillan Commission Plan of 1902 proposed an official architecture for Washington: white marble buildings in orderly rows, adorned with columns, pediments, grand staircases, and sculpture. By 1908 the plan was literally fixed in stone as the federal government finished work on several monumental buildings including Union Station, the Natural History Museum, the Agriculture Department building, and new House and Senate office buildings. The plan recommended restoring the Mall to the intentions of the city's designer, Pierre (Peter) L'Enfant, but in 1908 the park was still choked with dense Victorian plantings and ornate brick buildings.

Washington newspapers predicted that 1908 would best be remembered for advances in "aerial navigation." The army realized the potential importance of the airplane for military use and in 1908 had the Wright brothers and others demonstrate their aircraft at Fort Myer. Trials ended for the year when pilot Orville Wright crashed his plane, killing his passenger, Lieutenant Thomas E. Selfridge, in the world's first fatal airplane accident. Orville Wright's demonstrations a year later at Fort Myer were more successful.

Even though considerable advances were made in "wireless telegraphy," newspapers failed to recognize its importance. That year the government established a permanent radio link between stations in San Francisco and Honolulu.

In 1908 automobile accidents were still rare enough to be front-page news. Motorists normally drove injured pedestrians to the hospital themselves, even though there was no law in Washington requiring them to stop. In the presidential election of 1908, William Howard Taft, a member of the Metropolitan Club, defeated William Jennings Bryan. Once in the White House, Taft built the Oval Office in the West Wing and replaced the presidential horses with automobiles.

These historical photographs taken in 1908 show the vast changes in the way residents of Washington lived a century ago compared with the present day. In all but the downtown neighborhoods, travel by automobile was slow and unreliable because of poorly paved city streets and suburban dirt roads. Even the fire department was slow compared to today, because it depended on horse-drawn steam pumpers and ladder trucks. People traveled long distances by train because air travel was still in its infancy. City residents usually traveled by streetcar on a daily basis to shop for groceries in one of Washington's seven public market houses. Today Washingtonians use the more convenient modern neighborhood supermarkets. The lack of air-conditioning caused many families to spend summers in the country to escape the heat and humidity. Many of those who could not afford to leave the city would spend nights on sleeping porches or in parks. President William Howard Taft's hobby of playing golf in Washington helped make this sport nationally popular among the middle class. There is much from 1908 that seems familiar today, but the subsequent technological advances are nothing short of astonishing.

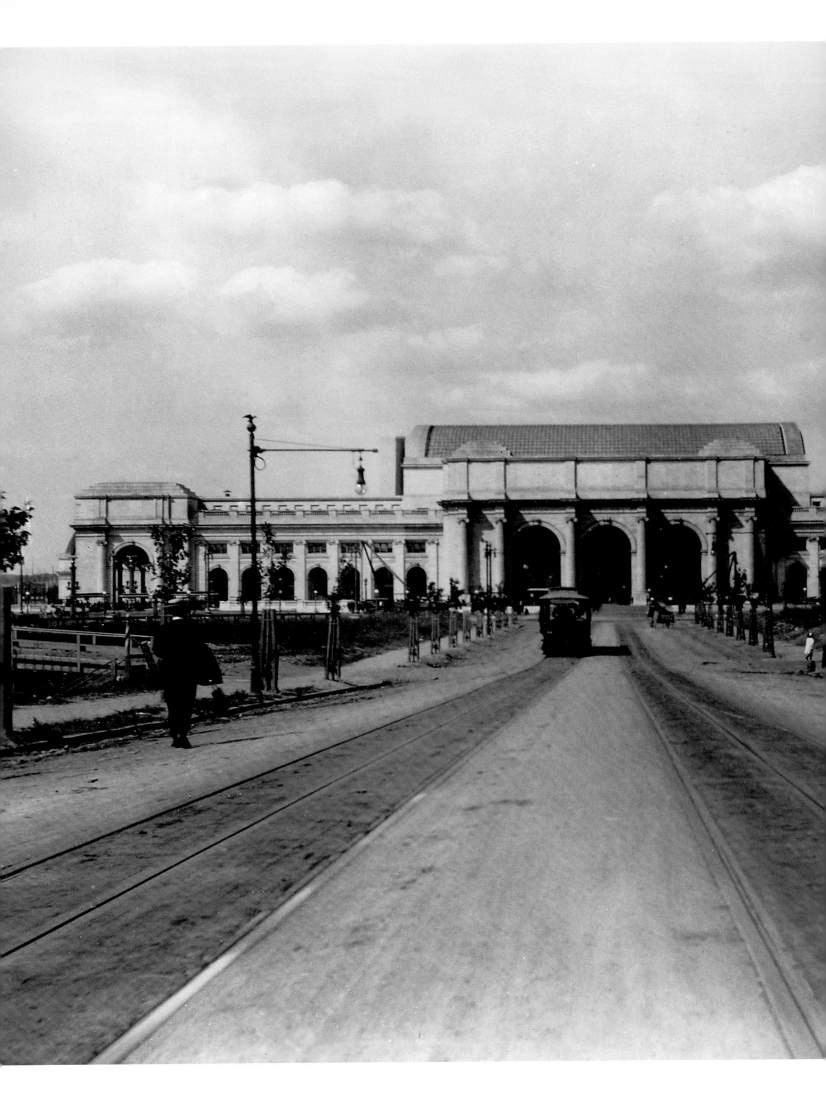

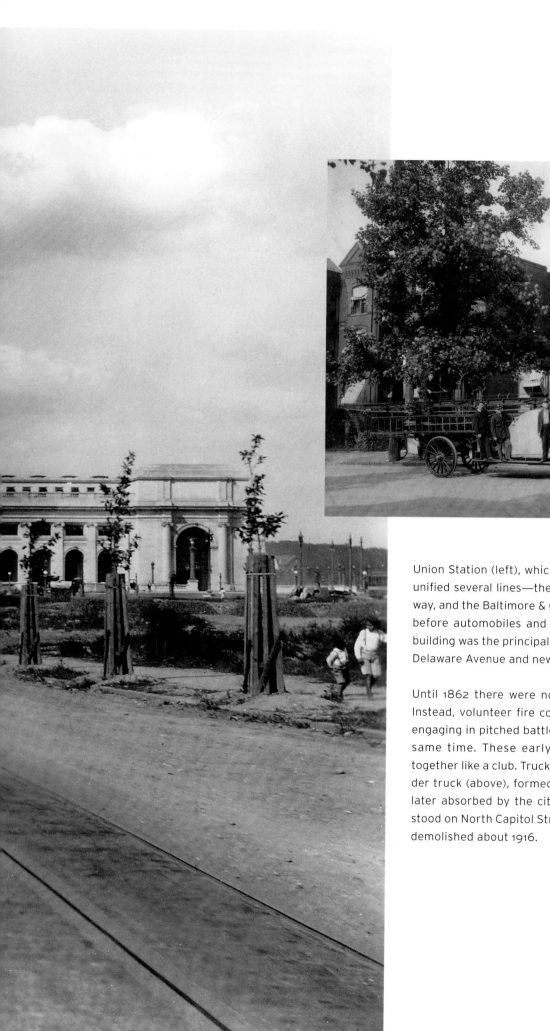

Union Station (left), which opened in 1907, was so named because it unified several lines—the Pennsylvania Railroad, the Southern Railway, and the Baltimore & Ohio Railroad—into one station. In the days before automobiles and airplanes became popular, the enormous building was the principal gateway to the capital. In the foreground is Delaware Avenue and newly laid streetcar tracks.

Until 1862 there were no professional firefighters in Washington. Instead, volunteer fire companies competed to put out fires, often engaging in pitched battles if two companies arrived at a fire at the same time. These early firefighters were not paid but worked together like a club. Truck Company No. 1, seen on a horse-drawn ladder truck (above), formed as a volunteer company in 1855 and was later absorbed by the city fire department. Their firehouse, which stood on North Capitol Street just north of Constitution Avenue, was demolished about 1916.

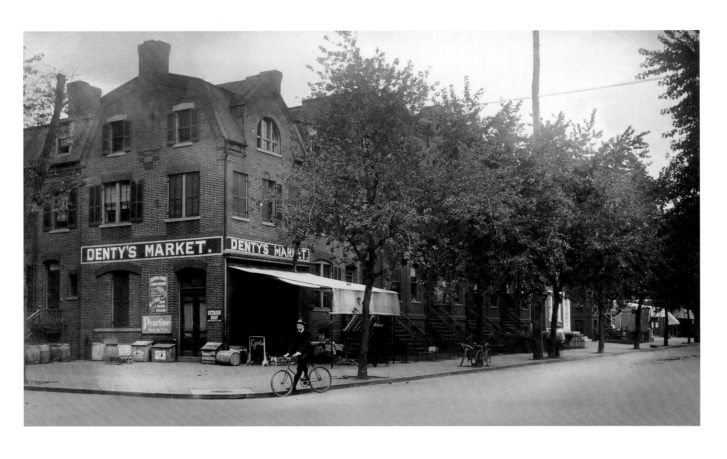

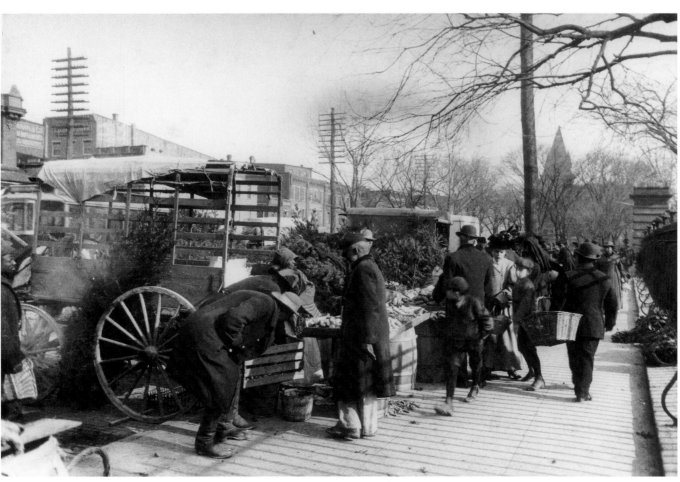

Denty's Market (opposite, top) occupied the northeast corner of H and Sixth Streets, NW. Remarkably, the building has survived and still operates as a market. In 1908 the neighborhood was predominantly German. In the 1930s, the city's Chinatown moved here from Judiciary Square, after federal construction projects razed that neighborhood.

In an age before supermarkets and refrigeration, Washingtonians shopped for fruit, vegetables, meat, and fish at Center Market (opposite, bottom), an enormous market house that stood on the site of the present National Archives. Vendors spilled over into the surrounding blocks. Here they can be seen on Constitution Avenue near Tenth Street.

The photograph below of F Street was taken from the monumental south steps of the old Patent Office, now the National Portrait Gallery and the Smithsonian American Art Museum. The steps were removed in 1936 to improve traffic flow, and in the 1950s the historic building itself was nearly demolished by the federal government for a parking lot. The Washington Loan & Trust Company building, on the left, was built in 1891. It is now a Courtyard by Marriott hotel, which opened in 1999.

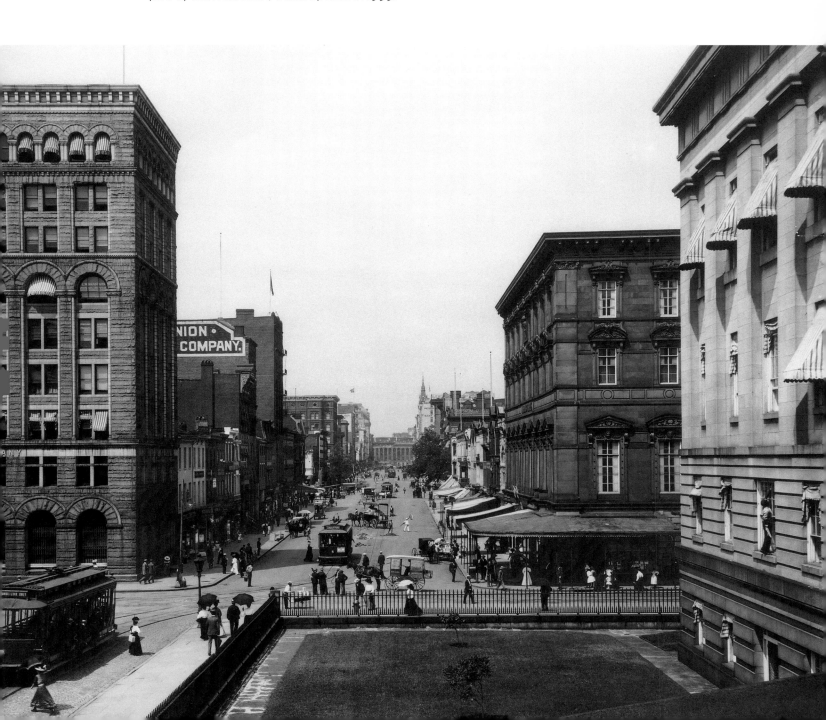

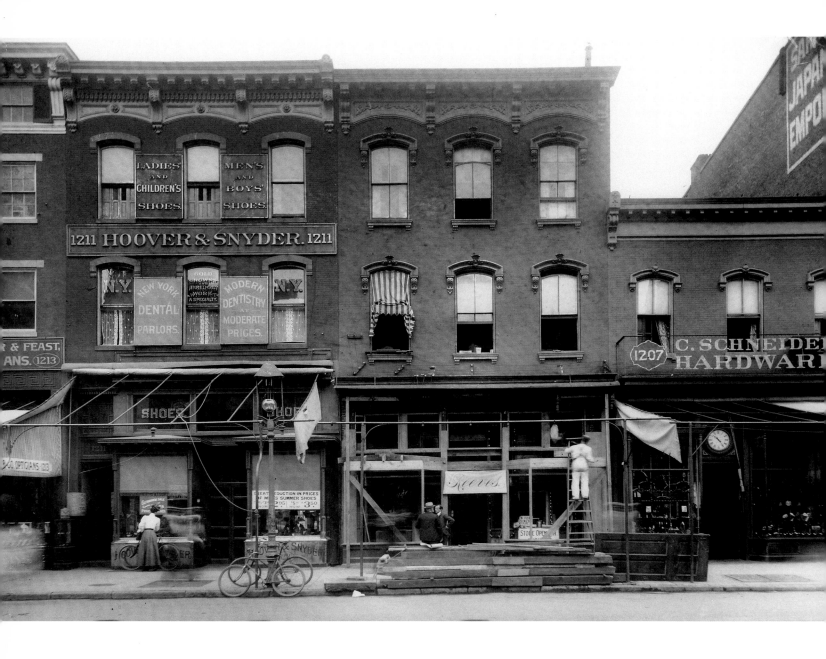

F Street (above) became the city's most important commercial street in the late nineteenth century, supplanting Seventh Street. In the days before suburban malls, shoppers took streetcars downtown to visit shops like Hoover & Snyder's shoe store. They normally had their purchases delivered to their homes, a service almost forgotten today. Numbers 1207 and 1211 F Street are now the site of an office building constructed in 1990. This view shows a house being converted to commercial use.

The first hotel at Pennsylvania Avenue and 14th Street opened in 1818, and by 1850 it was operated by the Willard family. During the Civil War, the Willard Hotel was the most important hostelry in the city; guests included Abraham Lincoln and Ulysses S. Grant. The present Willard (opposite, top) was built in 1901 in a skyscraper version of the popular Beaux-Arts neoclassicism of the day. After World War II, the landmark hotel fell into decline and closed in 1968. Narrowly escaping demolition, the Willard was restored, expanded, and reopened in 1986.

The Washington Academy of the Visitation (opposite, bottom) was a Catholic school and convent, built in 1877 on the east side of Connecticut Avenue at L Street. The sisters named DeSales Street, which crossed their seven-acre property, for one of the founders of their order. In 1919 they sold their land for the Mayflower Hotel and moved to Bethesda, Maryland, where they remain today. The building was razed in 1923.

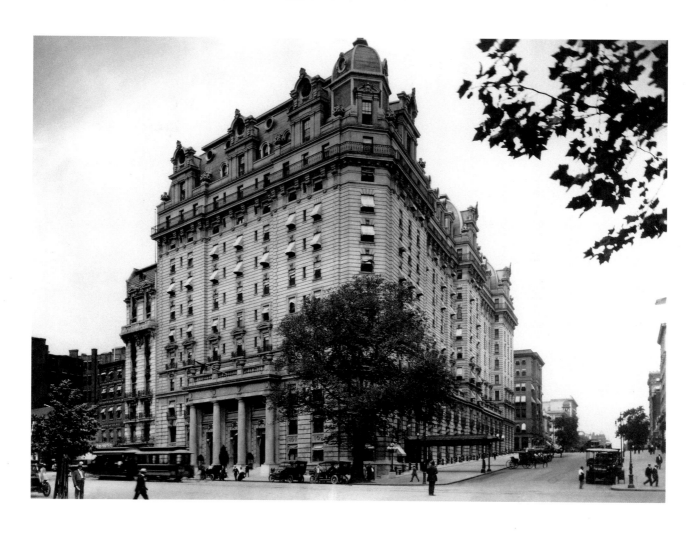

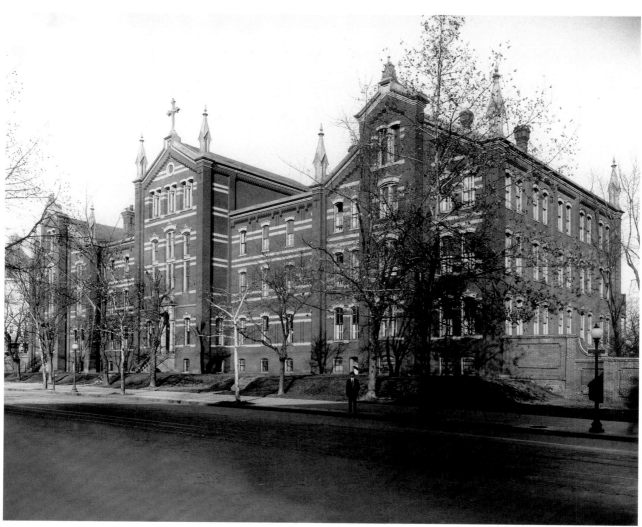

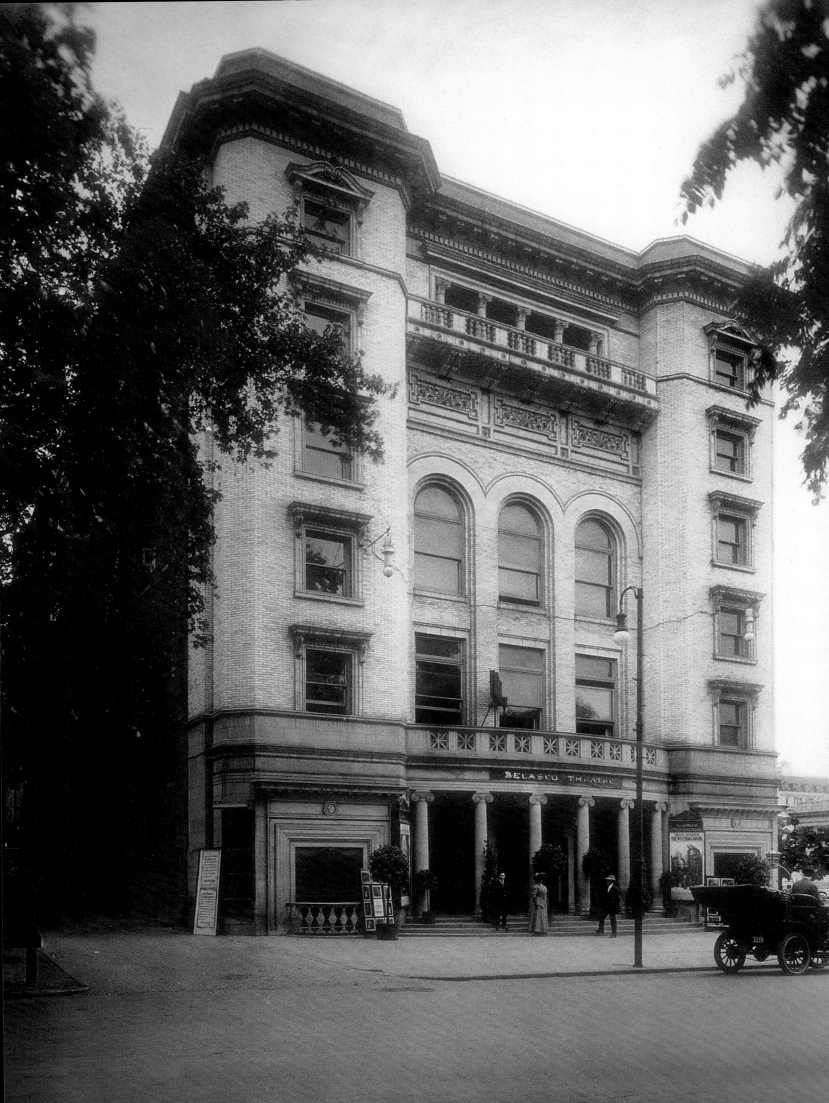

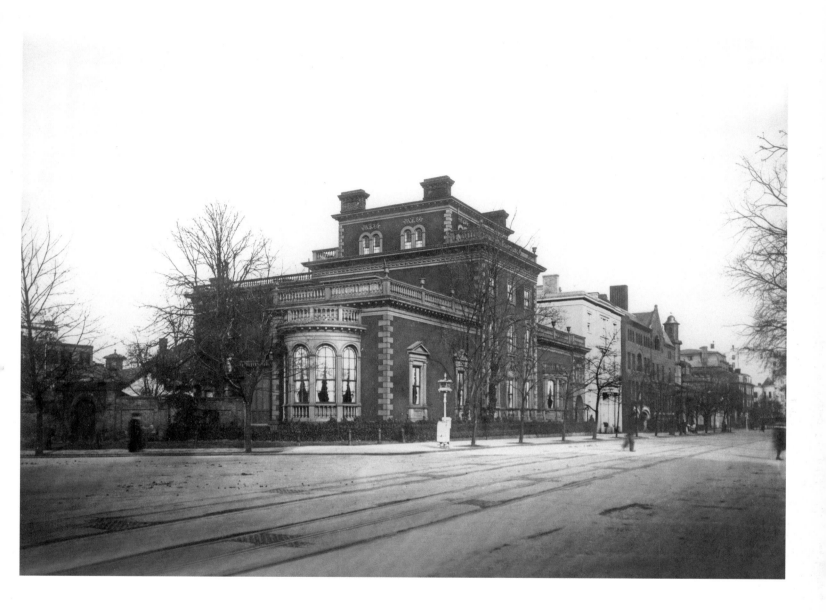

Enrico Caruso, Al Jolson, Will Rogers, Mae West, Fanny Brice, and many others performed at the Belasco Theatre (opposite), and five-year-old Helen Hayes was "discovered" there as a child actress. Built in 1895 on the east side of Lafayette Park, the theater became Washington's premier venue for opera, ballet, and plays. In 1935 the Belasco was converted to a movie theater; during World War II and afterward, it served as a USO canteen. In 1964 it was demolished for a federal courthouse.

The Corcoran House (above) once stood at the northeast corner of Connecticut Avenue and H Street. It was the home of William W. Corcoran, a banker and financier best known for founding Riggs Bank and the Corcoran Gallery of Art. Corcoran bought the Federal house from Daniel Webster and had James Renwick Jr. completely remodel it in the Italianate style in 1849. It was razed in 1922 to make way for the U.S. Chamber of Commerce building.

Washington schoolchildren on an outing with their teacher can be seen at right stopping along the towpath on the Chesapeake & Ohio Canal in Georgetown. Work on the canal started in 1828, but the waterway was never a commercial success due to competition from the Baltimore & Ohio Railroad. The canal was abandoned in 1924 after damage by a flood, and the area encompassing the canal is now a national park. Currently, during the summer months, park rangers give tourists short boat rides up the canal from Georgetown. Although most of the canal is dry, the towpath is a popular site for walking, running, and biking.

Washington schoolchildren visit the bears at the National Zoo (below), which was founded in 1889. The bear yards were built between 1902 and 1909, replacing cages located in an old quarry that exposed the animals to falling rock. The bear yards survive today and are now one of the oldest structures at the zoo, although the cages have long since been replaced with a moat.

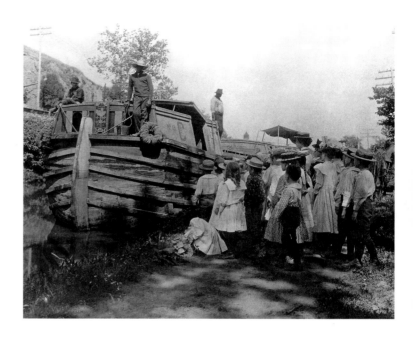

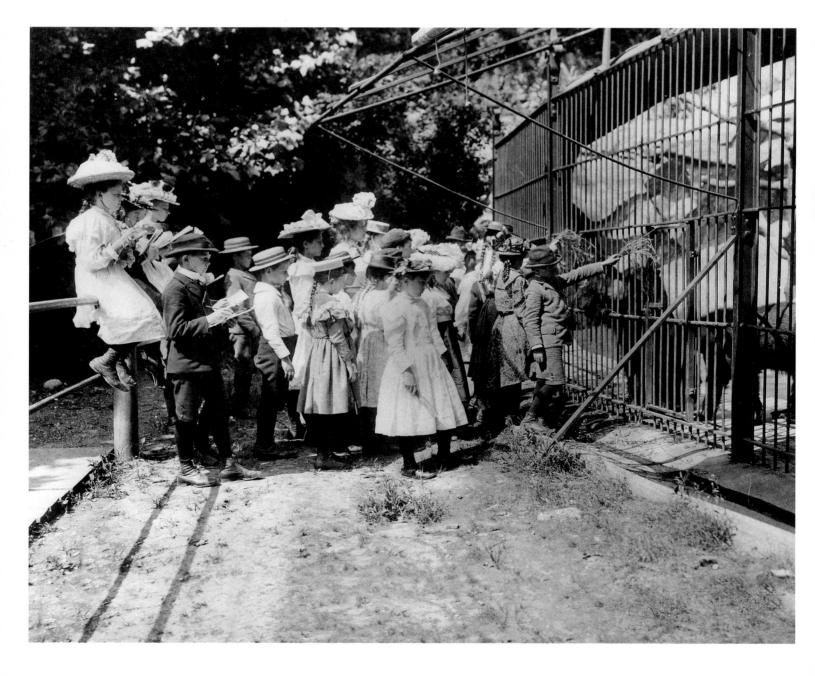

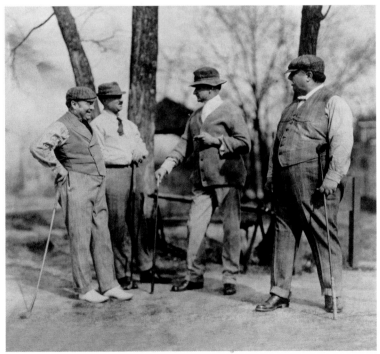

The early photograph above of the Cleveland Park neighborhood circa 1905 shows a streetcar traveling on Connecticut Avenue. On the far left is a rock quarry that is now the site of the Uptown Theater. The gully in the foreground was eventually filled, and in the 1920s, a shopping strip was built there between Macomb and Ordway Streets. Cleveland Park was known as a "streetcar suburb" because it sprang up along the route of a new streetcar line.

President William Howard Taft (right in the photograph at left) frequently played golf at the new Columbia Country Club on Connecticut Avenue in Chevy Chase. Elected in 1908, he was the first president to play golf and his fondness for the sport helped increase its popularity. Taft's popular military aide, Archibald "Archie" Butt (second from the left), went down with the Titanic in 1912 and all the city mourned him.

Fairfax City (right) grew up around the Fairfax County courthouse (located behind the photographer), which was established at this location in 1800. Isolated by the county's notoriously bad roads and lack of rail connections, the town stagnated in the late nineteenth century. It wasn't until an electric trolley line reached the town in 1904 that it began to grow. Northern Virginia's trolleys ran until 1937, when they were supplanted by buses.

In 1896 trolley lines reached East Falls Church in Arlington. All around Washington the new electric streetcars spurred growth. New suburbs sprang up in outlying areas, including Clarendon, Takoma Park, Brookland, and Chevy Chase. In the view below of the East Falls Church Trolley Station, Fairfax Drive is in the foreground and Lee Highway is on the right.

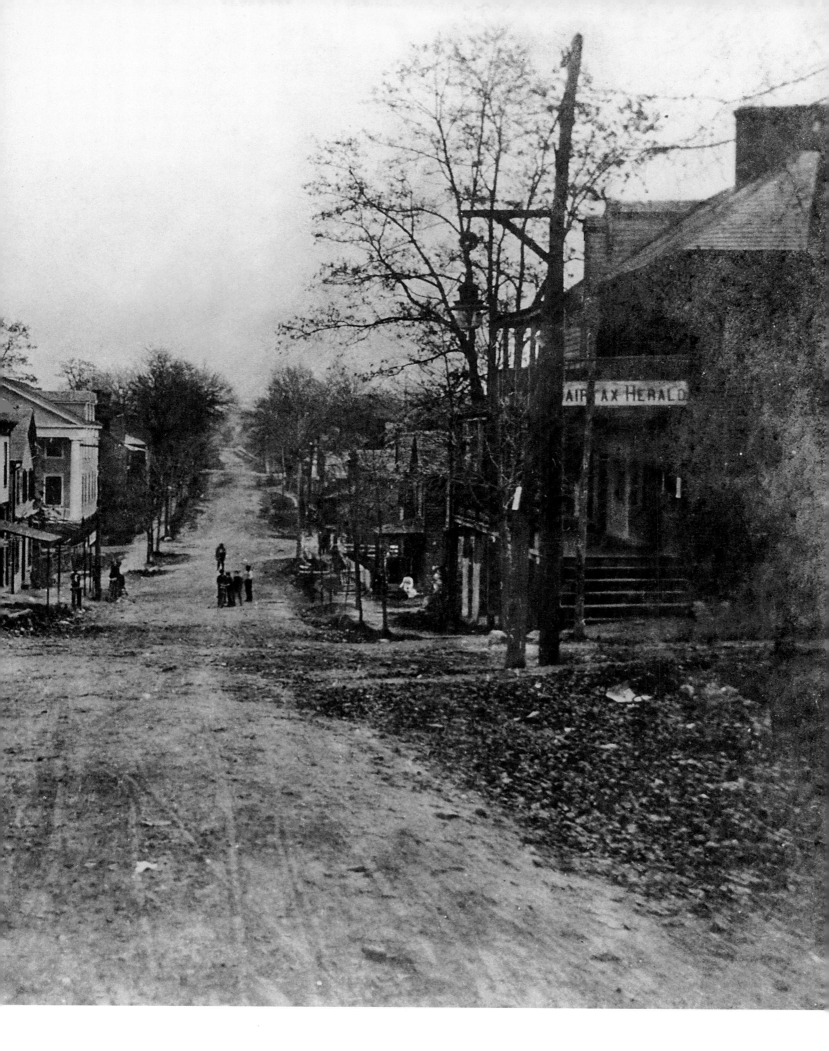

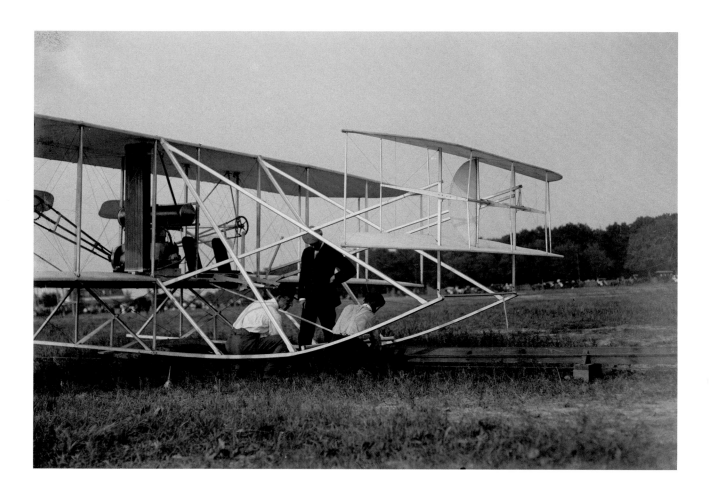

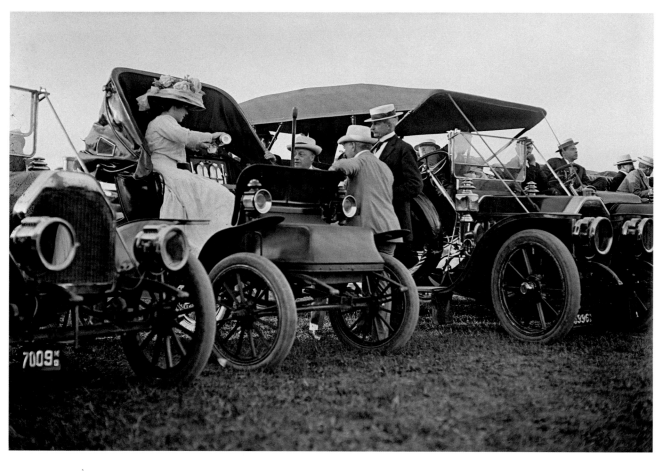

After their epochal flight at Kitty Hawk, North Carolina, in 1903, Orville and Wilbur Wright constantly improved their airplane designs. They built the first military airplane in the world for the U.S. Army Signal Corps and delivered it to Fort Myer, Virginia, in 1908. Although they made several successful flights, their plane crashed on September 17, 1908, due to a cracked propeller, injuring Orville and killing his passenger, Lieutenant Thomas E. Selfridge. He was the first fatality in an airplane accident. Pictured is their improved model (opposite, top), which they successfully demonstrated at Fort Myer in 1909.

Among the spectators attending the demonstrations of the Wright brothers' airplane in 1908 and 1909 at Fort Myer was Alice Roosevelt Longworth, the daughter of former President Theodore Roosevelt, shown (opposite, bottom) in her Baker Electric car pouring coffee. Standing to the right of her car and facing the camera are two members of President Taft's cabinet, Secretary of State Philander C. Knox, left, and Secretary of Commerce and Labor Charles Nagle, right. The Baker Electric, made in Cleveland, was mainly used by upper-middle-class women who found it difficult to start a gasoline car, which required cranking the engine by hand. In 1908 most electric cars had a maximum speed of 18 mph and a range of fifty miles before their charge was exhausted.

The neoclassical buff-brick Metropolitan Club building (below) stands on the southwest corner of 17th and H Streets, NW. The club had been founded in 1863 by William W. Corcoran and other prominent Washingtonians. After renting several buildings on H Street, the club purchased a lot at 17th and H Streets and built its clubhouse there in 1883. After that building burned in 1904, the membership quickly commissioned New York architect Christopher Grant LaFarge, who had designed St. Matthew's Cathedral, to plan a new clubhouse. It opened in 1908 and remains in use today.

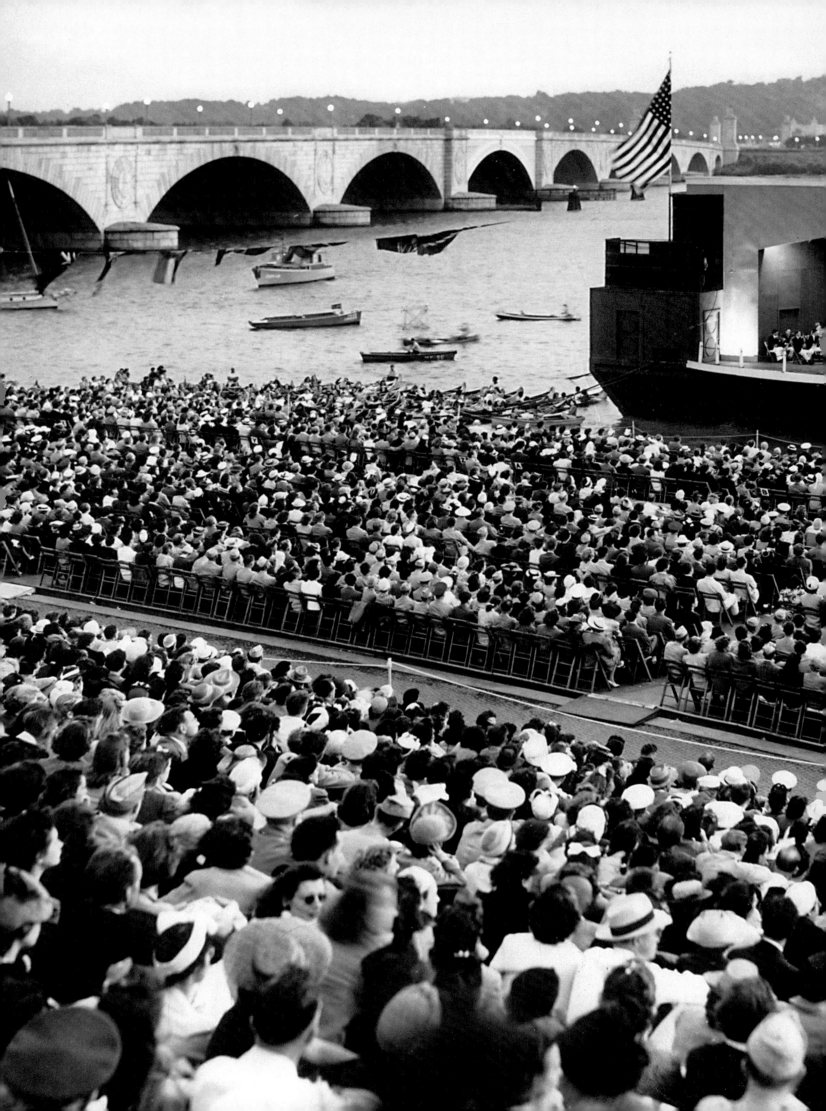

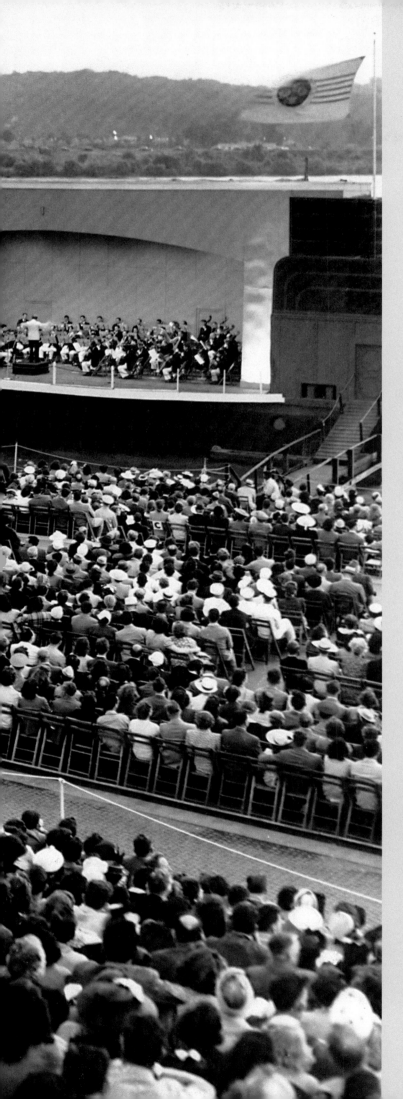

# WASHINGTON, D.C., IN THE 1930S

The Water Gate Barge is seen here on the evening of July 12, 1939. Beginning in 1935, summer concerts were given on a barge adjacent to the Memorial Bridge and the "Water Gate," or steps leading down to the river from the Lincoln Memorial Circle. On this evening, Dr. Hans Kindler directs the National Symphony Orchestra before a crowd of 20,000 music lovers, including President Franklin D. Roosevelt. These concerts were discontinued in 1965 because of the noise from low-flying jet planes approaching nearby National Airport.

THE GREAT DEPRESSION, which began with the stock market crash in October 1929, did not seriously affect Washington until 1932. The city had experienced a building boom in the 1920s, and the first sign of the Depression came when developers could no longer obtain loans from banks, resulting in the collapse of the construction industry. Middle-class Washingtonians were somewhat insulated from the economic downturn because most worked for the federal government or had jobs that were dependent on it. In contrast many wealthy Washingtonians, who were dependent upon investment income, lost their houses when businesses closed or stopped paying dividends. The working classes fared worst of all when jobs disappeared and unemployment rose. In some industrial cities, workers were forced to accept meager offerings at soup kitchens or go hungry. In spite of the dismal economic conditions nationwide, Washington became a boomtown in the latter part of the decade. Franklin D. Roosevelt's inauguration in March 1933 brought great changes to the city. Roosevelt's New Deal, a vast program to fight the Depression, included an array of new federal agencies to jump-start the economy and lower unemployment. As thousands moved to Washington to fill jobs in the rapidly expanding bureaucracy, the city's population grew by 36 percent, reaching 663,000 in 1940. In addition, the city's suburbs expanded rapidly—by 1939 Arlington had become the fastest-growing county in the nation.

The gathering clouds of war affected Washington as well. By the late 1930s, Japan was already at war with China and tensions were rapidly mounting with the United States. England, one of America's allies in the Great War, was preparing for a second war with Germany. In June 1939 King George VI and

Queen Elizabeth of Great Britain came to Washington to promote closer relations with the United States. In 1940 the draft was reinstated, and the government built temporary office buildings on the Mall as the defense effort expanded. After the United States declared war on the Axis powers in December 1941, the city became a veritable beehive of activity as the federal government mobilized the entire nation to fight the war.

The 1930s were important years for the city in another way. The federal government completed about sixty important federal buildings, bridges, and highways in Washington. These projects established the monumental character of the city. Some, including the Arlington Memorial Bridge and the George Washington Memorial Parkway, were timed to coincide with the 1932 bicentennial of George Washington's birth. The most significant was the Federal Triangle, which consisted of seven enormous classically styled buildings constructed between 1928 and 1938. At the same time, the Mall's Victorian landscaping was replaced with the broad greensward and rows of elms that are familiar today.

The arrival of World War II marked a sharp termination to the relatively slow pace of the capital and ended a way of life. Because of the new wartime footing, the population of the city increased 40 percent, from 663,000 in 1940 to 938,000 in 1945. Residents experienced a shortage in housing; meat, sugar, rubber products, and gasoline were rationed. In addition, public transportation facilities, including streetcars and trains and even the new National Airport, became extremely overcrowded. The war years, illustrated here with four photographs, marked an end to the Great Depression, which dominated the 1930s.

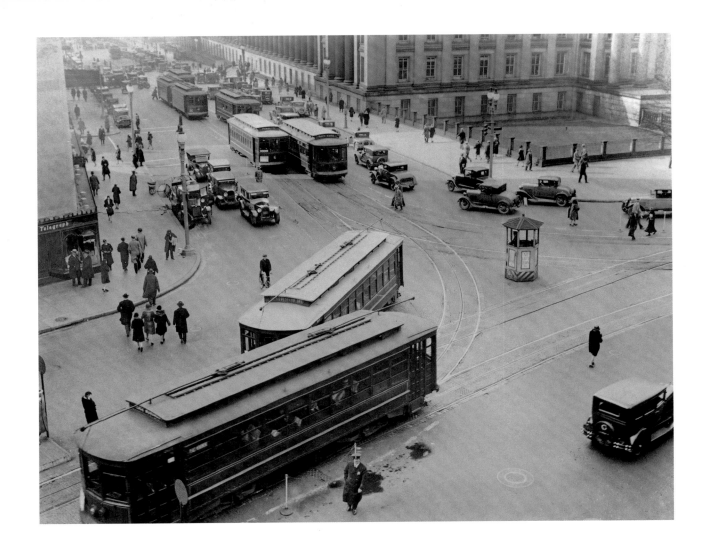

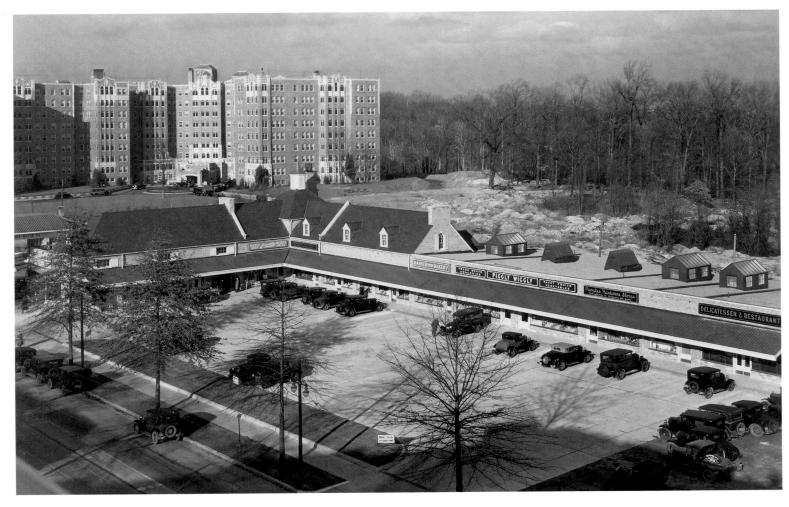

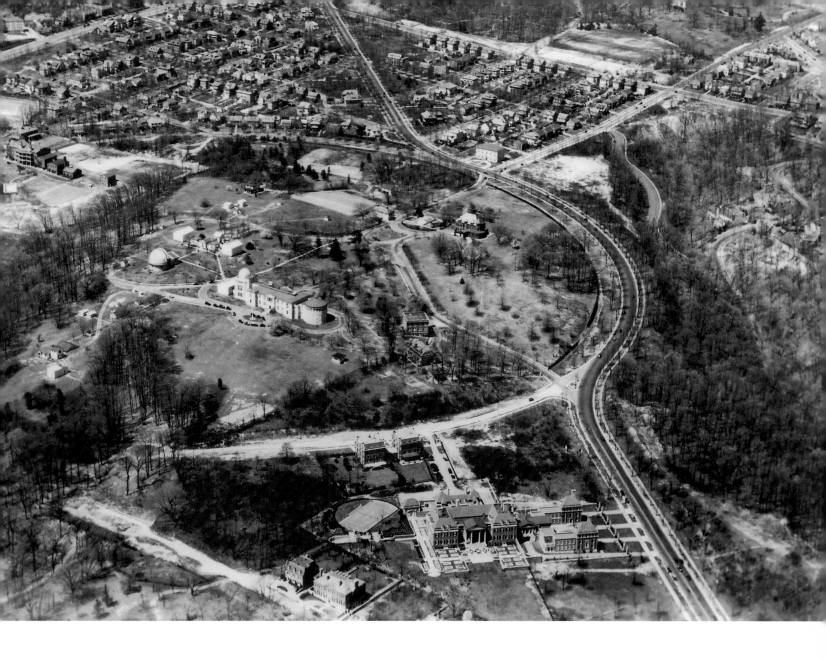

Streetcars were a common sight throughout Washington from 1862 until they were discontinued in 1962. A 1930 view (opposite, top) shows the busy intersection of Pennsylvania Avenue, New York Avenue, and 15th Street, then both a transportation hub and the center of the city's financial district. The booth in the center of the intersection houses a policeman who directs traffic. The first streetcar line used horse-drawn cars, which were replaced in the early 1890s by cable cars and in the late 1890s by electric cars.

The Park and Shop (opposite, bottom), located on Connecticut Avenue adjacent to Porter Street, NW, was designed by Arthur B. Heaton and built in 1930. It was the first shopping center in Washington with off-street parking and served as a model for two dozen others built in the area in the late 1930s. Within the colonial revival design were spaces for ten stores with a permanent canopy to protect their entrances.

When the U.S. Naval Observatory moved from its old location on 23rd Street in Foggy Bottom to this hilltop in northwest Washington in 1893, the area was still quite rural. The observatory was set in the center of a two-thousand-foot circle so traffic vibrations from carriages and wagons would not affect the instruments. When construction of Massachusetts Avenue cut through soon after, the street was curved to avoid the grounds and maintain the standoff distance (above). In the foreground is the British Embassy, completed in 1931, just a year before this photograph was taken.

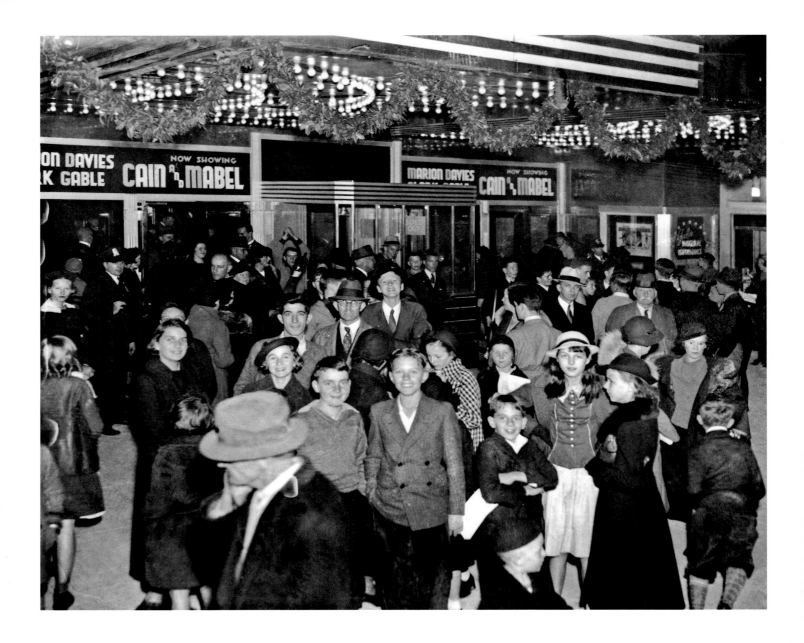

The historic Uptown Theater (above) at 3426 Connecticut Avenue, NW, opened on October 29, 1936, with the musical comedy *Cain and Mabel* starring Marion Davies and Clark Gable. Although the Art Deco limestone façade remains intact, the original interior design was lost during remodelings in 1956 and 1962. With 1,200 seats, the Uptown is the last large neighborhood movie theater in Washington.

Remnants of the Mall's Victorian landscaping (opposite, top) surround the Natural History Museum in 1931. The curving paths and artfully scattered trees would soon be swept away in favor of the broad greensward and rows of elms that we see today. Across Constitution Avenue, which cuts diagonally across the photograph, is the Federal Triangle. This complex of seven massive government office buildings was begun in 1928. The Internal Revenue Service building seen here was one of the first to be completed.

A 1932 aerial photograph (opposite, bottom) shows the beginning of construction of the U.S. Supreme Court opposite the Capitol. Appearing above the Capitol is the first Senate office building, built 1905–1909 and later named for Senator Richard B. Russell Jr. of Georgia. The first House office building (in the lower right-hand corner), built 1904–1908, was named after Speaker Joseph Cannon of Illinois, who ironically was a relentless opponent of expenditures for public buildings. At this time the second House office building, named for Speaker Nicholas Longworth of Ohio, was under construction next to the Cannon building.

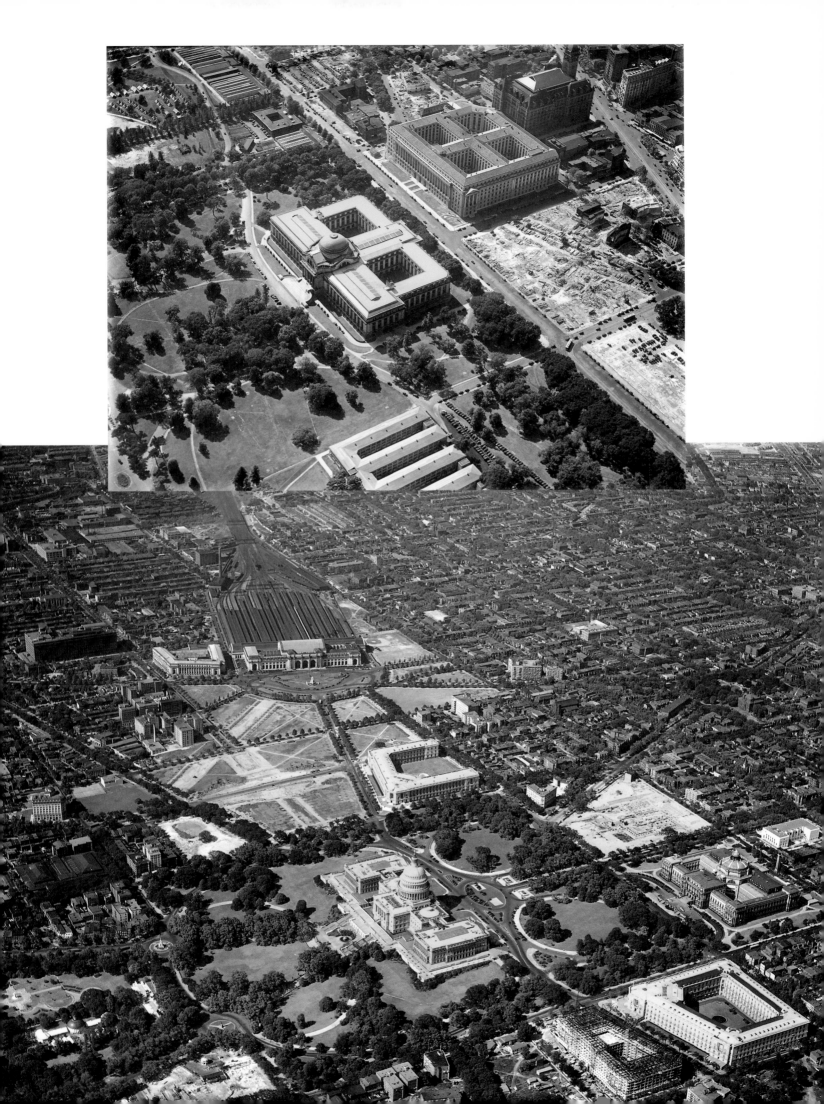

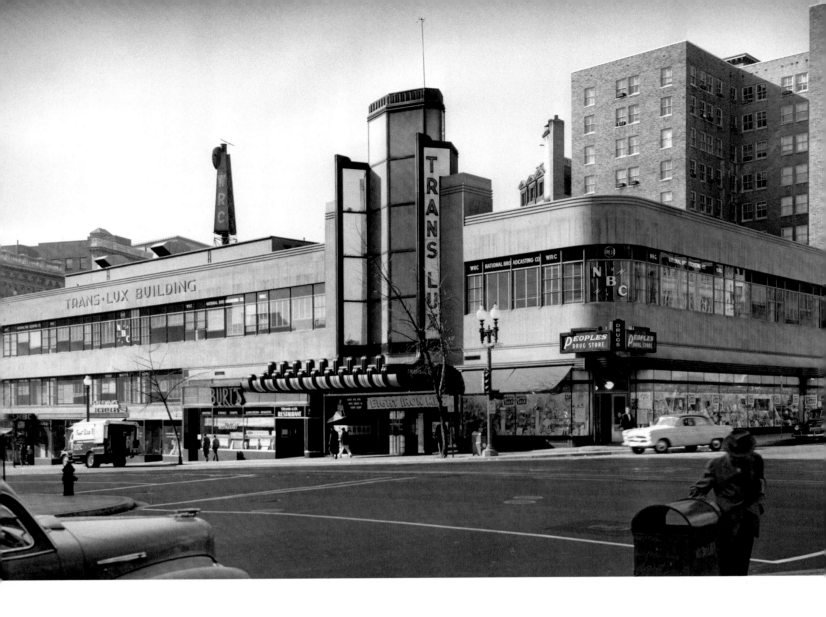

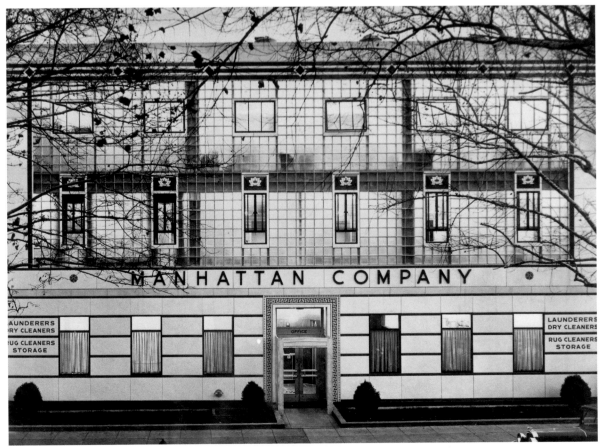

The Trans-Lux Theater (opposite, top) opened in 1937 in downtown Washington. Located at 14th and H Streets, the theater showed newsreels and short films rather than feature-length movies. Its name came from an innovative rear-projection screen. Built in the Art Deco style, the building's streamlined contours suggested movement and speed. Besides the theater, the structure also had offices and shops, and featured a seventy-five-foot tower with mirrors and colored lights. It was razed in 1975, shortly before the Art Deco style returned to popular favor.

One of the best surviving examples of Art Deco architecture in Washington, D.C., is the 1935 Manhattan Laundry building (opposite, bottom) at 1326 Florida Avenue, NW. Its most distinctive feature is the extensive use of glass brick on both the front façade and interior partitions. The façade is further enlivened by details including green-and-yellow enameled metal panels of water lilies. Laundry rooms occupied the first and second floors, while the clerical staff worked on the third floor. The façade was recently restored and the building converted to condominiums.

The photograph below shows crowds of Christmas shoppers at F and 11th Streets, NW, in 1939. During the first half of the twentieth century, F Street was the most fashionable shopping street in Washington. Three department stores, Garfinckel's, Woodward & Lothrop, and Hecht's, as well as Lowe's Columbia Theatre and the Fox Theatre, were located here. F Street fell into rapid decline in the 1960s as it lost business to suburban shopping malls.

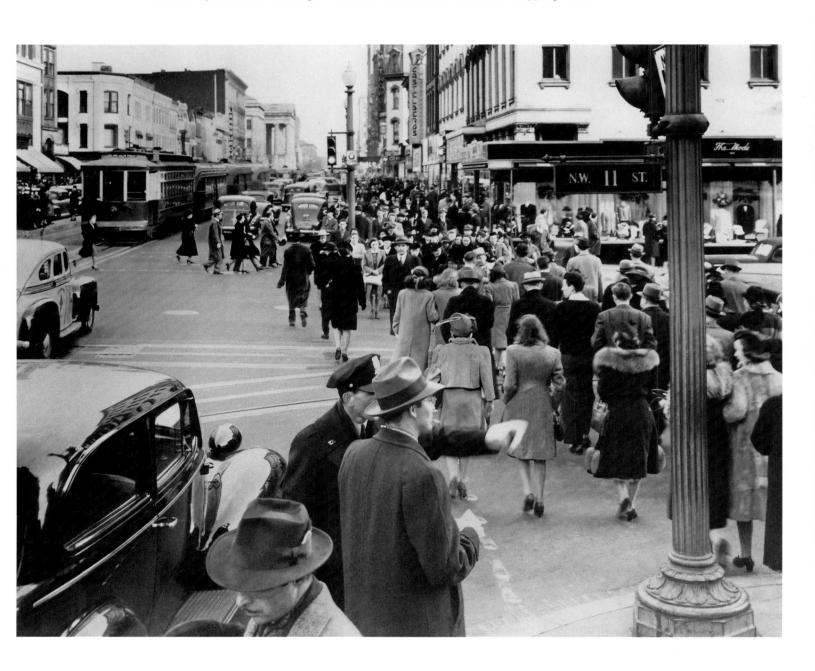

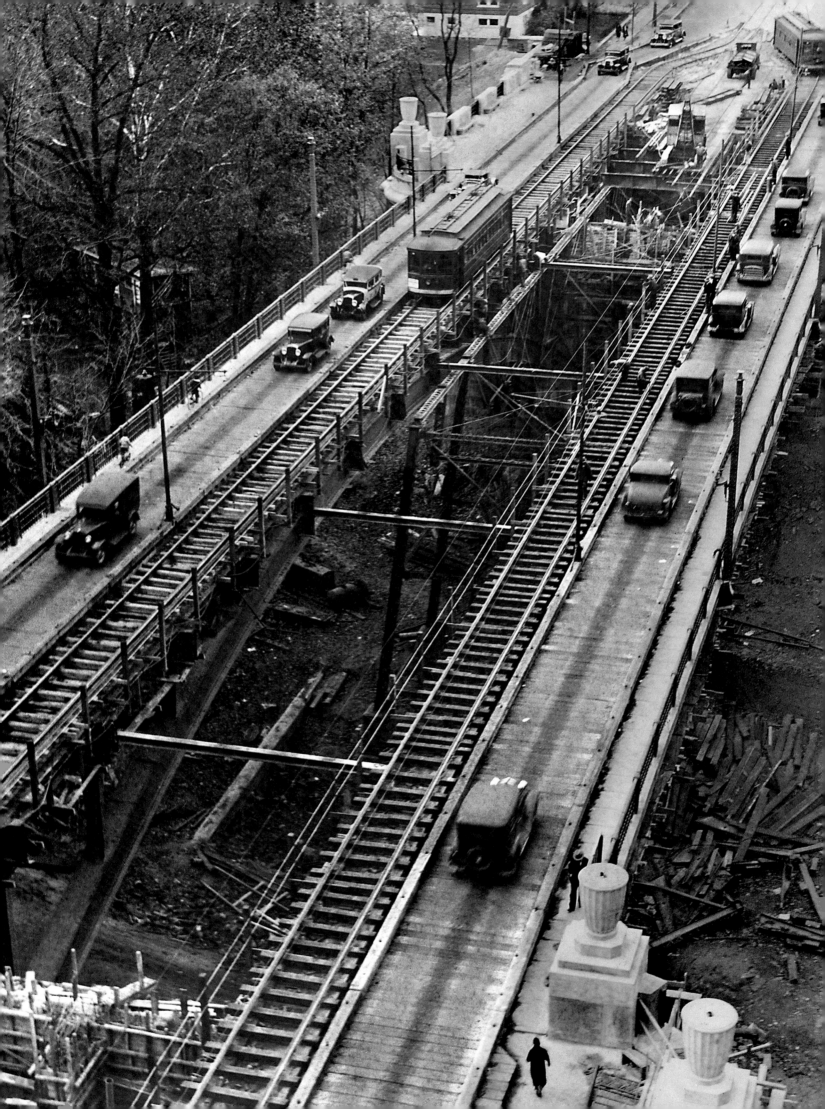

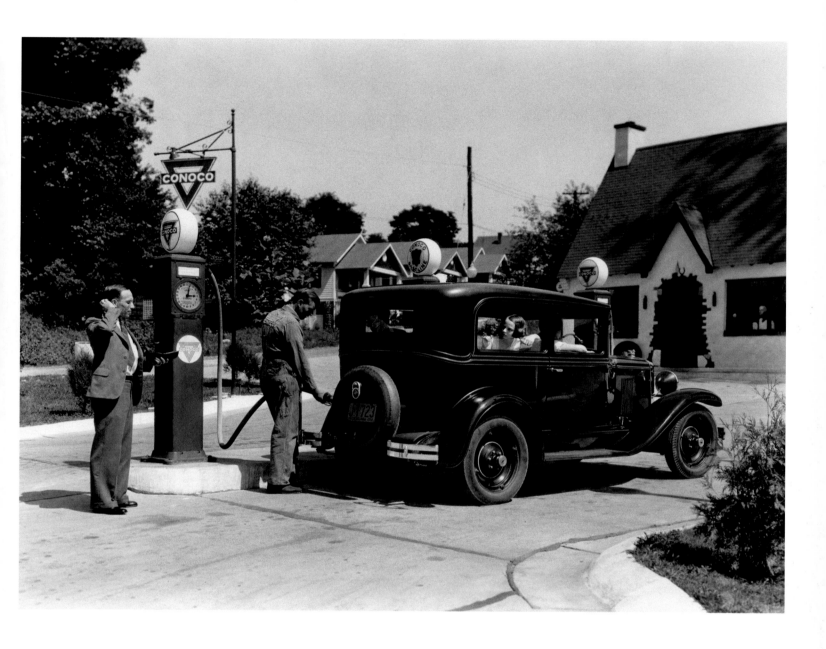

A rare photograph (opposite), shot in November 1931 from the roof of the recently opened Kennedy-Warren apartment house, shows the new Klingle Bridge on Connecticut Avenue under construction . The new steel bridge, designed by Philadelphia architect Paul Cret, was erected on each side of the old 1891 bridge, which then was torn down. This engineering feat allowed traffic, including both automobiles and streetcars, to flow uninterruptedly during construction.

The 1932 photograph above was taken at a Conoco gas station on Colesville Road in Silver Spring, Maryland. The Portico Apartments occupy the site of the bungalows in the background on present-day Fidler Lane. A McDonald's restaurant at 8407 Colesville Road, constructed in 1998, occupies the site of the Conoco gas station today. The Continental Oil Company started in Utah in 1875 by selling kerosene to settlers. In 1928 it merged with the Marland Oil Company and the combined operation retained the Conoco name. This station had doubtless been a Marland station before the merger. The company's founder, E. W. Marland, was an Anglophile who favored fox hunting and Norfolk jackets. Reflecting his taste in architecture, Marland gas stations resembled English cottages.

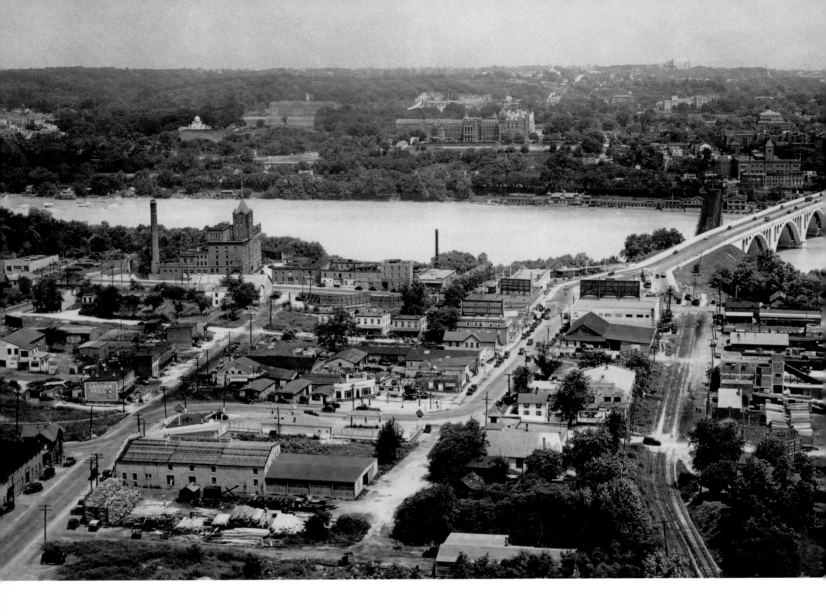

In 1930 Rosslyn, Virginia, (above) was very industrial in character. Many of its businesses catered to the construction boom in Northern Virginia, aided by the then-excellent rail connections. The tall building in the center left is the Cherry Smash bottling plant, which had been a brewery before Prohibition. On the right is the Key Bridge, completed in 1923, and underneath it, the older Aqueduct Bridge, which was soon removed. The first tall office building in Rosslyn was completed in 1961, beginning an era of rapid change.

In the 1930s, the rotunda of the National Museum of Natural History (opposite, top) on the Mall was used to display art. These sculptures were part of a 1932 exhibition marking the bicentennial of George Washington's birth. Mounted on the walls are quotations about Washington by Abraham Lincoln and Napoleon. The famous African elephant was not installed in the rotunda until 1959. The last of the art collections was moved out in the 1960s.

A 1934 photograph (opposite, bottom) shows the center of the Adams Morgan neighborhood at 18th Street and Columbia Road. The building at the corner was constructed in 1901 as a private residence but was soon converted to commercial use. It served as a Peoples Drug Store for many years and is now a McDonald's restaurant. The streetcar on the right is headed to Chevy Chase via Connecticut Avenue.

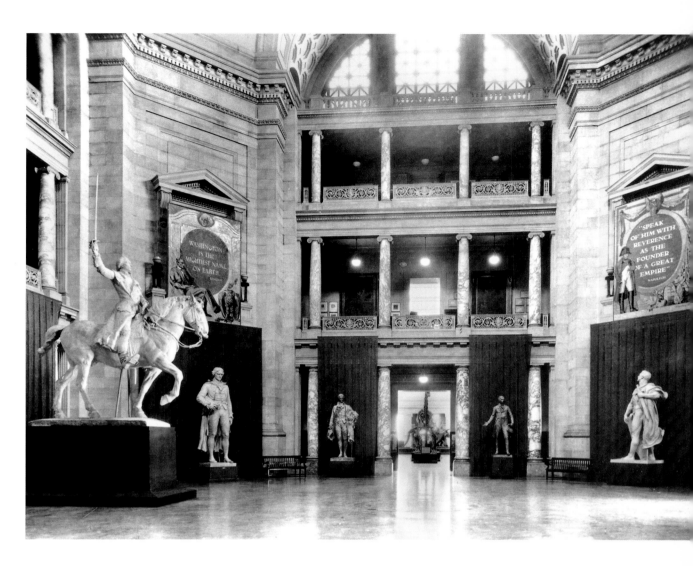

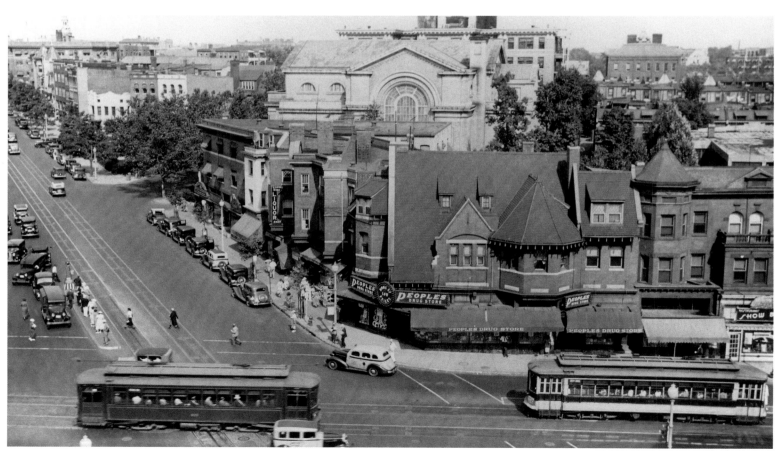

The polo grounds in West Potomac Park (below), located south of Independence Avenue and west of the Tidal Basin, were first laid out in 1908 and used by military polo teams from nearby Fort Myer. During World War II, barracks for WAVES, women naval personnel, were built on the site. In the 1960s, the buildings were razed and the polo grounds restored. Polo matches between private teams are still held there today.

The Washington Riding Academy (opposite, bottom), which opened in 1888, for many years carried considerable social prestige in Washington. The building, located at P and 22nd Streets, had a large riding ring for lessons and events, stables for boarding horses, various club rooms, and a veterinarian and blacksmith. The academy vanished during the Great Depression along with the other Washington riding clubs, and the site was taken by a gas station. Mrs. Ambrose Preece (opposite, top) was a native of England who taught horsemanship and etiquette at the academy.

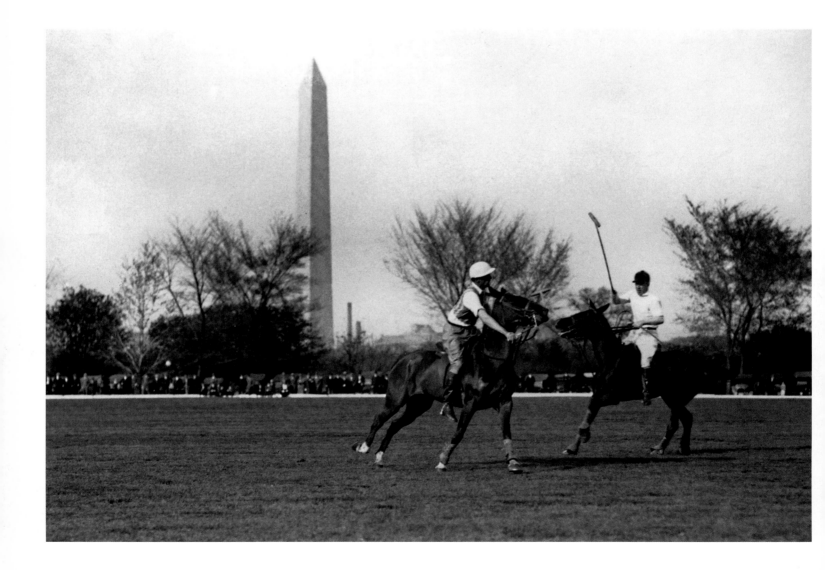

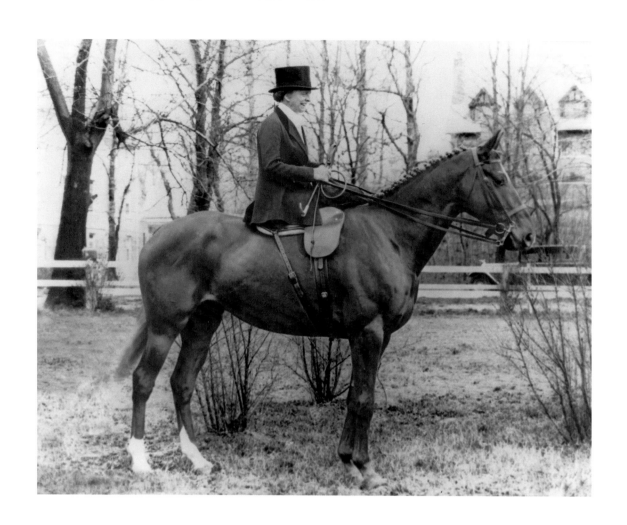

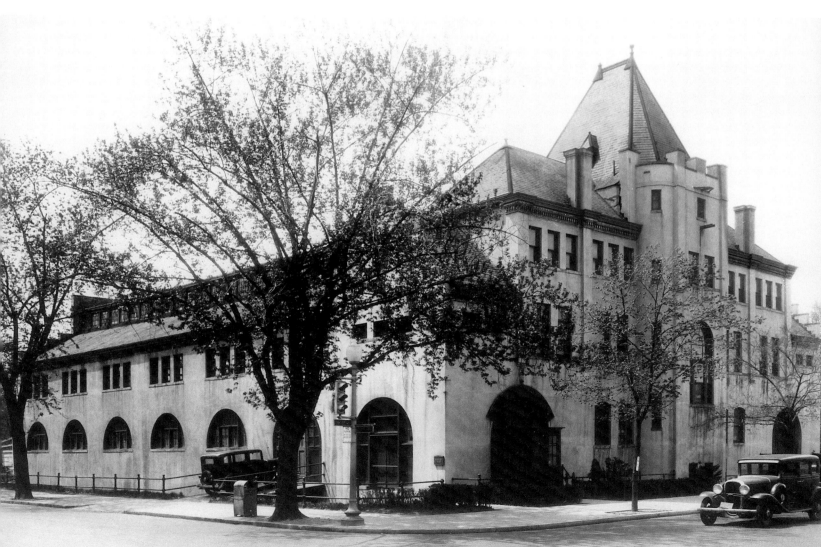

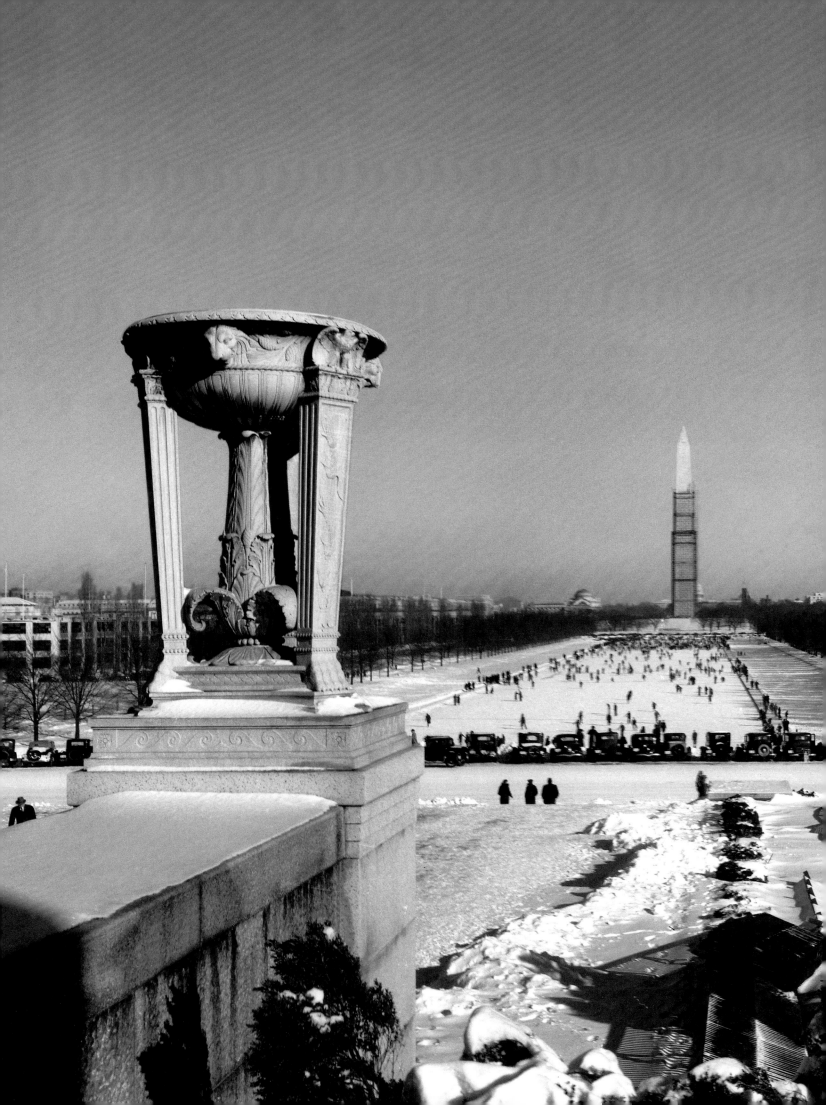

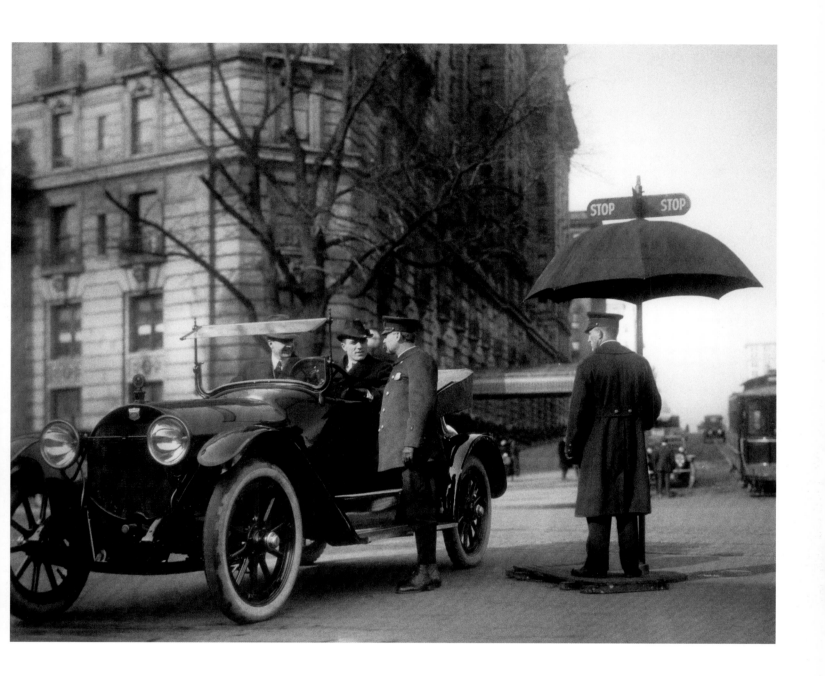

The reflecting pool, seen opposite from the Lincoln Memorial during the winter of 1935–1936, was once a popular spot for ice-skating, which was allowed on the pool until the early 1980s. In the distance, the Washington Monument is shrouded in scaffolding, erected in 1934 as part of a New Deal public works project. The obelisk was cleaned, repaired, and repointed at a total cost of $86,375.98.

The view above at the intersection of 14th and E Streets, NW, shows an old-fashioned hand-operated traffic-control sign. The officer would give a blast on his whistle and then turn the sign manually. In the early 1930s, electric traffic signals replaced these at Washington intersections.

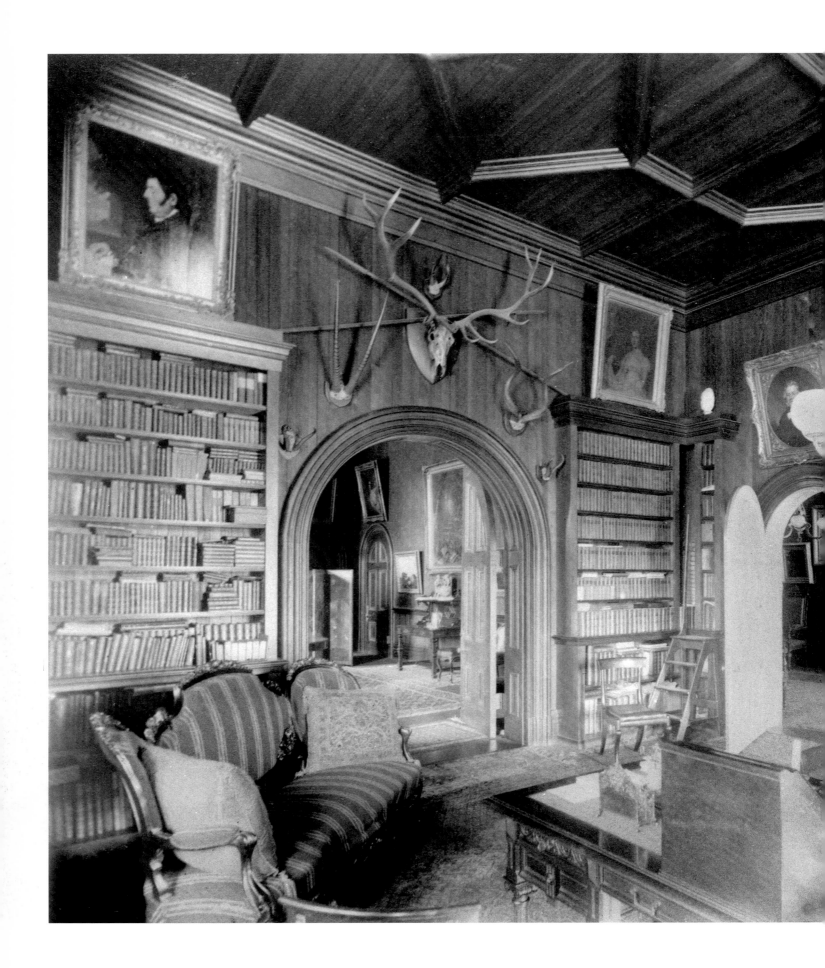

The Riggs House, which once stood at 1617 Eye Street near Farragut Square, was built in 1858 by George Riggs, the cofounder of Riggs Bank. In the library, shown at left in 1868, Secretary of State William Seward and the Russian minister signed papers completing the purchase of Alaska by the United States; Riggs Bank handled the transaction. In 1936 during the Great Depression, the owners had the house demolished to avoid heavy property taxes.

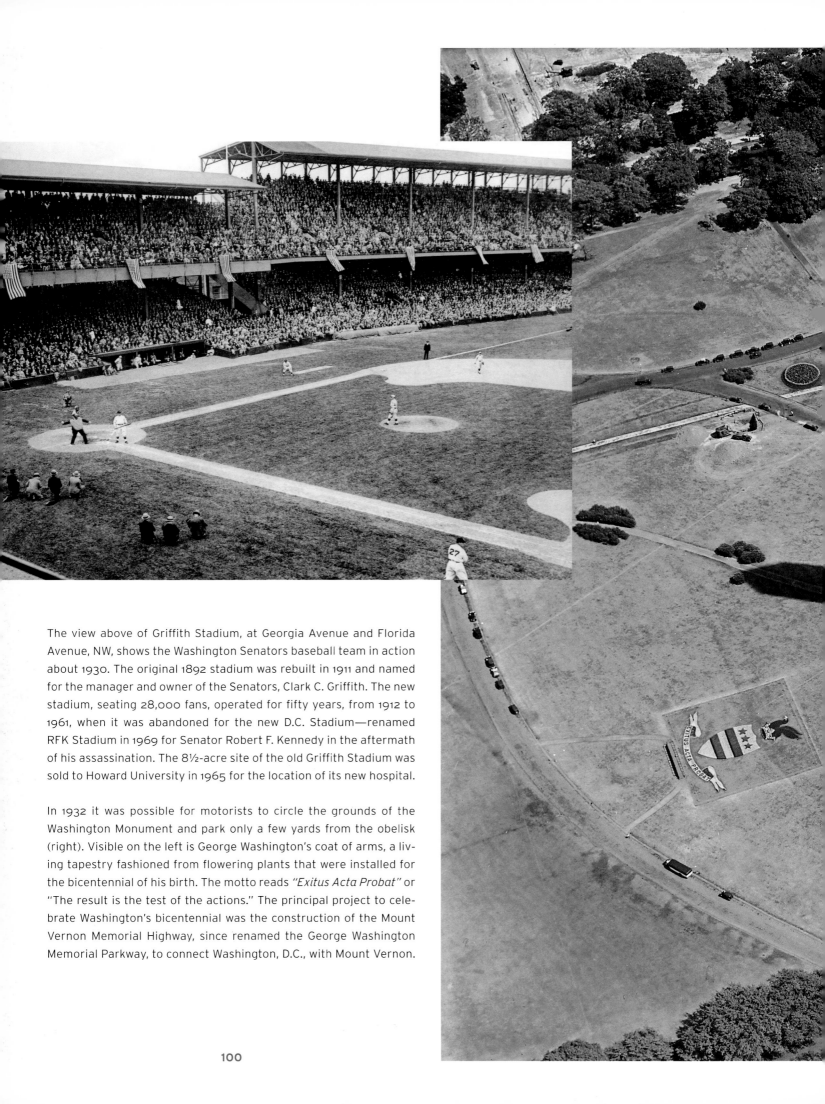

The view above of Griffith Stadium, at Georgia Avenue and Florida Avenue, NW, shows the Washington Senators baseball team in action about 1930. The original 1892 stadium was rebuilt in 1911 and named for the manager and owner of the Senators, Clark C. Griffith. The new stadium, seating 28,000 fans, operated for fifty years, from 1912 to 1961, when it was abandoned for the new D.C. Stadium—renamed RFK Stadium in 1969 for Senator Robert F. Kennedy in the aftermath of his assassination. The 8½-acre site of the old Griffith Stadium was sold to Howard University in 1965 for the location of its new hospital.

In 1932 it was possible for motorists to circle the grounds of the Washington Monument and park only a few yards from the obelisk (right). Visible on the left is George Washington's coat of arms, a living tapestry fashioned from flowering plants that were installed for the bicentennial of his birth. The motto reads *"Exitus Acta Probat"* or "The result is the test of the actions." The principal project to celebrate Washington's bicentennial was the construction of the Mount Vernon Memorial Highway, since renamed the George Washington Memorial Parkway, to connect Washington, D.C., with Mount Vernon.

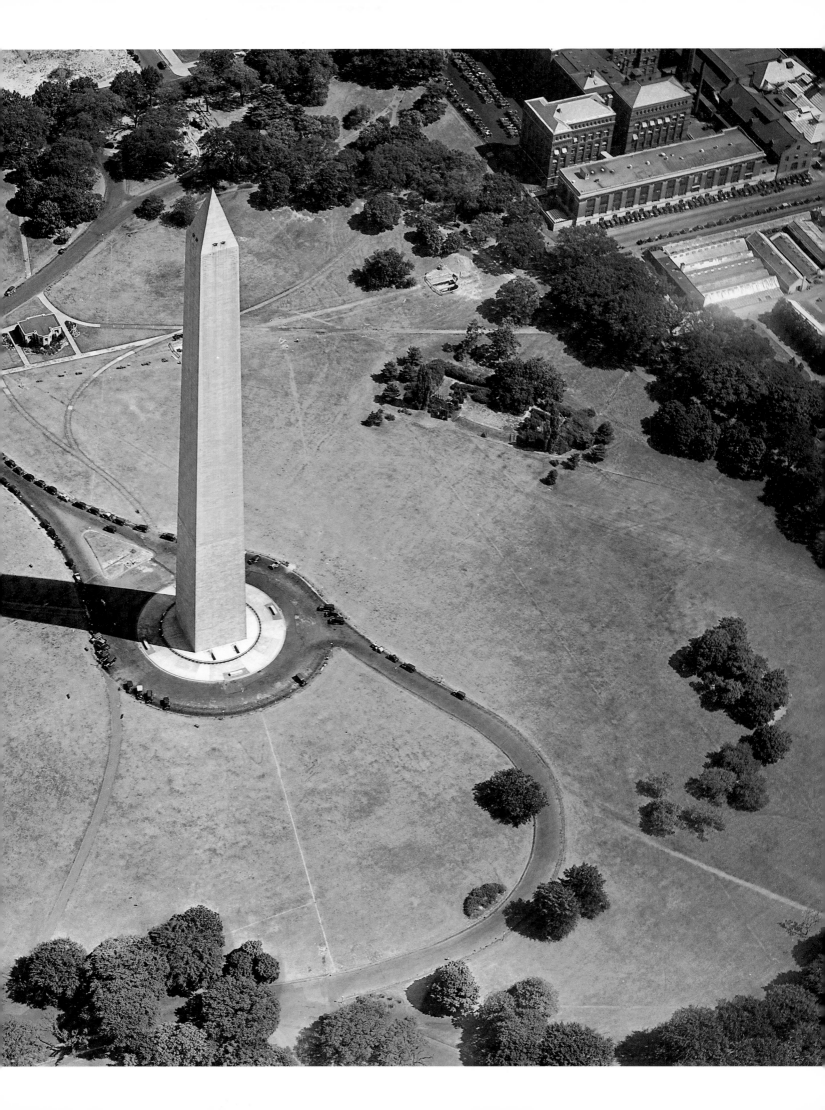

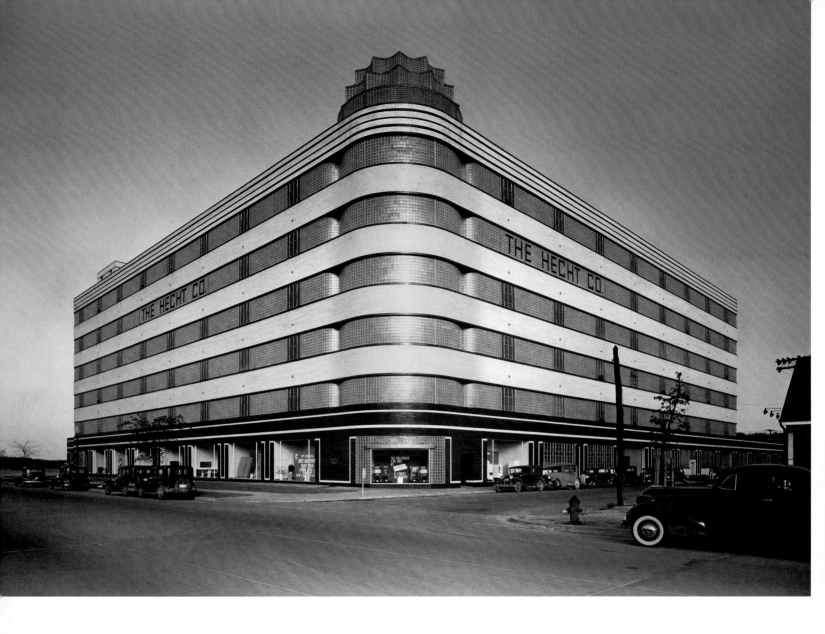

The Hecht Company Warehouse (above), on New York Avenue, NE, was completed in 1937. Still standing today, it is recognized as a nationally significant Art Deco landmark. The extensive use of glass brick in the façade demonstrates a strong preference for the material that lasted from the 1930s through the 1950s. Belts of the translucent bricks alternate with buff-colored bricks in an exuberant streamlined composition that reflects the era's infatuation with speed and progress. On the corner, a crown of glass bricks tops a round tower.

The Mayflower (right), which opened on Connecticut Avenue in 1925, has always been one of the finest hotels in Washington. President-elect Franklin D. Roosevelt stayed in Suite 776 where he wrote his famous "We have nothing to fear but fear itself" speech before his first inauguration in 1933. FBI Director J. Edgar Hoover ate lunch at the Mayflower every day for twenty years with colleague and friend Clyde Tolson, always sitting at the same table and ordering the same meal—chicken soup, buttered toast, and a salad of lettuce, cottage cheese, and grapefruit. He always brought his own diet salad dressing.

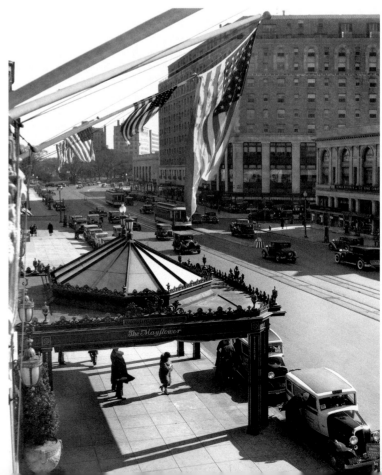

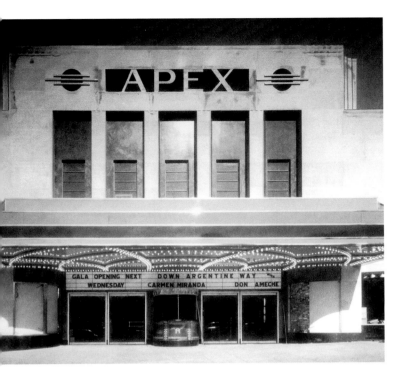

The Apex (left) was a noted streamlined Art Deco theater, designed in 1939 and built in 1940. Its features included an aluminum ticket booth, stepped-back marquee, and the name APEX set within the pediment above. This landmark, located next to the Spring Valley Shopping Center at 4813 Massachusetts Avenue, was unfortunately demolished in 1977 for an office building now occupied by American University's Law School. The Apex architect, John Zink, also designed the Uptown Theater, which still stands on Connecticut Avenue.

The stylish Art Deco cocktail lounge at the Carlton Hotel (below) at 16th and K Streets was installed in 1934 shortly after the end of Prohibition. Due to a peculiar—and short-lived—D.C. law requiring working bartenders to be invisible to patrons, drinks emerged from the bar through small revolving doors. The room was decorated with red-and-white leather armchairs and medallions made of porcelain and inlaid metal.

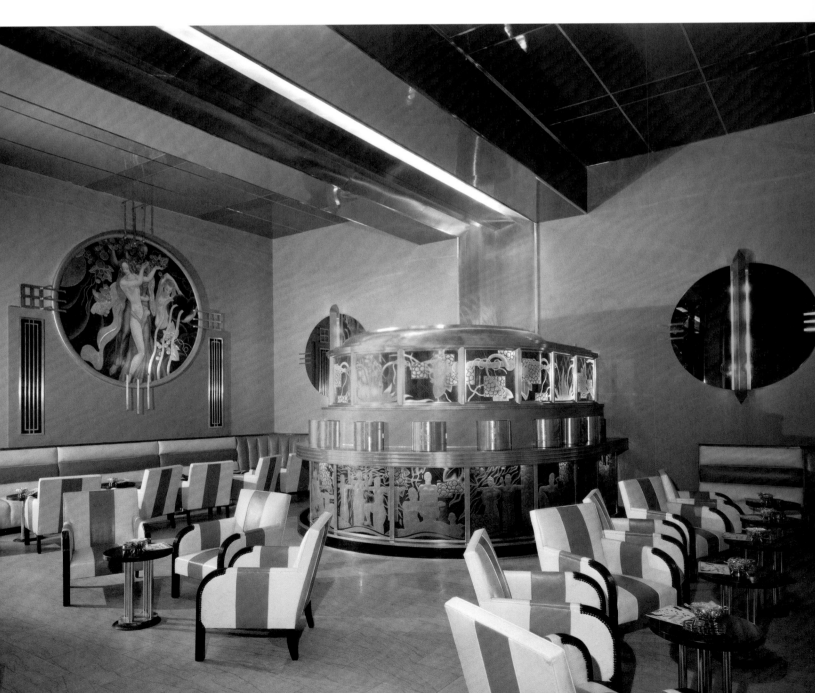

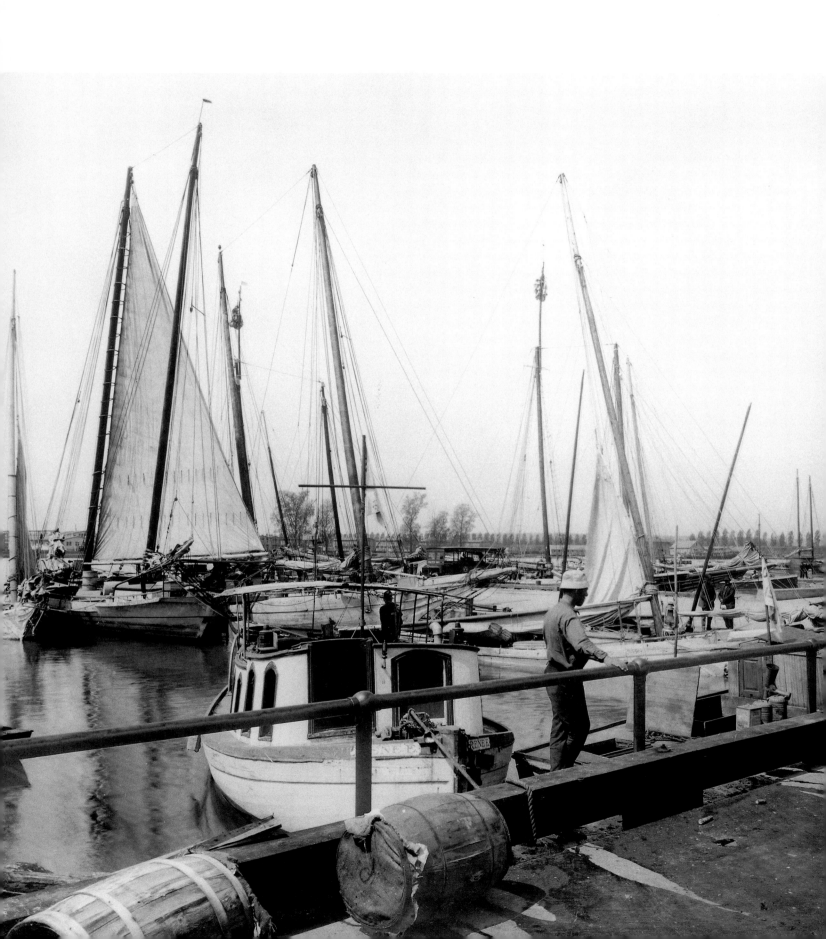

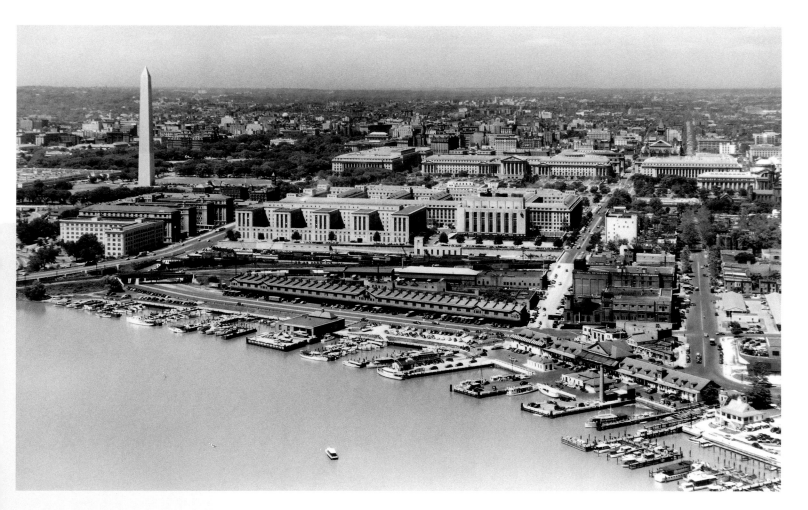

The Southwest waterfront, seen above during the Great Depression, is located south of the Mall and east of 14th Street. Fishermen from the Chesapeake Bay brought their daily catch here to sell and the docks were home to all sorts of pleasure craft. The long brick building along the shore (above, lower right) housed the Municipal Fish Market, built in 1916 to replace unsanitary wooden shacks. The handsome fish market building unfortunately disappeared in 1960 when 550 acres of buildings in Southwest were razed as part of the first and largest urban renewal project in the country.

In the 1930s Washingtonians came to the Southwest waterfront (left) to buy seafood, as they do today. Fishermen brought clams, oysters, crabs, and fish from the Chesapeake Bay and its tributaries and sold them directly from their sailboats, along with watermelons from farms located downstream from the city.

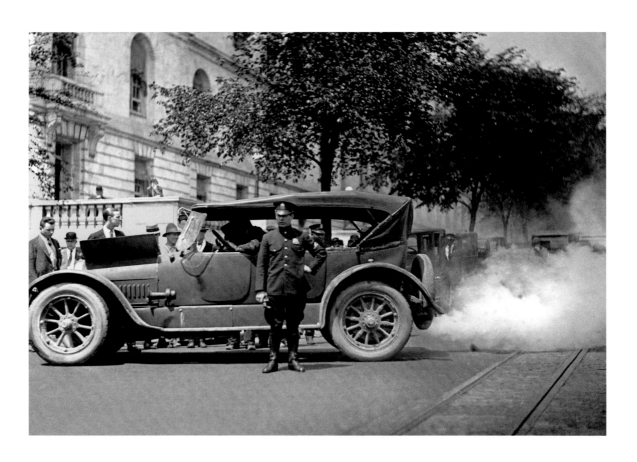

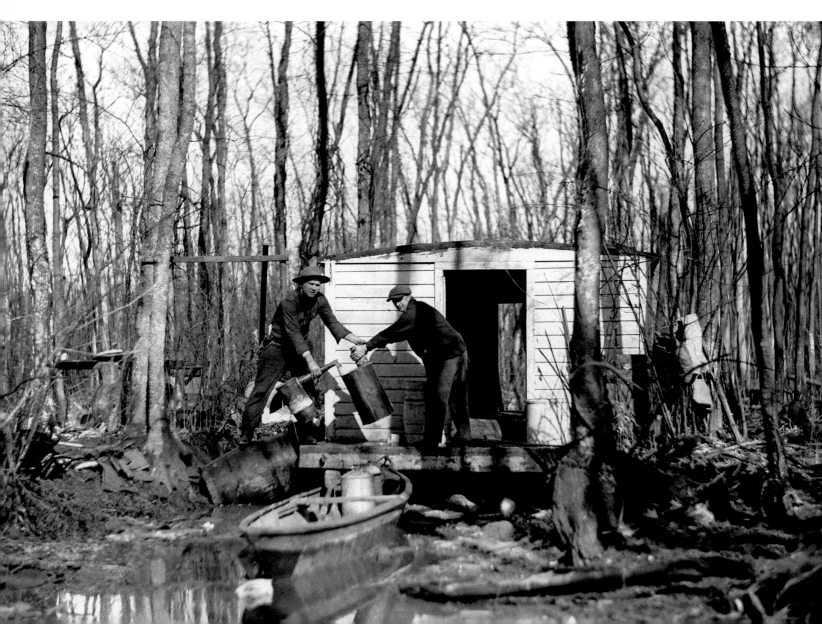

During Prohibition in Washington, D.C., federal agents played a constant game of cat and mouse with bootleggers. The top photograph (opposite) depicts federal agents next to the Cannon House Office Building demonstrating to some congressmen a confiscated bootlegger's car that could emit a smoke screen. The bottom photograph (opposite) shows agents destroying a still hidden in an Alexandria swamp.

James Earle Fraser designed *The Arts of Peace,* a monumental pair of gilded neoclassical equestrian statues, for the entrance to the Rock Creek Parkway adjacent to Memorial Bridge. The statues were to be carved from granite but instead were cast in bronze in Italy after World War II and given to the United States as a gift from the Italian government. The plaster model of *Aspiration and Literature* is pictured on page 8. The other statue of the pair, *Music and Harvest,* is shown below in 1949, in Rome, shortly after its completion.

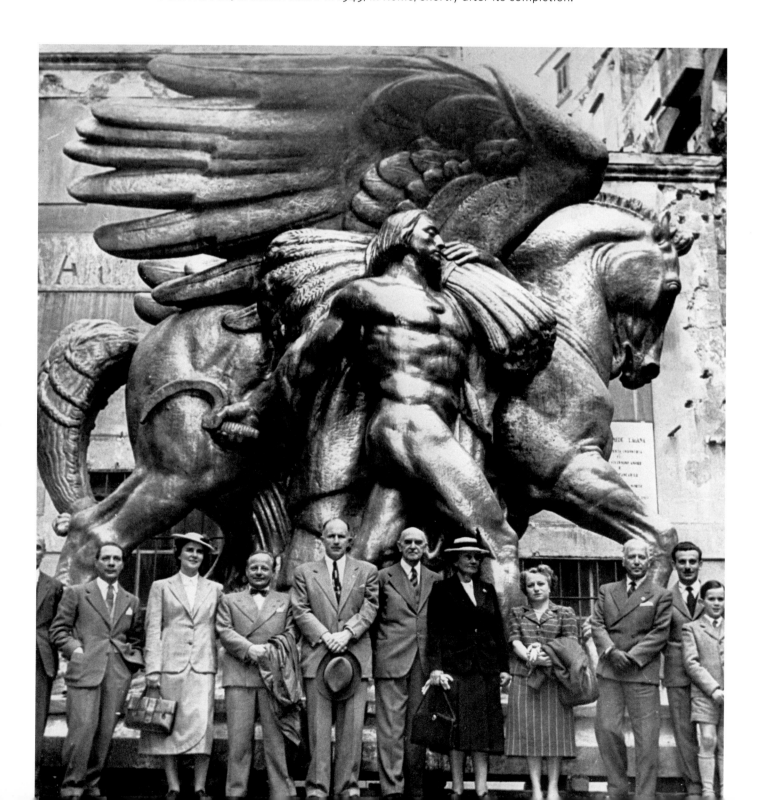

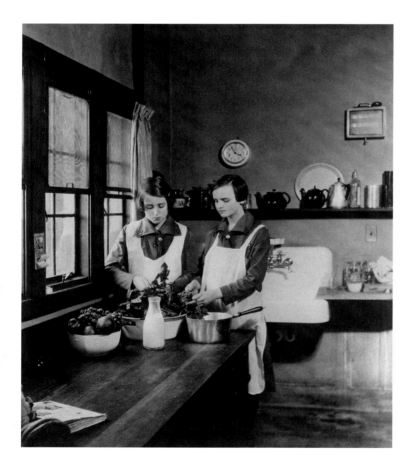

The Girl Scout Little House (left, top) stood on New York Avenue near the Corcoran Gallery of Art for more than forty years before it was razed in 1969. The house was originally erected on the Ellipse to demonstrate advanced building materials, then moved to New York Avenue where the Girl Scouts used it for training and demonstrations in home economics. Two Girl Scouts (left, bottom) prepare a meal at the house.

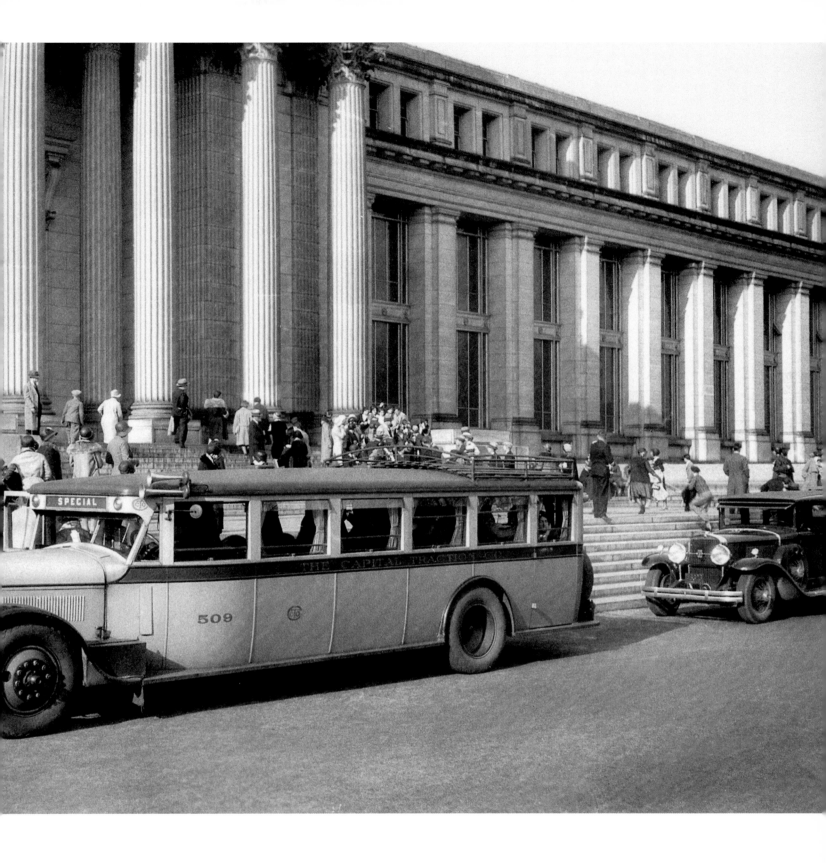

This 1931 photograph of a tour bus in front of the National Museum of Natural History suggests the growing volume of visitors to the Smithsonian since motor vehicles and a shorter workweek allowed tourism to become more common after World War I. The museum, which opened in 1910, was built in the neoclassical style following recommendations of the McMillan Commission Plan of 1902. Today popular features include the Hope diamond, an insect zoo, and an IMAX® theater.

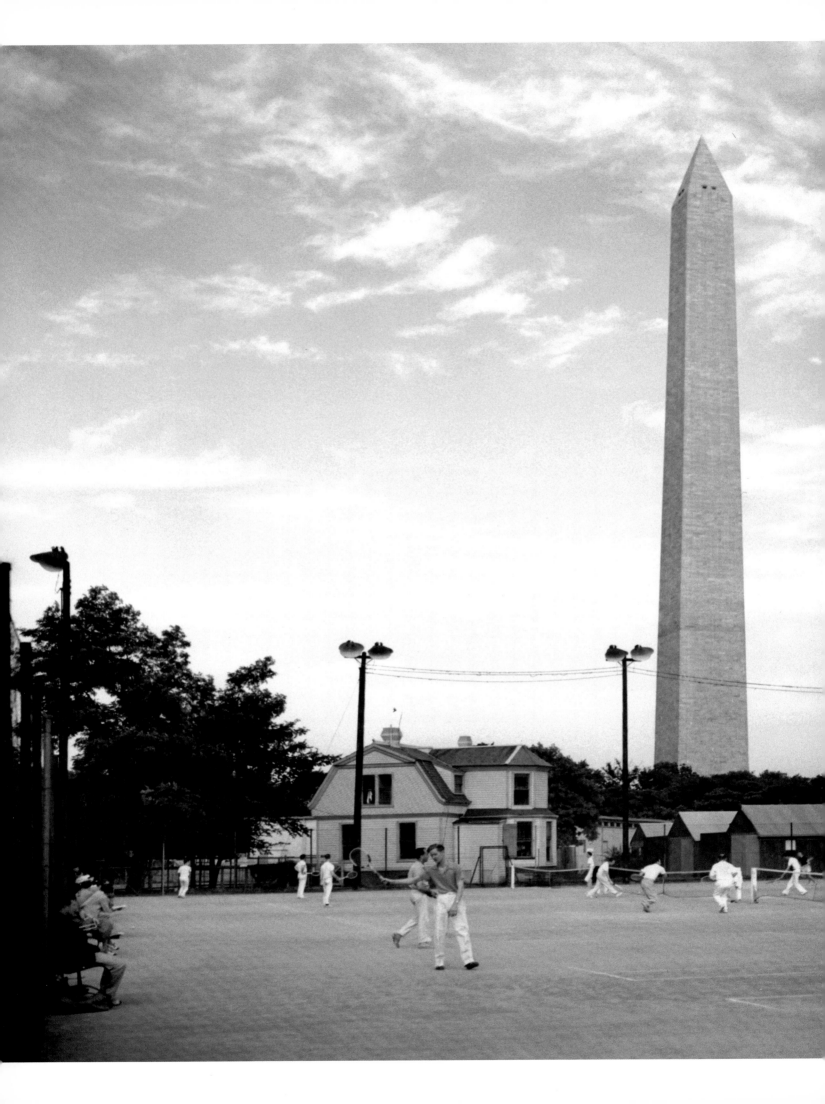

In the 1930s there were tennis courts, football fields, soccer fields, baseball diamonds, and a public swimming pool on the grounds of the Washington Monument (left). Operated by the District of Columbia municipal government, these facilities were racially segregated. They were removed in 1942 for the construction of temporary government office buildings for war workers.

The Ruppert House (below), built about 1775, once stood at the southeast corner of New York Avenue and Bladensburg Road, NE. After the Civil War, Anton Ruppert operated a slaughterhouse there; two brick icehouses for storing meats were still standing behind the house in the 1930s. In 1937, shortly before the house was demolished, this photograph was taken by the Historic American Buildings Survey, a New Deal program (the only one still active) to document important early buildings and employ unemployed architects. Because there were no laws protecting landmark buildings, a number of eighteenth-century houses were razed in Washington in the 1930s. The young Yale graduate shown in the photograph is Frederick Doveton Nichols, who later became a prominent architectural history professor at the University of Virginia.

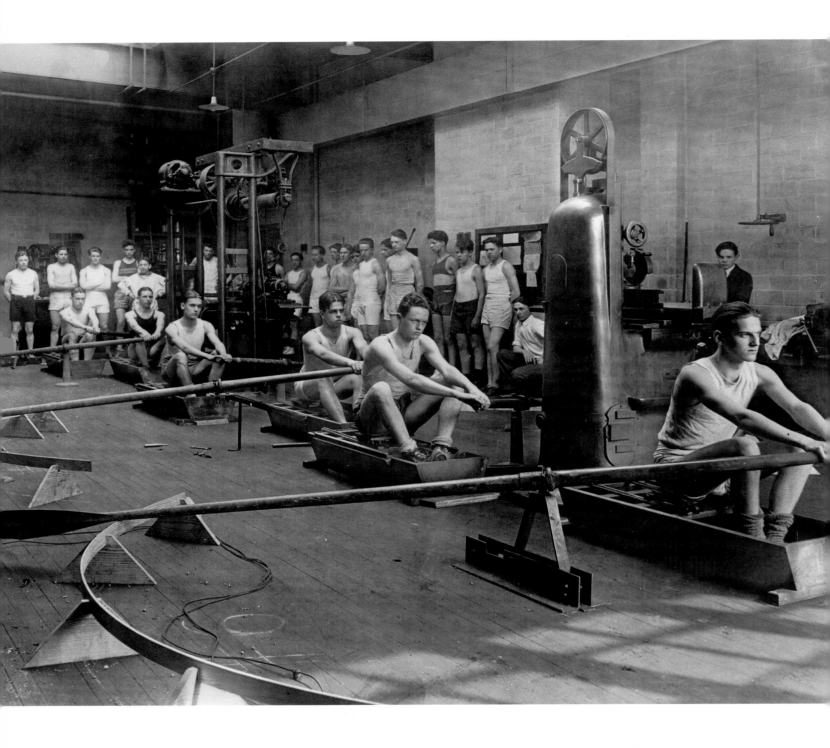

The photograph above shows a rowing class at Central High School in Columbia Heights before the war. Central was one of the best public high schools in the country and one of the first to have an indoor swimming pool. In the era of segregation, Central was originally built for whites only; in 1950 it was renamed Cardozo, after Supreme Court Justice Benjamin Cardozo, and became a high school for blacks only.

The Esso Building (opposite, top), located at Constitution Avenue and Third Street, NW, was once billed as the largest service station in the world. Built by the Standard Oil Company of New Jersey in 1931, the building had service facilities (opposite, bottom) in the basement and on the first and sixth floors, while rented offices filled the other floors. It was razed in 1968 for the construction of Interstate 395.

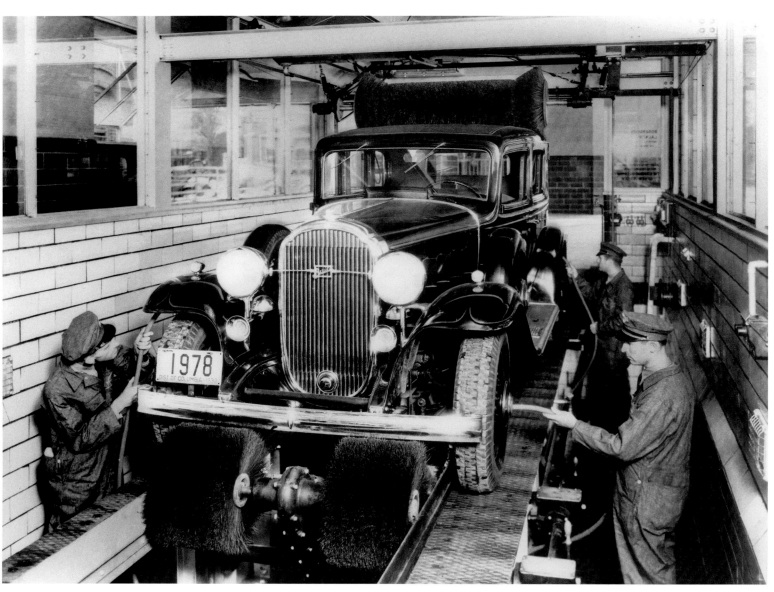

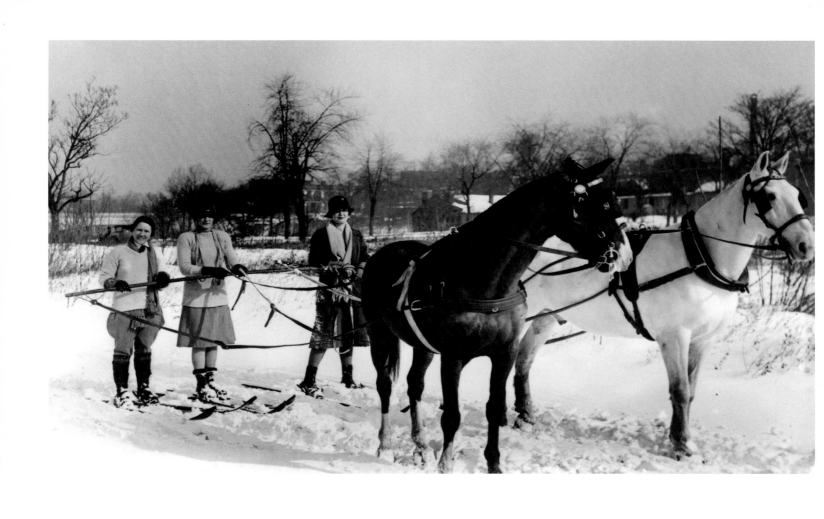

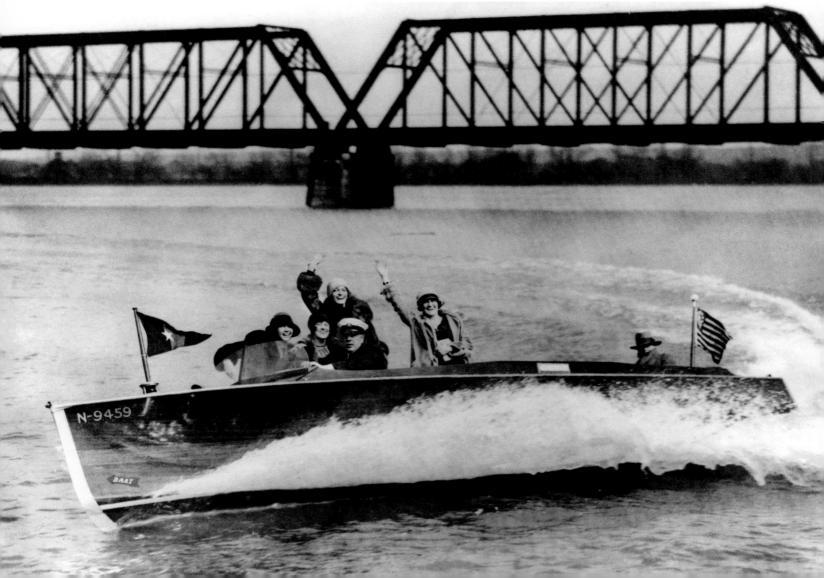

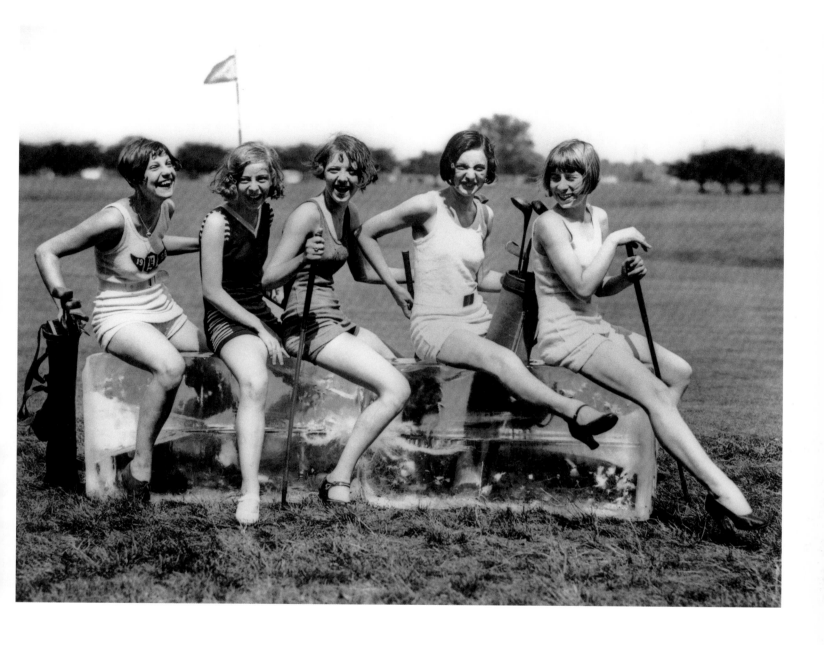

In a photograph taken around 1930 (opposite, top), Washington "society girls" enjoy a winter sport then much in vogue: donning a pair of skis and being pulled across the snow by a team of spirited horses in Rock Creek Park.

In a newspaper society column photograph (opposite, bottom), Gardiner Orme gives a ride on the Potomac in his new mahogany speedboat to several debutantes, one the daughter of a general and another the daughter of a U.S. senator. In pre–World War II years, a speedboat ride marked the opening of the yachting season. In the background is the old railroad bridge, which is still standing near the 14th Street Bridge, although the steel through trusses have long since been replaced by steel plate-girders.

The five Washington girls above were playing golf on the hottest day of the year when they sought relief by sitting on a huge block of ice. This photograph was taken around 1930, on the golf course located in East Potomac Park; the course remains popular today.

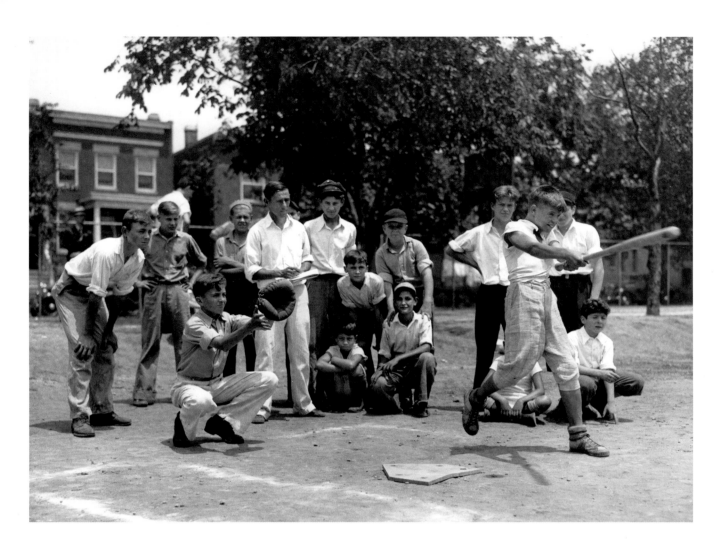
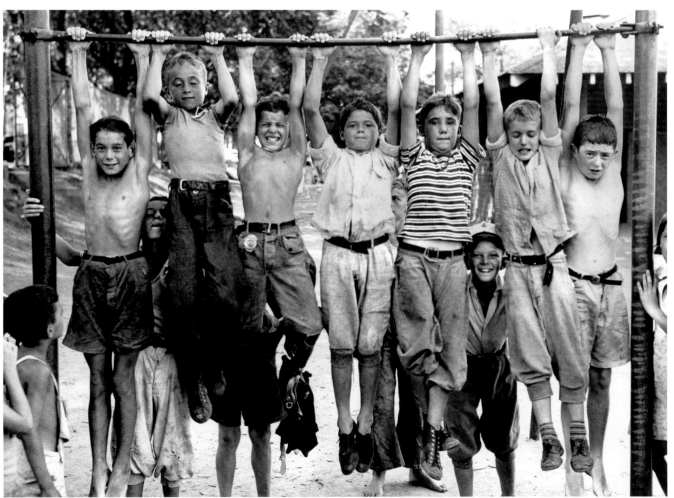

In the late 1930s, the Works Progress Administration, created as part of Roosevelt's New Deal, was the largest employer in the country. The WPA, headed by Harry Hopkins, renovated many District playgrounds, which included baseball diamonds (opposite, top) and chin-up bars (opposite, bottom). The latter scene shows Rosedale Playground, near Benning Road, NE, which is still in use today.

Girl Scouts from Washington (below) practice lifesaving techniques at a camp in Magnolia, Maryland, on the Chesapeake Bay north of Baltimore.

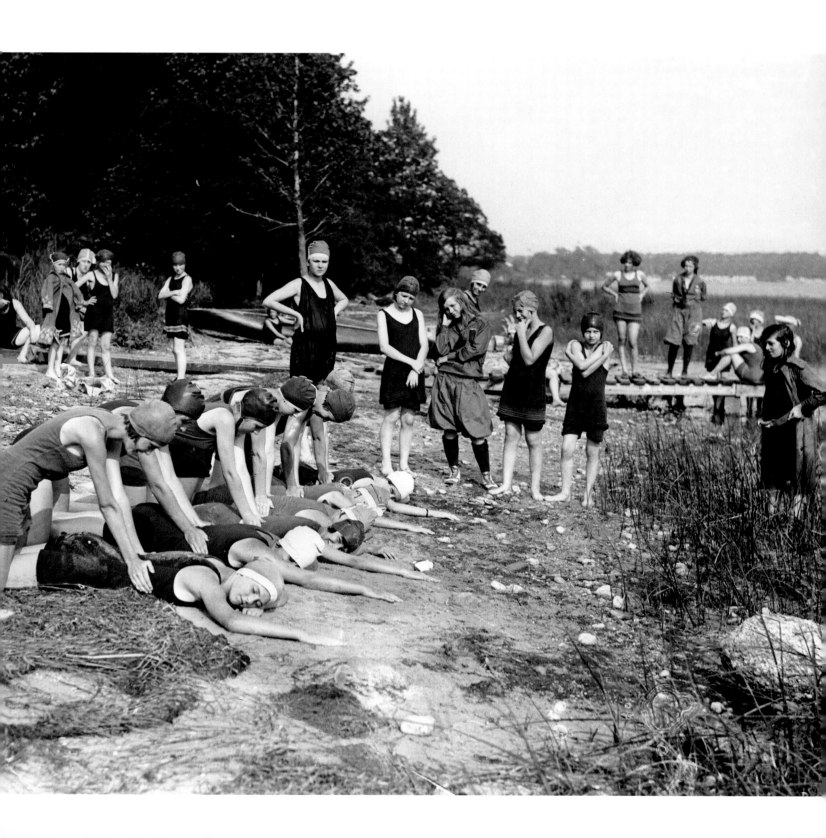

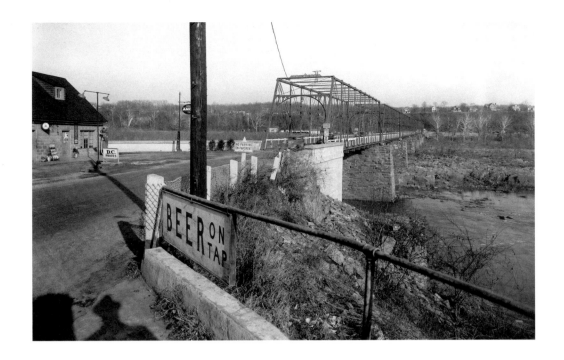

The photograph above of Chain Bridge from the Virginia side of the Potomac was taken shortly before the flood of 1936 damaged the iron truss superstructure, forcing its replacement. The stone piers date from the 1850s and are still in use today. The appellation Chain Bridge comes from a chain suspension bridge that was built here in 1810.

The Kennedy-Warren (opposite), Washington's finest example of an Art Deco apartment house, was designed by Joseph Younger and built in 1930–1931 at 3133 Connecticut Avenue, NW. In the 1930s it was the home of many prominent individuals: Harry Hopkins and General Edwin Watson, both close personal aides to President Franklin D. Roosevelt, as well as Lyndon B. Johnson, then a junior congressman from Texas.

Traffic at the intersection of Pennsylvania Avenue and 14th Street (below), one of the busiest in Washington, forms an abstract composition in this overhead view. David Myers, a photographer with the Farm Security Administration, a New Deal agency, took this photograph in 1939. FSA photographers, such as Walker Evans and Dorothea Lange, produced some of the iconic images of the Great Depression.

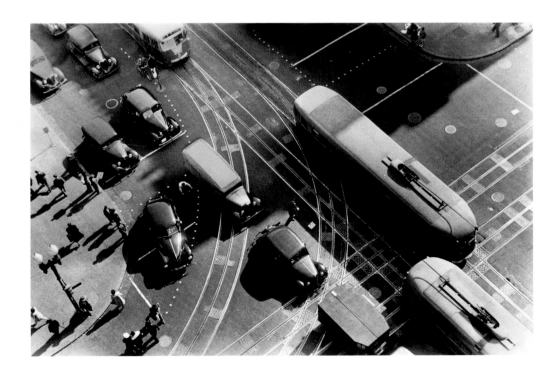

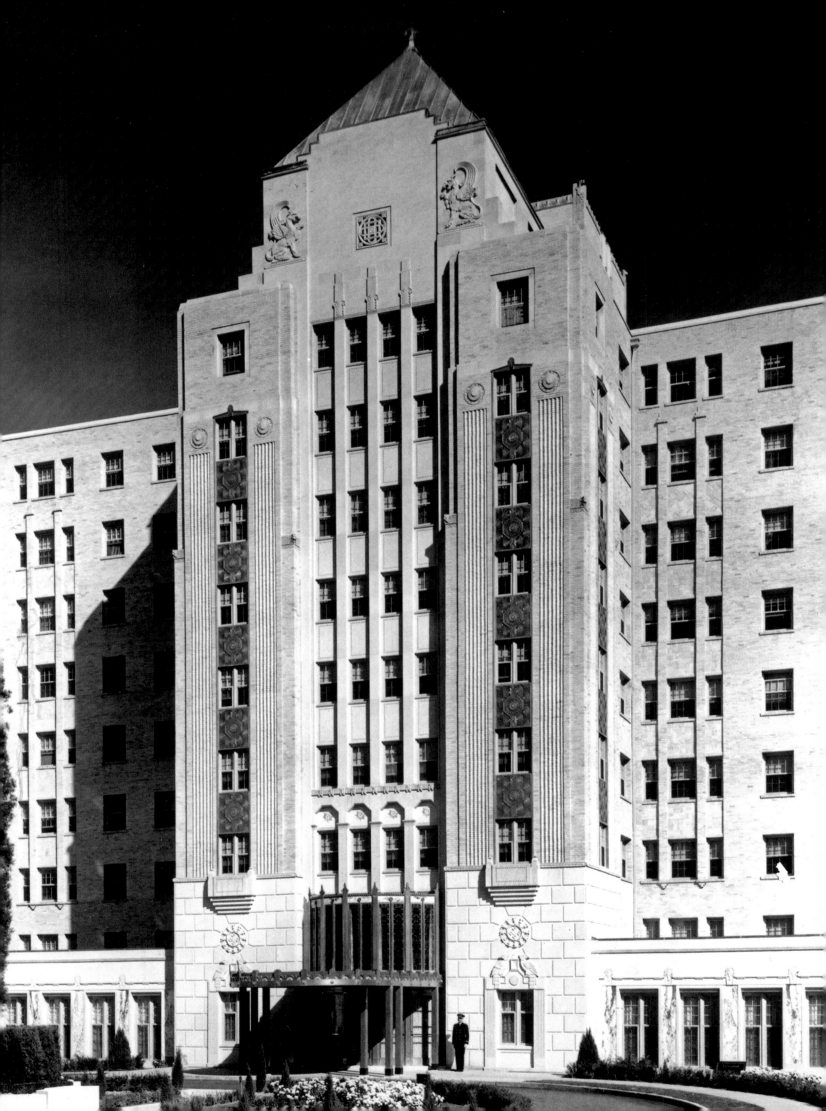

The April 1941 view at right, taken by a photographer from the Farm Security Administration, marks the abrupt change in temperament in Washington, D.C., between the slow-paced decade of the 1930s and the rapid defense mobilization of the early 1940s. Here cars tow a hundred house trailers from their Michigan factory across the Memorial Bridge on their way to Wilmington, North Carolina, to house shipyard workers.

The streamlined modern terminal at National Airport (below) opened in June 1941, replacing the outmoded Washington Airport, which was razed for the construction of the Pentagon. National Airport was a remarkable engineering achievement, since two-thirds of its 729 acres consisted of land created by dredging the Potomac River. At the time National, with its large terminal and traffic control tower, four concrete runways, and six large hangars, was the most modern airport in the country.

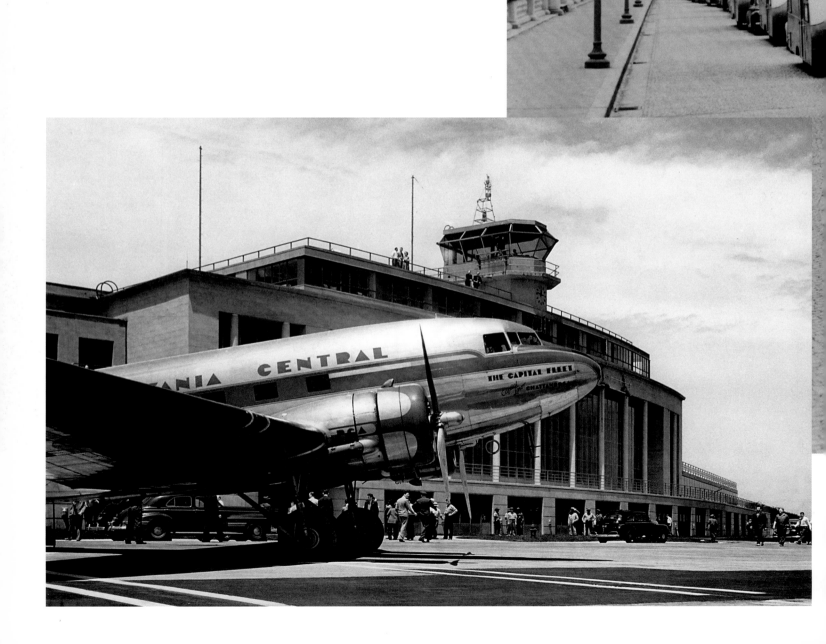

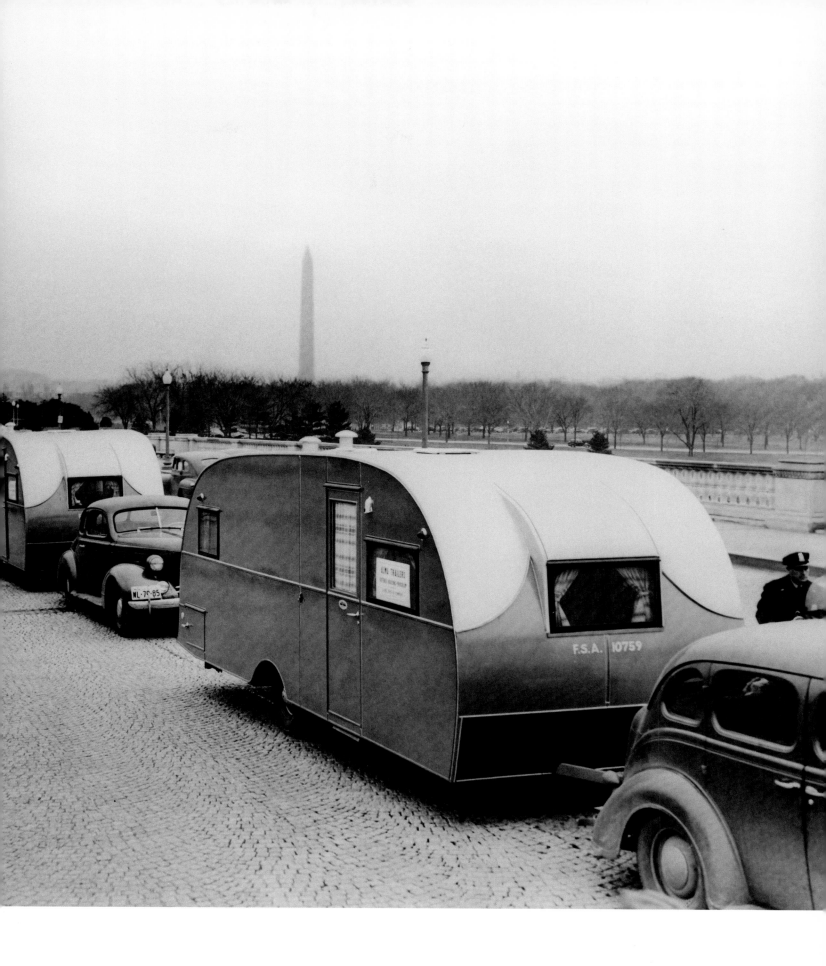

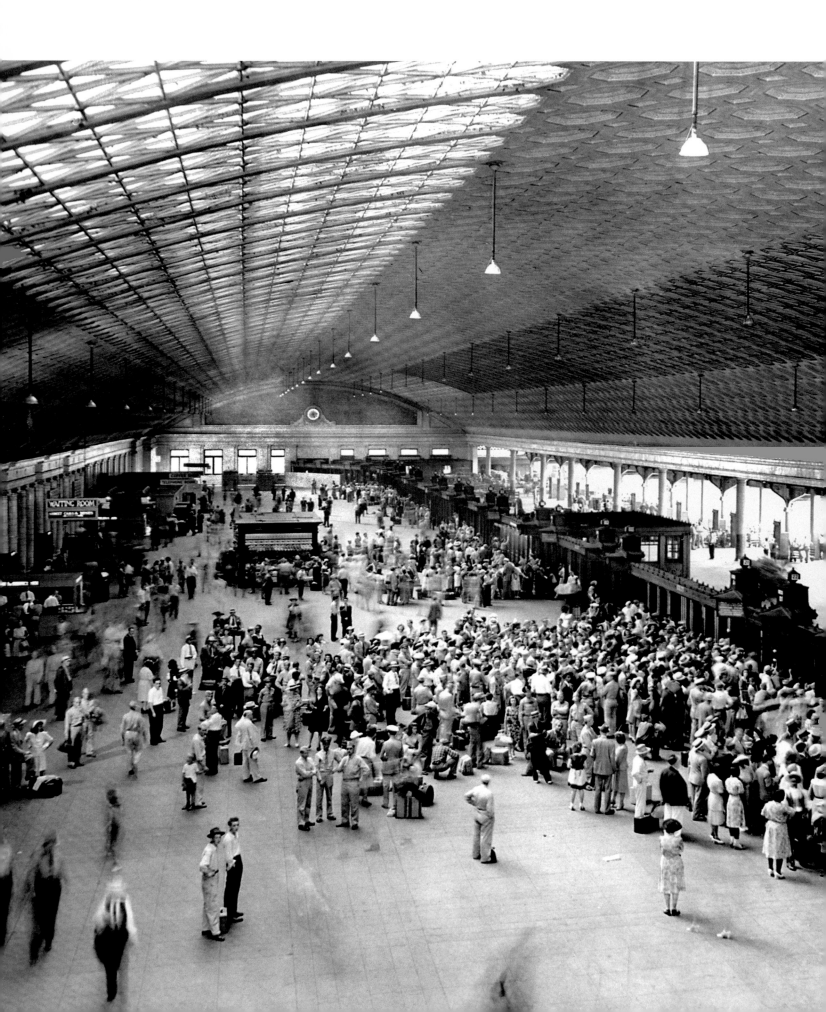

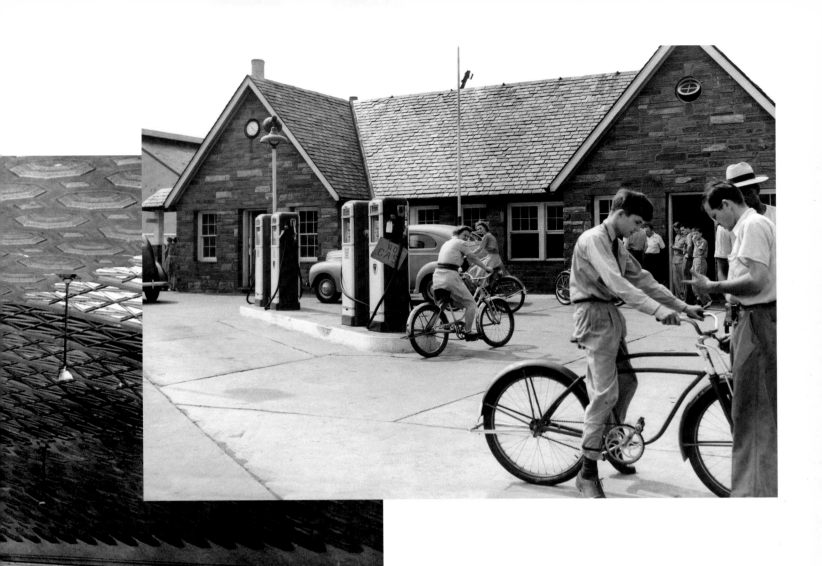

Life in Washington, D.C., changed abruptly with the arrival of World War II, which brought with it a shortage of housing and many commodities. The 1942 photograph above shows the Esso gas station at Virginia Avenue and Rock Creek Parkway out of gas because of wartime rationing. The enterprising owner rented bicycles instead. The historic stone building still stands today next to the Watergate complex.

Before and during World War II, railroads remained the principal mode of long-distance travel to and from Washington. Union Station, designed by architect Daniel Burnham and opened in 1907, is shown at left during World War II. Draftees heading off to war and servicemen and women home on leave crowd the 760-foot grand concourse, adding to a city population swelled by war. After the war, as the automobile became the favorite means of transportation and airline travel became common, the mammoth station fell into disuse. It was restored to its former grandeur in 1988; the concourse was converted into a three-level shopping mall.

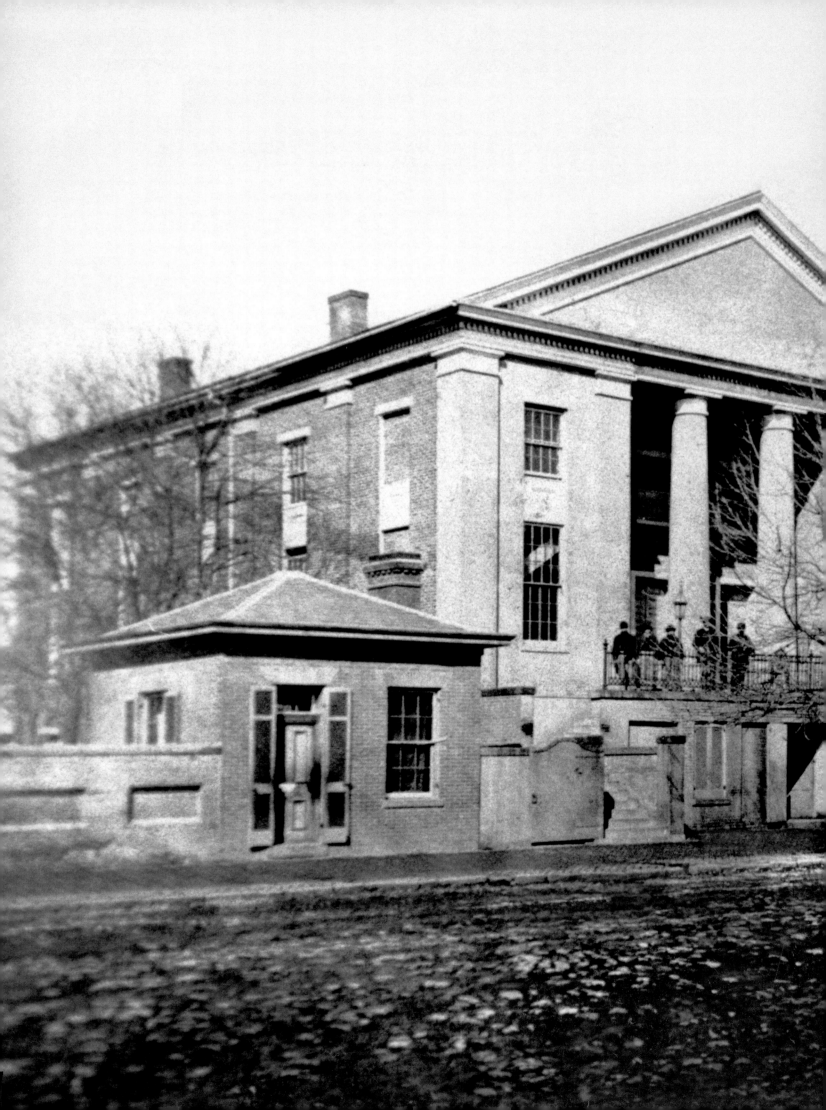

# LOST LANDMARKS OF ALEXANDRIA

The Washington Street United Methodist Church still stands at 115 South Washington Street, although it has been extensively altered. Work began on the edifice in 1850 after the Methodist Church split into southern and northern factions on the eve of the Civil War. The handsome original Greek Revival façade seen here was demolished in 1876 and rebuilt in a style that conformed to Victorian tastes. This photograph was taken during the Civil War when the church was used as a hospital by the Union Army.

ALTHOUGH THE BUILDINGS featured in this chapter have been lost, Alexandria is fortunate in that many of its other landmark buildings have survived. Like nearby Georgetown, it was a thriving port city before the Civil War; it later stagnated, sparing the city from the widespread destruction that would have come with large-scale industry. During the 1930s, as the federal government's rapid New Deal expansion caused a housing shortage, many of the old houses in Alexandria and Georgetown were restored, saving them from demolition.

Alexandria is older than the city of Washington. Around 1740 a tobacco warehouse was built on the present site of the city, and in 1749 the town was laid out and the first lots sold. Alexandria was named for the Alexander family, who were landowners in the area. By the 1780s it was one of the richest cities in Virginia—Alexandria carried on a robust trade in grain with the Shenandoah Valley and flour milling was its most important industry.

In 1790 Congress authorized George Washington to choose a ten-mile-square site along the Potomac River for a new national capital; the states of Virginia and Maryland contributed the land. The president, who lived nearby at Mount Vernon, angled the square to include both Georgetown and Alexandria, and Alexandria became "Alexandria, D.C." In 1800 Alexandria had five thousand people, compared to the city of Washington numbering only three thousand.

In the 1830s and '40s, Alexandria lost much of its flour and grain trade to Baltimore, which had better rail and shipping connections. In 1846 Congress returned present-day Alexandria and Arlington to Virginia at the request of its citizens. Alexandrians were dissatisfied with economic conditions and expected that the slave trade, a lucrative business, would be banned in the District of Columbia. Prosperity returned in the 1850s as rail connections improved, causing the flour industry to thrive. The port city's population jumped to 12,600, and hundreds of new houses were built.

The buildings shown in this chapter include some of Alexandria's most important landmarks that have been lost to fire, business development, and the ravages of a mediocre urban redevelopment program. In spite of these setbacks, the city has an extraordinarily rich architectural heritage, with more than two hundred surviving buildings that predate 1820. The city government

enacted its first historic preservation law in 1946; although weak, the preservation law was one of the earliest in the country. In the 1960s urban renewal claimed three blocks of King Street. Today considerable tension still exists between developers and preservationists in Alexandria.

Ironically the city's occupation during the Civil War aided its preservation. Virginia voted to secede from the Union on May 23, 1861, and early the following morning, 2,100 federal troops marched into the city. Alexandrians spent the rest of the war under martial law as the city became an enormous supply depot for the Union Army, but were spared the destruction that heavy fighting visited on the Virginia cities of Norfolk, Richmond, Petersburg, and Fredericksburg.

After the Civil War, Alexandria's economy stagnated, and for some fifty years, life in the city moved slowly. During World War I, a large shipyard was built, along with plants to produce war materiel, including the Torpedo Factory—which is still standing. Alexandria was important for its rail connections, and Potomac Yards was said at the time to be the second-largest rail yard in the world. In 1932 the Mount Vernon Memorial Highway, later renamed the George Washington Memorial Parkway, opened and continued through the city on Washington Street. The parkway brought new business to the city, but also caused the destruction of numerous historic buildings, in defiance of the town's original agreement with the federal government.

Alexandria boomed again during World War II, and the Torpedo Factory employed six thousand workers. After the war the city moved from an industrial and commercial economy to one based on white-collar jobs connected to the federal government. The town became known for its historic buildings. In 1970 work began on the restoration of the 1753 Carlyle House, the city's most important eighteenth-century dwelling; it marks the commencement of British General Braddock's march to what is presently Pittsburgh at the beginning of the French and Indian War. Four years later, the unused Torpedo Factory was converted into an arts center, a project that has become a model for others around the country. The city's historic waterfront, formerly decrepit and overgrown, was transformed with new shops and attractively landscaped parks. Now an important tourist attraction, the waterfront again faces proposed controversial development. Preservationists are again rising to action.

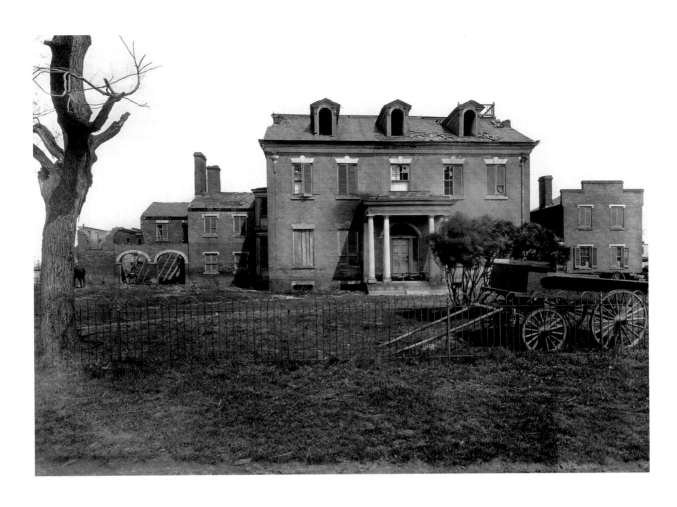

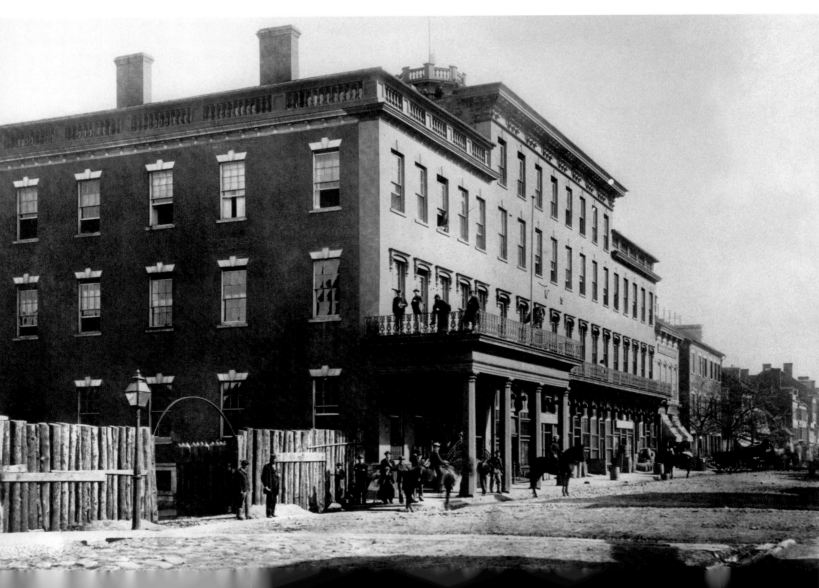

Colross (opposite, top) once occupied an entire square on Oronoco Street between Fayette and Henry Streets. The beautifully proportioned Federal-style main house was built about 1800; the wings and Greek Revival portico were added in the 1830s. Before the Civil War, its inebriated owner lost the house in a card game to Thomson Mason, a grandson of George Mason. After Mason moved into Colross, the accidental deaths of two of his children were attributed by many to the unfortunate circumstances of the house's acquisition. In 1929 industrialist John Munn disassembled the house and rebuilt it in Princeton, New Jersey, where it is now used as a private school.

The oldest part of the Mansion House hotel, fronting North Fairfax Street (opposite, bottom), and which appears on the left in the photograph, was completed in 1807 for the Bank of Alexandria. After the bank failed in 1834, it passed through several owners until James Green bought it in 1850. Green incorporated the building into a new hotel he named the Mansion House. In 1855 he added a large Italianate main building to the right of the old bank, making it one of the most fashionable hotels in Virginia. The stockade, on the far left in this Civil War–era photograph, was built to prevent Confederate raiders from approaching the waterfront. During the early 1970s, Green's addition was razed so that the historic Carlyle House, behind the building, could be viewed from North Fairfax Street. At the same time, the first floor of the original Federal bank building, at North Fairfax and Cameron Streets, was renovated and the upper floors converted to apartments.

The Fire Insurance Company of Alexandria building (above) once stood in the 500 block of King Street. It was built about 1812 to house the Mechanics Bank, which failed after a few years, and then became the home to the Fire Insurance Company of Alexandria until 1871. During the Civil War, it was used by the Union Army for the provost marshal's office. In the 1880s the handsome Greek Revival façade was severely altered. The entire block was razed in the 1960s as part of an ill-conceived urban renewal project.

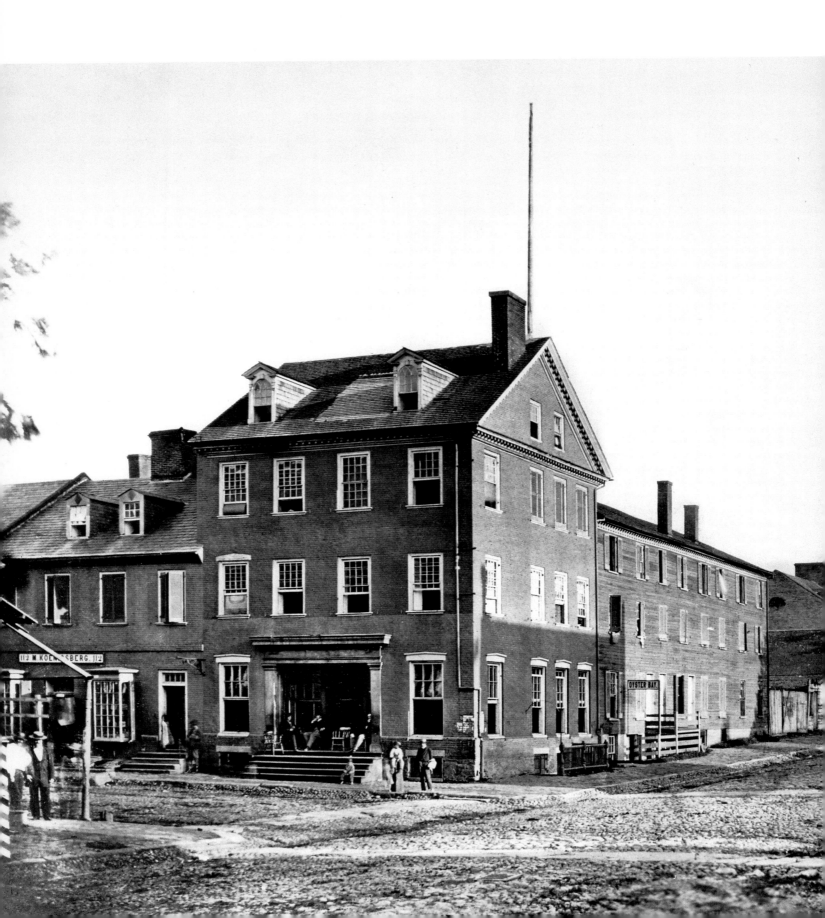

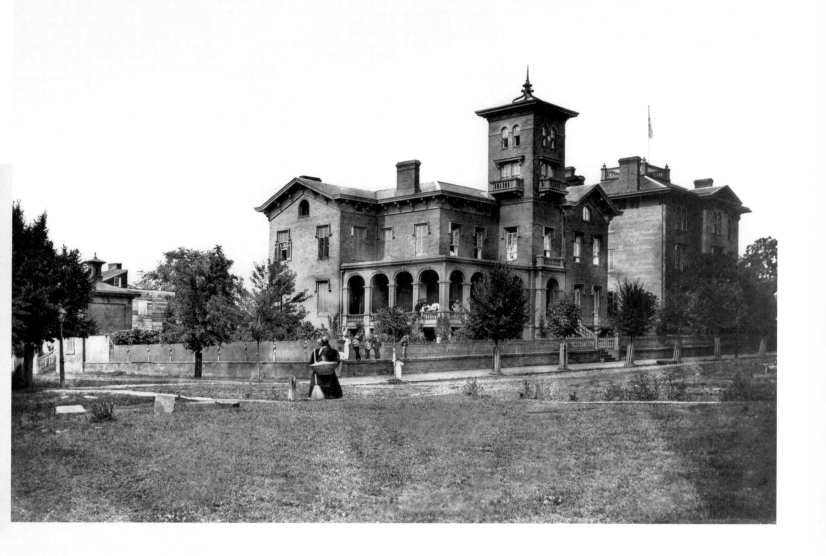

Marshall House (left), seen here during the Civil War, was located on the southeast corner of King and Pitt Streets. After Virginia seceded from the Union in 1861, proprietor James W. Jackson defiantly flew the Confederate flag over the hotel. When Union troops invaded the city, Colonel Elmer Ellsworth, a friend of Lincoln, who stayed in the White House, spotted the flag and tore it down. Acting to avenge that insult to Southern honor, Jackson shot him and was himself immediately killed by one of Ellsworth's soldiers. The building, which was built about 1785, was razed in 1951 for a Virginia state liquor store.

John L. Marshall, a wealthy shoe merchant, built the imposing Italianate house (above) about 1850 at the southwest corner of Wolfe and South Pitt Streets. During the Civil War, the Union Army converted the house into a hospital. The landmark was razed in 1961 for the construction of a group of townhouses.

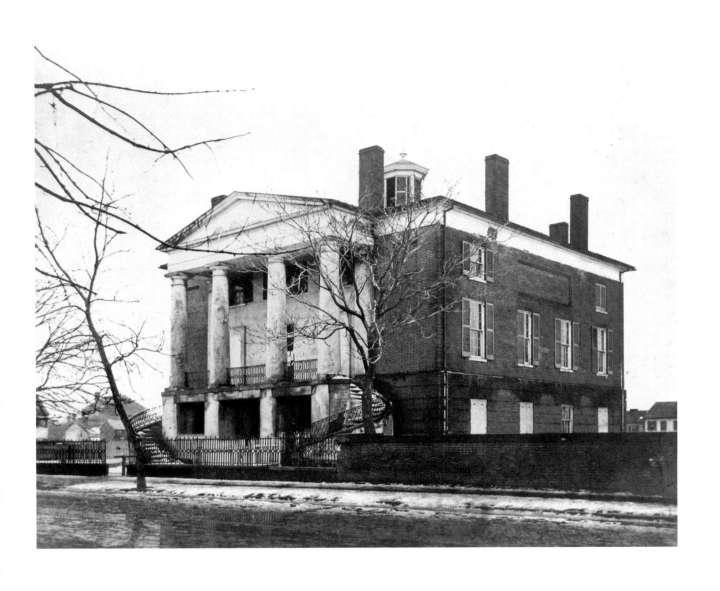

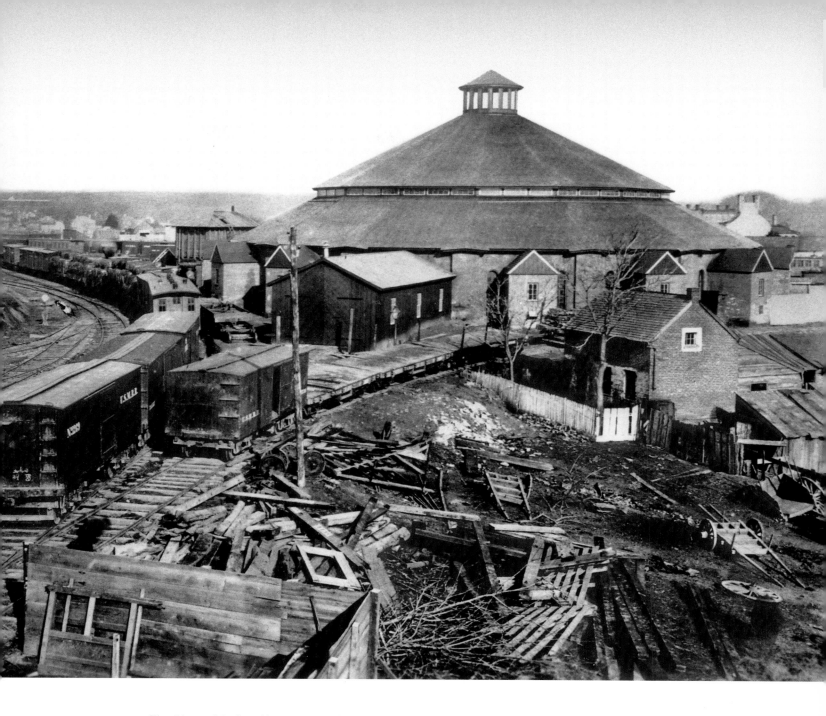

The Alexandria Courthouse (opposite, top) was built in 1838, when Alexandria was still a part of the District of Columbia. The Greek Revival building occupied the block on the west side of North Columbus Street between Queen and Princess Streets until it was razed in 1905. The architect, Robert Mills, also designed the Washington Monument and the U.S. Treasury building in Washington City and supervised the construction of the Patent Office building.

The Alexandria Poor House (opposite, bottom) was established in 1786 as a home for the indigent and disabled. Around 1800 this Federal building was erected near the present-day intersection of Jefferson Davis Highway and Monroe Avenue. A fourteen-acre farm, where residents grew most of their food, surrounded the building. The poor house closed in 1928 when it was replaced by another in Manassas, and the building was demolished in the 1940s.

This railroad roundhouse (above) held a large turntable for placing locomotives on assigned tracks for maintenance, light repairs, and storage. The Orange & Alexandria Railroad built it in 1851 at the northwest corner of South Henry and Wolfe Streets. This photograph dates from the Civil War period, when the structure was used by the U.S. Military Railroad. It burned down around 1900.

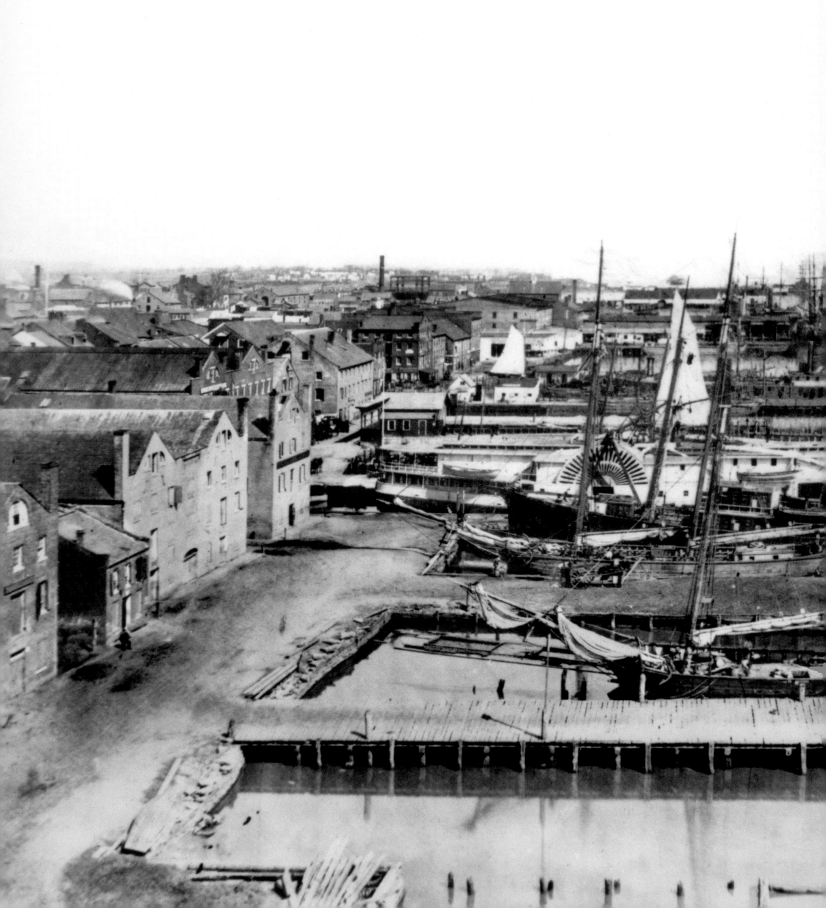

The Pioneer Mill, constructed at the foot of Duke Street on the Potomac River in 1852, was the largest building at the time in Alexandria and the second-largest flour mill in the country. Grain was unloaded at an adjacent wharf and ground into flour with steam power. Both photographs date from the Civil War era; one is a view of the busy waterfront from the mill (left) and the other is a view of the building itself (above). The mill was destroyed by fire in 1897.

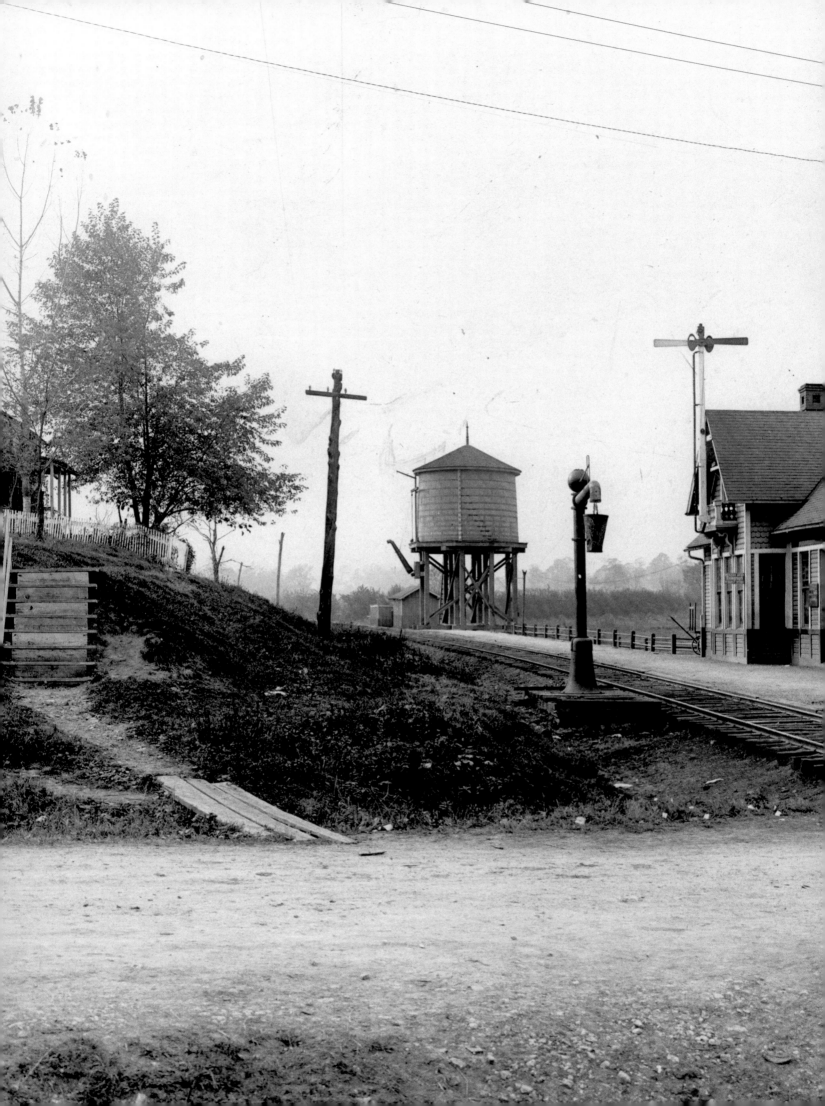

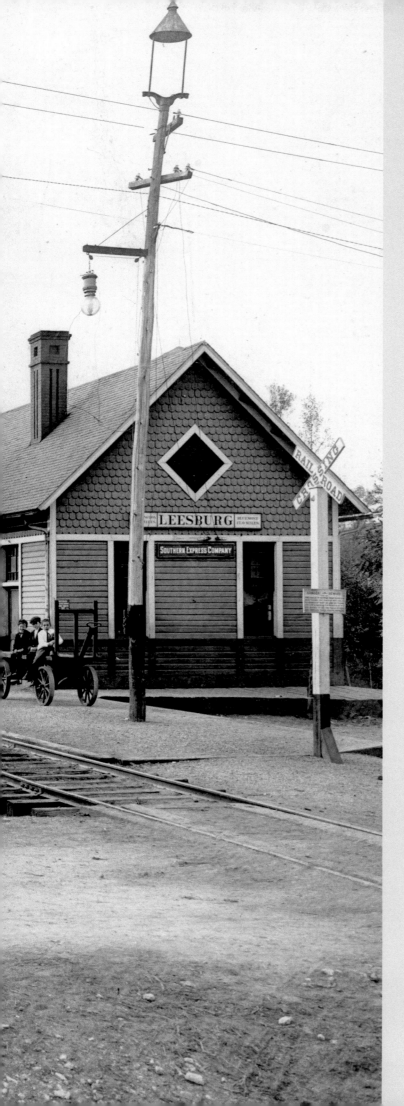

# CHAPTER SEVEN

# LOUDOUN COUNTY, VIRGINIA

The Leesburg railroad passenger depot, seen here about 1910, was located on South King Street, adjacent to the present bicycle trail. The Alexandria, Loudoun & Hampshire Railroad reached Leesburg in 1860. The railroad was intended to link the seaport of Alexandria with the coalfields of Hampshire County in present-day West Virginia but never raised enough capital to extend its tracks beyond Bluemont, at the western edge of Loudoun County. Known after 1911 as the Washington & Old Dominion Railroad, the company survived by carrying local agricultural products. Passenger service ended in 1951, but the railroad continued to carry freight until abandonment in 1968.

ETWEEN 1720 AND 1750, hundreds of settlers arrived to farm the rich Piedmont soil east of the Blue Ridge in what is now Loudoun County, which was then still a wilderness. Wealthy planters from the Virginia Tidewater purchased large tracts of land in the southern and eastern portions of the county. These families, including such familiar names as Lee and Carter, sent their overseers and slaves in advance to work the land. Others, mostly Quakers and Germans, settled on smaller farms to the north and west. Because residents had to travel some 35 miles on rough roads to the Fairfax County seat in Alexandria, the Virginia legislature allowed them to form a new county in 1757. It was named for John Campbell, fourth Earl of Loudoun, who had recently been appointed commander-in-chief of British forces in North America and royal governor of Virginia.

In 1758 Captain Nicholas Minor laid out the town of Leesburg at the intersection of two major colonial highways, the north–south Carolina Road and the east–west Alexandria–Winchester Road. It soon became the county seat, and the first courthouse was built there in 1761. By the end of the Revolutionary War, there were three dozen communities in Loudoun County.

Although no battles were fought in Loudoun County during the Revolutionary War, more than 1,700 residents enrolled in militia units to protect the county in case of British attack. In addition, the county government assisted many families of soldiers in the American army with donations of food or cash. Residents supported the war effort by giving clothing and wagons. Quakers, who refused to support the war, were taxed, and a few had their property confiscated.

By 1805 Loudoun County was an innovator in agricultural reform, led by John A. Binns. Under his "Loudoun system," farmers doubled their production of crops with deep plowing and the use of clover and gypsum to renew the soil. County farms produced wheat and corn, as well as cattle, hogs, and sheep. Water-powered mills ground grain into flour or cornmeal. In 1818 Loudoun County's first bank, the Bank of the Valley, opened next to the courthouse. By 1825 there were eight communities in the county that were large enough to have municipal governments: Leesburg, Middleburg, Waterford, Hillsboro, Aldie, Union (now Unison), Bloomfield, and Snickersville (now Bluemont). At the same time, a revolution occurred in transportation with the establishment of a number of turnpikes or toll roads in Loudoun County. By 1806 the Little River Turnpike (now U.S. Route 50) extended thirty-four miles from Alexandria to Aldie. The Leesburg Turnpike (now Virginia Route 7), completed about 1820, connected the county seat to Georgetown, D.C. Before

the Civil War, a canal was built along Goose Creek to join Loudoun's mills with the Chesapeake & Ohio Canal, but it was a financial failure. The Alexandria, Loudoun & Hampshire Railroad was extended from Alexandria to Leesburg by 1860. Later known as the Washington & Old Dominion Railroad, it reached Bluemont in 1900. The last train ran in 1968, and later the right of way was developed into a bicycle trail.

By the time of the Civil War, Loudoun County had a number of large plantations, but as late as February 1861, most of the residents opposed secession. A major change in public opinion came in April, however, after President Lincoln called for troops to suppress the rebellion in the South. The majority of residents of Loudoun County then gave their support to the Confederacy rather than take up arms against their fellow Southerners. During the course of the Civil War, there was only one major engagement in the county: the Battle of Ball's Bluff, which was fought outside Leesburg in October 1861 and ended in a Confederate victory. During both the Antietam and Gettysburg campaigns, Union and Confederate armies overran the county and stripped the countryside of foodstuffs.

Loudoun County was bountiful in agriculture, and produce and dairy farms had always been important. In the mid-nineteenth century, the arrival of the railroad made it cheaper to transport fertilizer to farms and deliver produce to cities. The introduction of gasoline-powered tractors in the early twentieth century was another marked improvement. In the late 1930s, the Rural Electrification Administration, a part of the New Deal, brought electricity to many Loudoun farms and provided convenient lighting and refrigeration.

In the 1960s many of the dairy, poultry, and livestock farms in the eastern half of the county rapidly began to give way to suburban development as a result of the construction of Washington Dulles International Airport on ten thousand acres straddling the Loudoun County and Fairfax County border. Development of sewers for the airport allowed private development to spread quickly westward. Within a few years, corporations began to build offices near the airport, and the planned communities of Sterling Park and Sugarland Run were undertaken with thousands of new houses. However, the attempt by Levitt and Sons developers to build a new town in 1969 was blocked because of fears that it would place a great burden on the county to provide more schools and public services.

Growth accelerated in the eastern part of the county in the 1980s with the residential developments of Ashburn Village and Ashburn Farms close to

Route 7. Dozens of large farms gave way to multitudes of houses in the new communities of CountrySide, Cascades, and South Riding. Thousands of new residents settled in the county to work at the many new corporate headquarters near Dulles Airport and along Route 7. To support development, the state constructed three new highways: the Loudoun County Parkway, the Algonkian Parkway, and Sully Road; it widened both Route 7 and Route 28. The opening of the Dulles Greenway, a high-speed toll road between the Capital Beltway and Leesburg in 1995, spurred the building of the most recent communities, Brambleton and Broadlands, which added thousands of new houses.

Today several of the county supervisors are attempting to preserve the rural character of the western half of the county. With its rolling hills and small towns including Middleburg, Round Hill, and Waterford, it is one of the most scenic parts of Virginia. Small housing developments have been allowed in the western part of the county, but it would be challenging to build large residential communities in most of that area because of the lack of major highways, sewers, and water mains.

Leesburg in the eastern part of the county is remarkably well preserved and retains the flavor of a small antebellum town. There, over fifty houses and several public buildings survive from the early periods. At least two buildings from the colonial period survive, the Donaldson Silversmith Shop, now part of the Loudoun Museum, and the William Baker House on Loudoun Street. The buildings from later eras include the 1818 Bank of the Valley building at East Market and Church Streets and the 1844 Greek Revival Leesburg Academy building at 16 East Market Street, both of which are now used as offices by the Loudoun County government. The oldest house of worship is the Leesburg Presbyterian Church at 207 West Market Street, built in 1804. The old Ball Mansion, built about 1827, was more famously the home of General George C. Marshall from 1941 to his death in 1959. Renamed Dodona, it has been restored to its appearance when he lived there.

Loudoun County is now one of the fastest-growing counties in the United States. Its population escalated from 24,000 in 1960 to 57,000 in 1980, to 169,000 in 2000, and 312,000 in 2010. It is also one of the wealthiest counties in the United States with a median household income of $114,200. For the time being, Loudoun County has managed to create a sustainable balance between economic development and the preservation of its agricultural heritage and open spaces. The eastern part of the county is booming with new construction, while the western part retains the rural flavor of Loudoun's past.

Loudoun County was named for John Campbell, fourth Earl of Loudoun (1705–1782), of Loudoun Castle in Ayrshire, Scotland. Campbell remained loyal to King George II and helped put down the Scottish rebellion of 1745. Early in the French and Indian War, in 1756, he was promoted to commander-in-chief of British forces in North America and governor of Virginia. Loudoun was outmaneuvered by the French general Louis-Joseph de Montcalm and lost Fort William Henry in New York. Consequently he was recalled to England in 1757, never having set foot in Virginia.

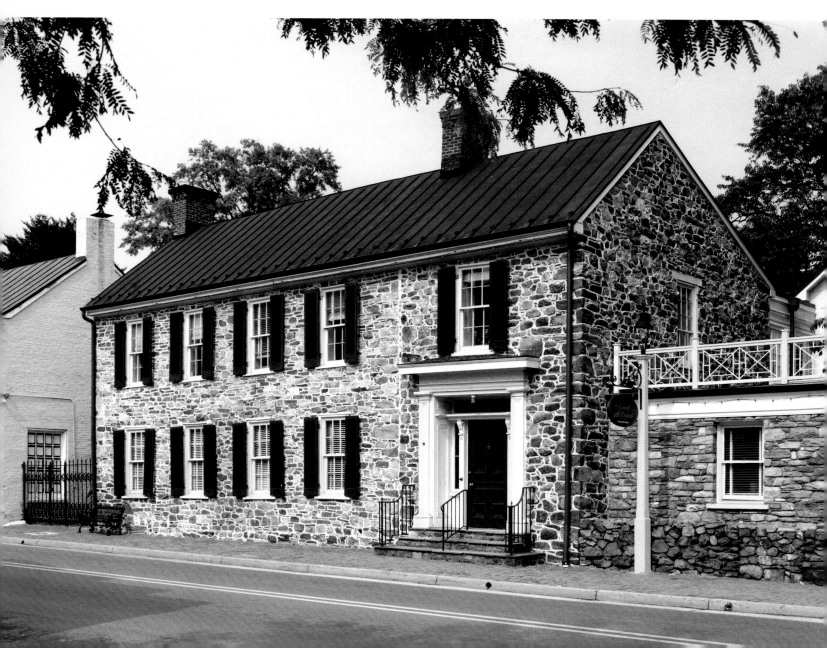

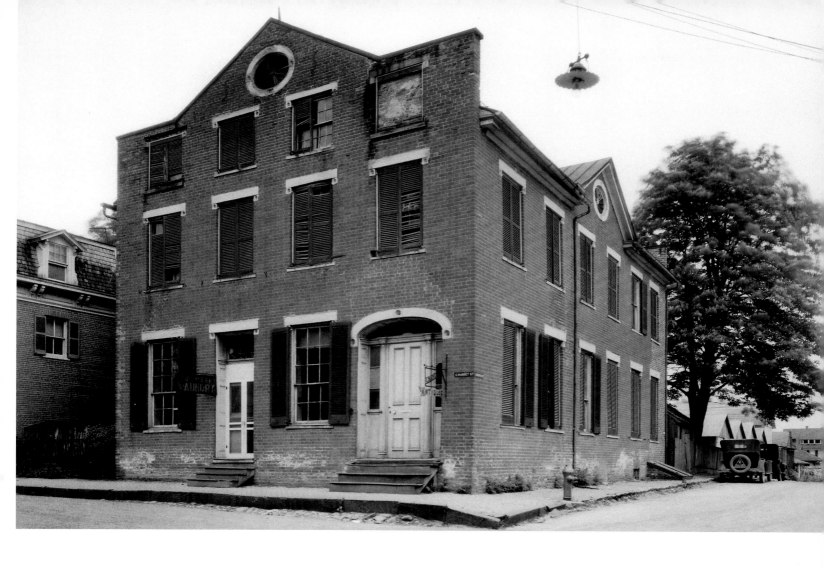

The Donaldson Silversmith Shop at 14 Loudoun Street (opposite, top) is one of the oldest buildings in Leesburg. Silversmith Stephen Donaldson bought the lot in 1763 from Nicholas Minor soon after Minor established the town. A covenant required Donaldson to build on the lot, resulting in this log structure which was just large enough to meet the requirements. Minor used it as a silversmith shop and lived outside of town. By the 1970s the building was clad in aluminum siding and used as a dry cleaners. Concerned citizens saved the building from demolition, and it was restored; the unusual central chimney and windows are reconstructions. The log cabin is now part of the Loudoun Museum.

The Laurel Brigade Inn (opposite, bottom), built as a four-bay stone house in 1800, was converted to an inn in 1817 by Eleanor and Peter Peers. In 1825 they added a rear wing in preparation for a banquet for the Marquis de Lafayette. The fifth bay (seen on the right), with its Greek Revival doorway, was added about 1840. The building was again used as a residence for about a century until it reopened as the Laurel Brigade Inn in 1946, named for one of the three Confederate regiments raised in Loudoun County at the outbreak of the Civil War. The landmark, which in the rear retains its two-hundred-year-old Osage orange tree said to have been planted from seeds from the Lewis and Clark expedition, is now used for law offices.

Located at the corner of East Market and Church Streets in Leesburg, the Bank of the Valley building (above) was built in 1818 in the Federal style of architecture. Originally the bank's cashier lived on the second floor to provide security—his door was on the left and the bank's door was on the right. After the Civil War, the building housed the Loudoun National Bank from 1870 to 1909. Following service as a clubhouse for the Loudoun Hunt between 1909 and 1915, the building was used as a store. Considerably altered, this landmark now houses office space for Loudoun County.

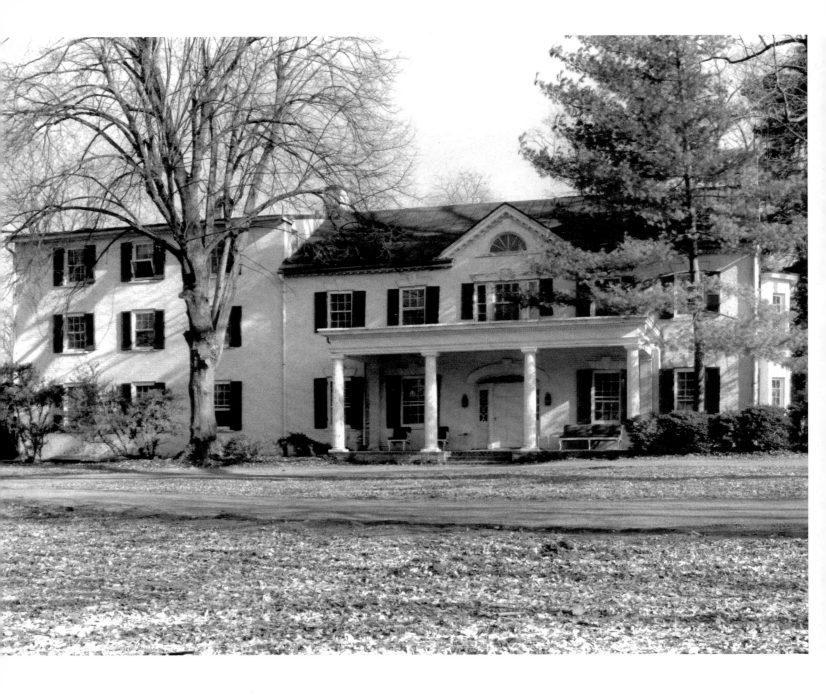

Located on Edwards Ferry Road in Leesburg, Dodona Manor (above) was built in two major sections: the three-story wing in 1828 and the two-story main house in 1850. The most famous owner was General George C. Marshall (right), who resided at Dodona from 1941 to 1959 when he served as U.S. Army chief of staff in World War II, and then as secretary of state and secretary of defense. While living there the general conceived the famous Marshall Plan under which the United States spent billions of dollars to rebuild war-torn Western Europe. President Harry S. Truman, Winston Churchill, and many other prominent leaders visited Marshall at Dodona. It is now open to the public as a house museum.

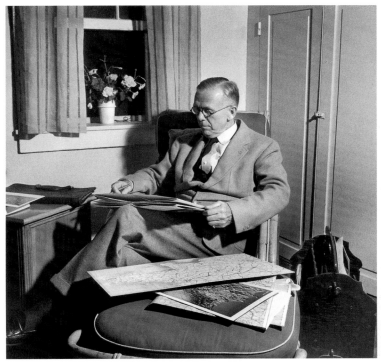

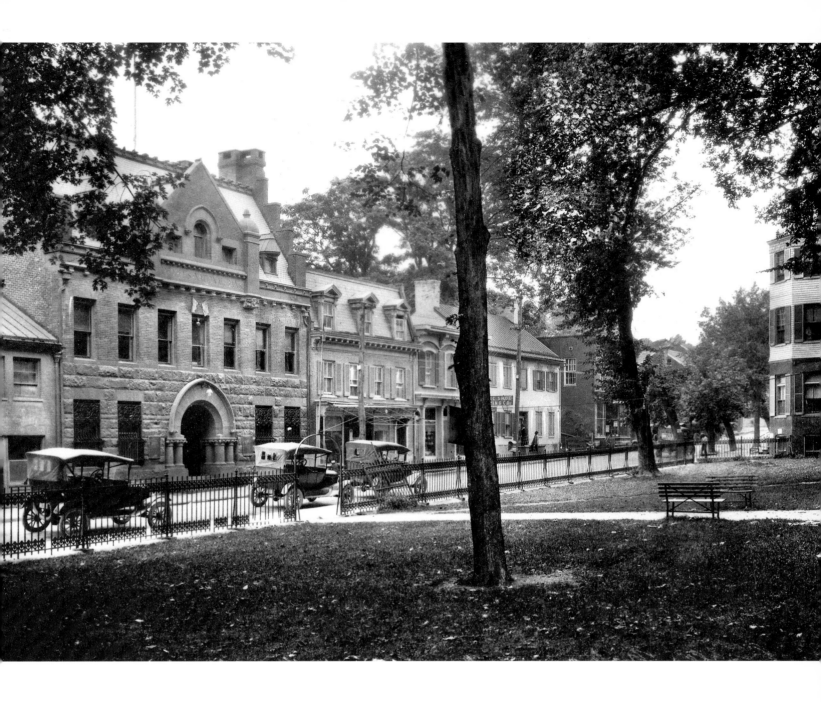

One of the most prominent commercial buildings in Leesburg is the People's National Bank (above) built in 1888 in the Romanesque Revival style. The stone façade was doubled in size in 1905 by architects Smithmeyer & Pelz of Washington, D.C., famous for their design of the Library of Congress. Many original details survive including the cast-iron window grills and the massive arched entrance framed by paired columns. The landmark has been used as a restaurant since 1999.

St. James's Episcopal Church (left), located at West Cornwall and Wirt Streets, was designed by Leon E. Dessez of Washington in 1892 and built in 1895. The building is Leesburg's best example of Romanesque Revival architecture with its massive three-story tower and asymmetrical rusticated stone façade. The nave has a distinctive hammer-beam ceiling and two important stained-glass windows, one by Louis Comfort Tiffany himself and one by his studio. A five-star banner hangs over the pew of General George C. Marshall, who was a member in the 1940s and '50s.

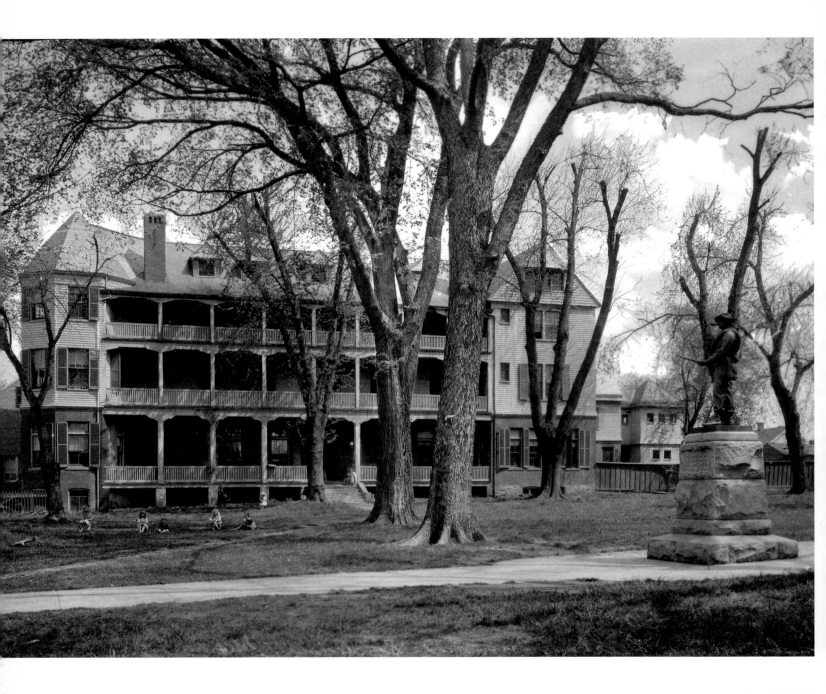

Built as a summer resort in 1889, the Leesburg Inn (above) remained open until 1953. The hotel, with its striking tiers of balconies, served as a social center for hunt breakfasts, wedding receptions, club meetings, bridge parties, dance lessons, and dinners. Loudoun County purchased the inn in 1953 and used it as office space until 1974, when it razed the landmark for the construction of a tall brick county office building. The latter is intrusive in the low-scale city.

The Loudoun County Courthouse (right), built between 1894 and 1898 in the Georgian Revival style, is the third courthouse on the site. The first was built in 1761, four years after Loudoun County was formed from Fairfax County, and the second in 1811. The Confederate Monument (opposite) was erected in 1908 in front of the third and present courthouse. The monument was designed by F. William Sievers of Richmond, who also sculpted the Virginia Memorial at Gettysburg and the Stonewall Jackson and Matthew Fontaine Maury statues in Richmond.

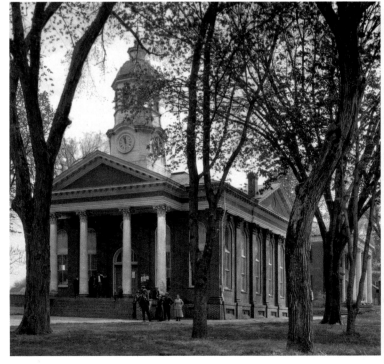

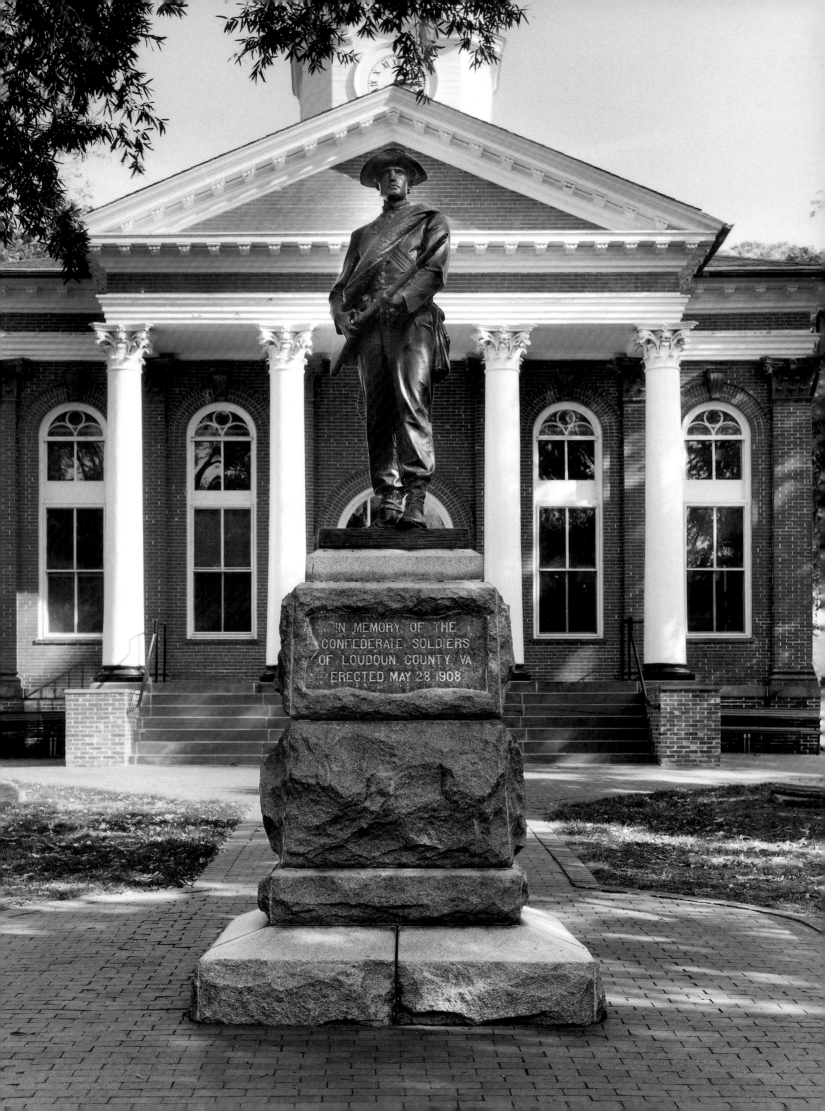

IN MEMORY OF THE
CONFEDERATE SOLDIERS
OF LOUDOUN COUNTY VA.
ERECTED MAY 28 1908

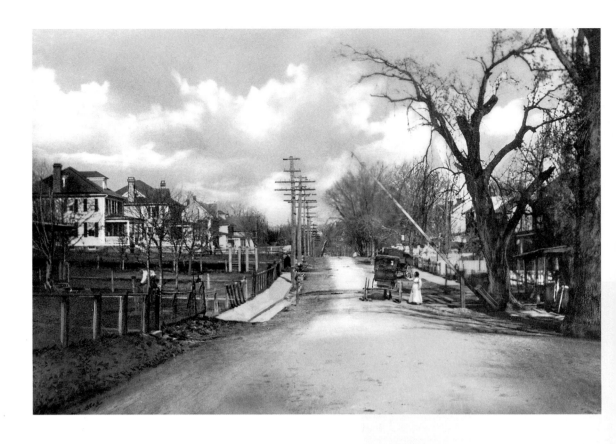

The photograph above, taken about 1915, shows a tollgate on South King Street in Leesburg, looking north. The present-day Safeway supermarket is just behind the camera's position; several of the houses on the left and right are still standing. In the early 1800s, turnpike companies, chartered by the state of Virginia, built a network of roads in Loudoun County for profit, the most important being the Leesburg Turnpike (Route 7) and the Little River Turnpike (Route 50). At tollhouses a pole or "pike" extended across the road that could be raised or turned, hence the term "turnpike." Turnpikes in Virginia were rarely profitable and all had become public roads by 1922.

The Mighty Midget Kitchen (opposite, top) has been a landmark in Leesburg from the time that Herman and Katherine Costello began operating it in 1947. It was one of hundreds of similar structures made in California of riveted aluminum from surplus B-29 bombers. When the first kitchen was destroyed in a car wreck in 1959, the Costellos brought a second one from Alexandria. After Mrs. Costello's death in 1989, the town of Leesburg acquired this six-by-eight-foot landmark, relocated it from near Dodona Manor, and currently rents it to a vendor who operates the kitchen at Harrison and Royal Streets.

One of Loudoun County's most important plantation houses is Belmont (right), located on the Leesburg Turnpike, six miles east of town. Ludwell Lee completed the five-part Federal-style brick house in 1802. His grandfather, Thomas Lee, had purchased the land from Lord Fairfax in 1728. It was here that Ludwell Lee entertained President John Quincy Adams and the Marquis de Lafayette on the latter's American tour in 1825. In 1995 the estate was developed for housing, and the mansion was restored for use as a country club.

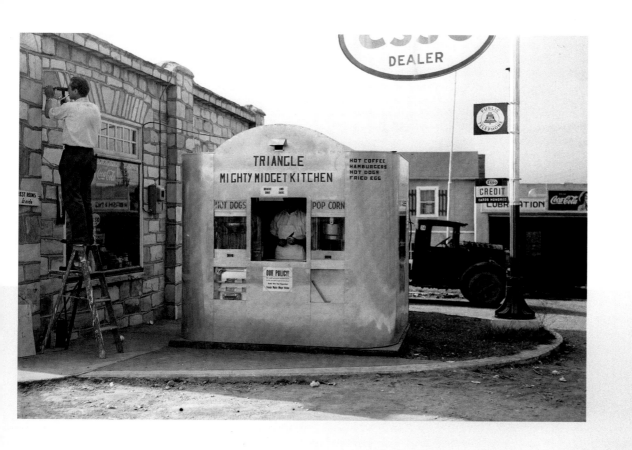

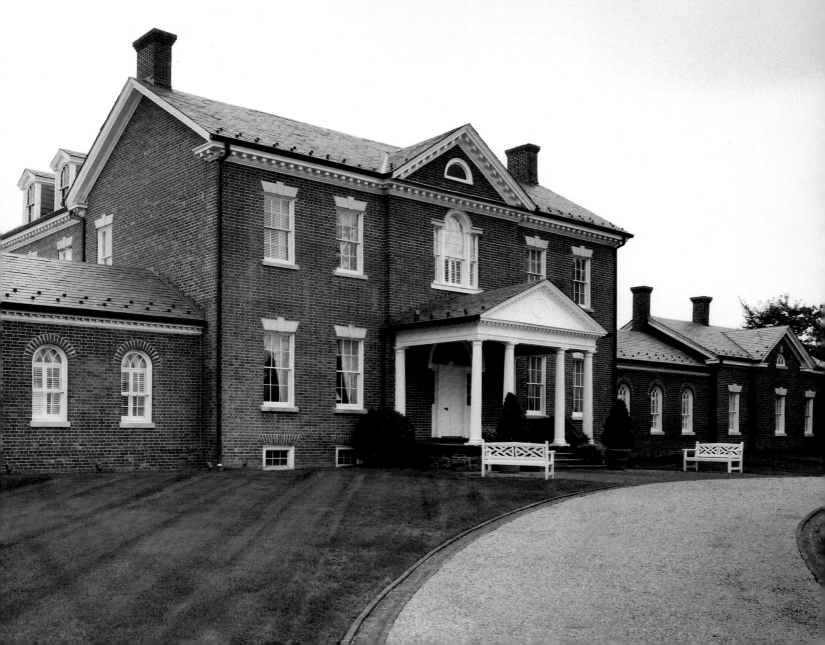

The Aldie Mill, seven miles south of Leesburg, operated from 1809 to 1971. Charles Fenton Miller built the mill with the labor of slaves, who fired the bricks and dug the millrace, which was two-thirds of a mile long and carried water from a dam on the Little River to the mill. On the left is the "merchant mill," where grain was ground in large quantities; most of it was shipped through Alexandria to markets on the eastern seaboard and overseas. On the right is the smaller "country mill," where farmers had grain ground for family use. Today the mill is managed by the Northern Virginia Regional Park Authority, and is open to the public.

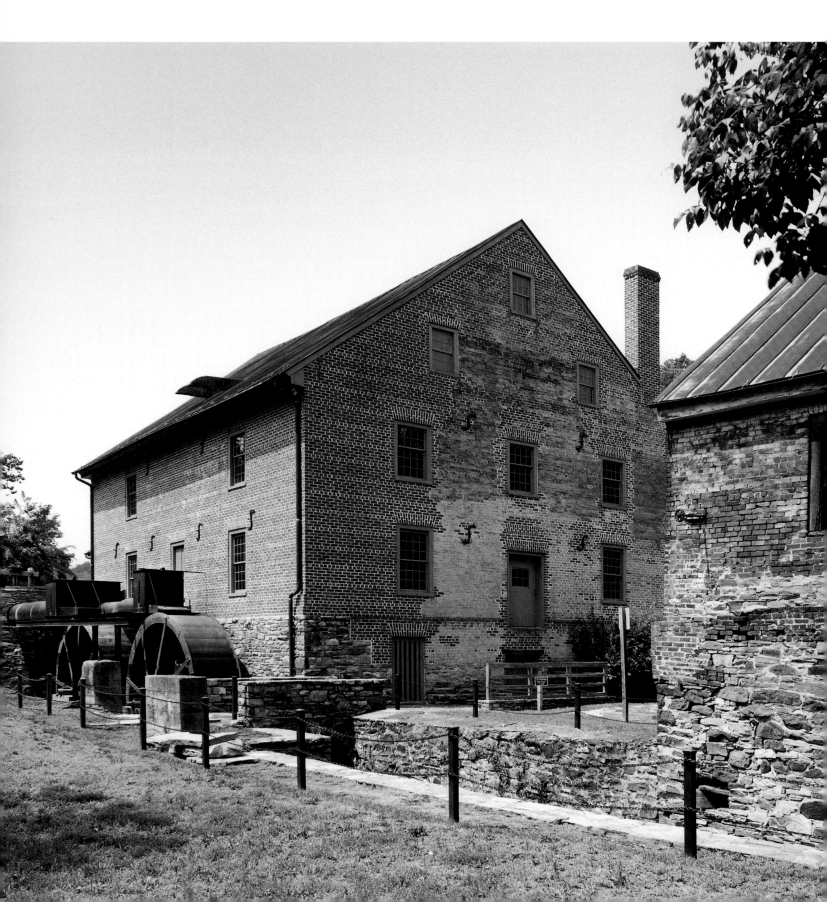

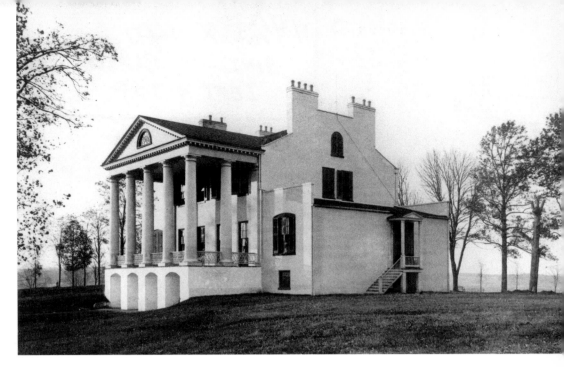

In 1794 the Monroe family acquired Oak Hill plantation (above), located near the village of Aldie. James Monroe (1758–1831), fifth president of the United States, built the main house in 1817–1823 and made it his family seat. James Hoban, the architect of the White House, contributed ideas for the design of Oak Hill. It was here that Monroe wrote the Monroe Doctrine in 1823, which warned European powers against future colonization in the Western Hemisphere. Monroe retired to the two-thousand-acre estate after leaving the White House and entertained the Marquis de Lafayette there in 1825. The main house, with expanded wings and a number of the original outbuildings, survives and is still privately owned.

George Carter began work on Oatlands in 1804 and completed it in the 1830s in the fashionable Greek Revival style (below). On 3,400 acres, he grew wheat, raised sheep, and operated a mill. By 1860 his widow, Elizabeth Grayson Carter, owned 128 slaves—more than on any other Loudoun plantation. After the war, the plantation gradually lost its profitability, and after operating it as a summer hotel for a generation, the Carters sold Oatlands in 1897. William Corcoran Eustis and Edith Eustis bought the house in 1903 and restored it; in 1964 their daughters gave it to the National Trust for Historic Preservation. Located six miles south of Leesburg on Route 15, it is now open to the public. Oatlands with its early 1900s garden is one of the most beautiful and best-preserved house museums in Virginia.

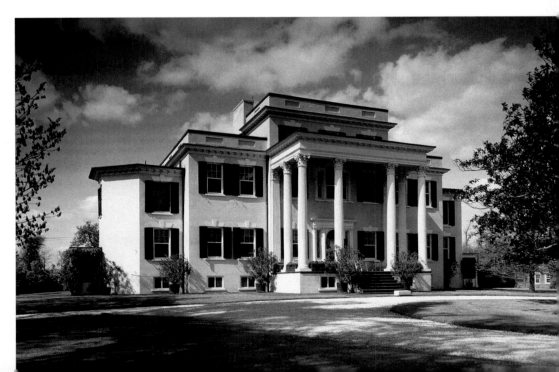

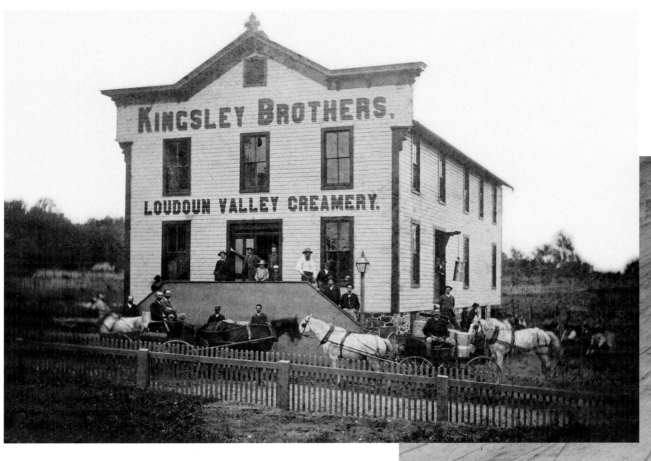

The remarkable photograph above from about 1885 shows the Kingsley Brothers' newly built Loudoun Valley Creamery building in Hamilton, Virginia. On the first floor, the company separated cream from milk and produced butter. The basement was rented out as a butcher shop and the town jail, while the second floor served as a public hall for oyster suppers, medicine shows, and early motion pictures. The picturesque structure was razed in 1900 for a gasoline-powered sawmill, which burned in 1913.

Camp Ordway (right), a temporary camp of tents erected on White's Farm on the Leesburg Turnpike 1½ miles east of town, housed members of the National Guard of Washington, D.C., for their eight-day annual encampment in June 1899. The group of a thousand men, some of whom had served in Cuba the year before during the Spanish-American War, arrived in three trains for drills, artillery practice, and training in marksmanship. Following a dress parade and a concert by the brigade band on the last day of the encampment, the ladies of the town entertained the men at a ball at the Leesburg Inn, while the officers attended a dance at the Titus farmhouse.

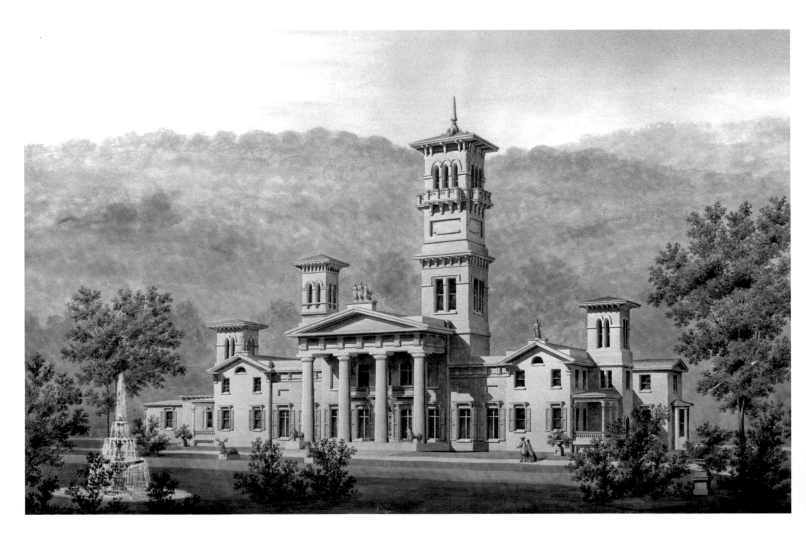

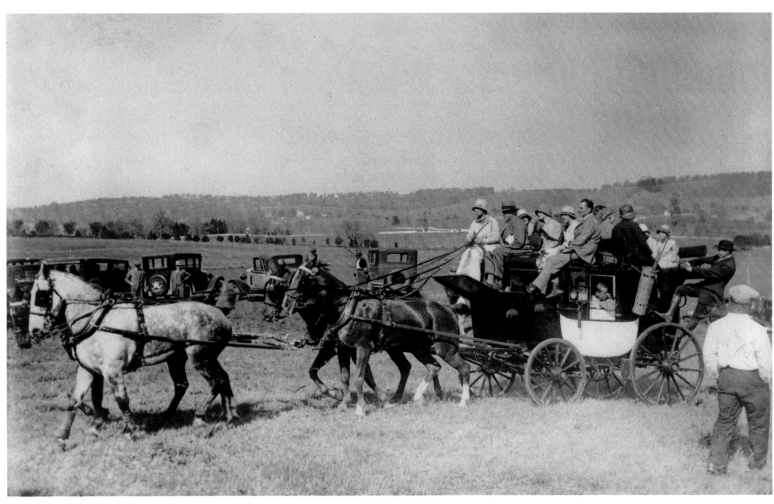

Morven Park (opposite, top), one mile northwest of Leesburg, was originally built about 1750 as a simple farmhouse. It was expanded and remodeled as an Italianate mansion just before the Civil War. A later owner remodeled it again, in the neoclassical style, shortly before West-moreland Davis bought the house in 1903. Davis, born in Richmond, left there literally in his mother's arms as she fled the burning city at the end of the Civil War. He made his fortune in New York but returned to his native Virginia and entered politics as a champion of the farmers. During the years that they lived on the 1,200-acre estate, Governor Davis and his wife, Margaret Inman Davis, held many fox hunts and carriage meets (opposite, bottom, and below). After his death, his widow gave the house to a private foundation, which opened it to the public in 1967. Besides the historic house itself, the estate now includes a fox-hunting museum, a carriage museum, and an equestrian center with many public events including coach-driving meets.

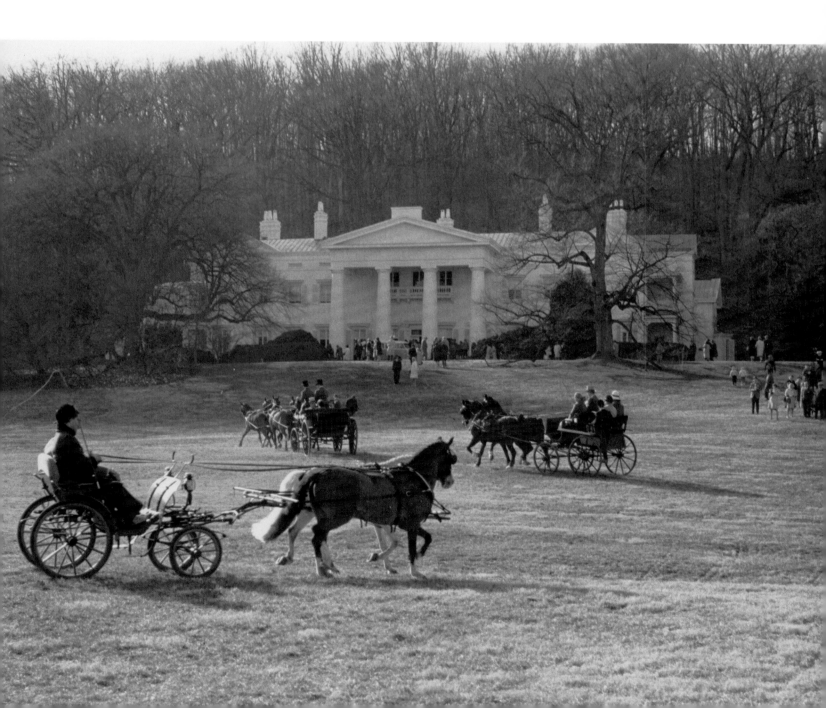

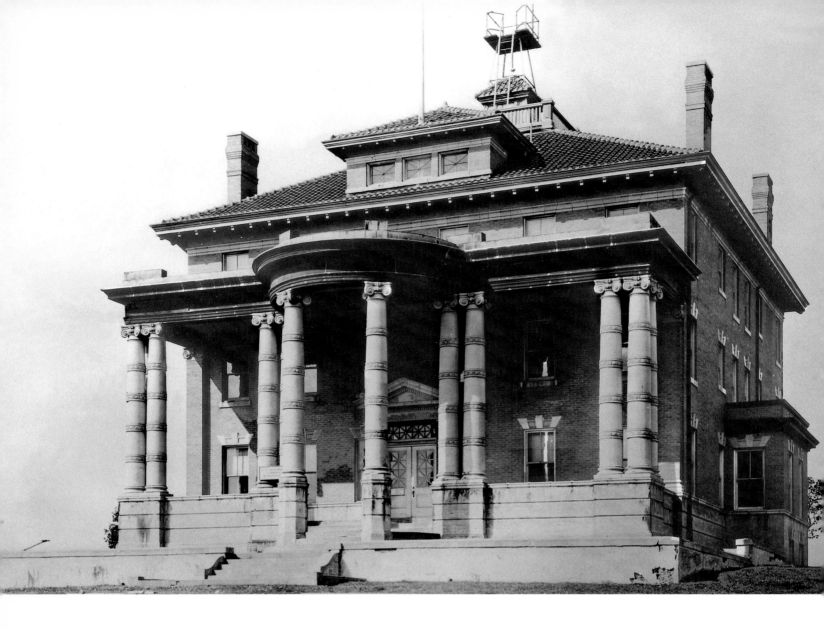

In 1902 the federal government established a weather station on a mountaintop at the western edge of Loudoun County. Shown above is the administration building built in 1909. The Weather Bureau conducted atmospheric research with kites and balloons, and in 1907 set a world altitude record for a kite: 23,110 feet above sea level. President Calvin Coolidge considered using Mount Weather, as it was known, as a summer White House. During the Cold War, a massive bunker was constructed inside the mountain as a potential wartime refuge for the president. FEMA continues to maintain this facility.

The Corner Store in Waterford, Virginia (opposite, top), was built about 1900 at the center of the village. The 1912 Cadillac automobile in the foreground belonged to Robert Walker, president of the People's National Bank in Leesburg. Walker lived on High Street in Waterford and used his car to commute to work. At the time, Waterford was a sleepy village—long overlooked by the march of progress—which preserved most of the early nineteenth-century buildings. In the 1930s restoration of the first houses began, and in 1943 the Waterford Foundation was created to preserve the entire town.

A labor shortage occurred on Loudoun County farms (opposite, bottom) during World War I when hundreds of young men were drafted into the army. Many women were hired to do work formerly reserved for men; these Loudoun County high school girls were recruited in 1918 to harvest peaches near Purcellville. During World War II, German prisoners of war, held in a camp near Leesburg, were assigned to the same task.

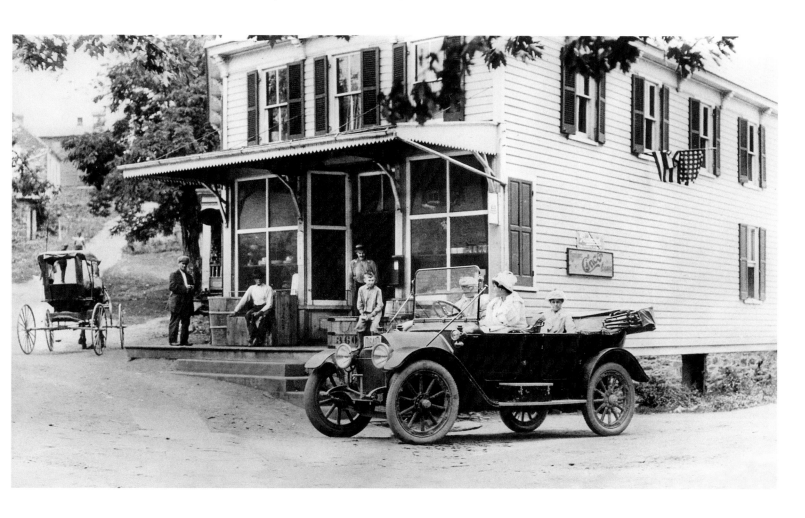

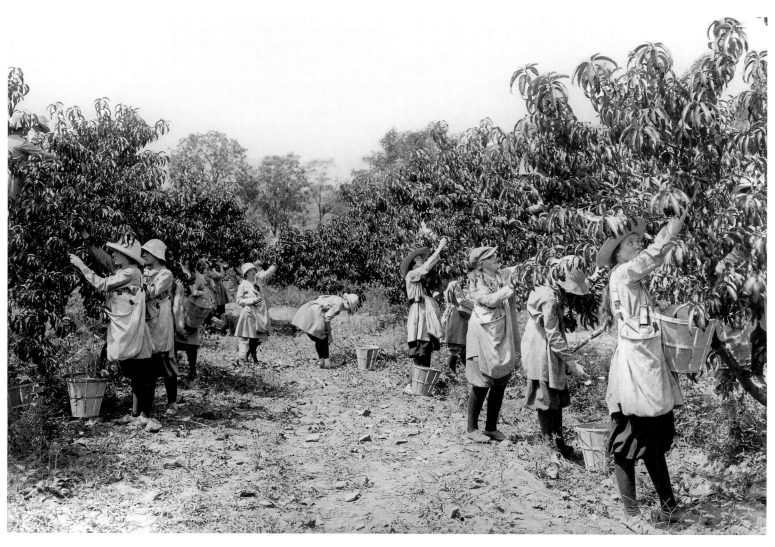

Purcellville was established in 1822 when storeowner Valentine V. Purcell was appointed post-master of "Purcell's Store." The village, renamed Purcellville in 1854, was occupied during the Civil War by both sides. With the arrival of the Washington & Old Dominion Railroad in 1874, farm produce could be conveniently transported to the port of Alexandria. Likewise, milk could be shipped to Washington fast enough to prevent its spoilage, and nearby dairy farms grew in number. The main street of Purcellville, shown in the 1935 photograph below, remains almost unchanged today. Only the gas pumps and the Buick dealership on the left have disappeared.

The Nichols family has owned and operated the Nichols Hardware store in Purcellville (opposite, top) since it was founded by Edward Enoch Nichols Sr. in 1914. The Nichols were farmers in Loudoun County and members of the Goose Creek Friends Meeting in the nearby village of Lincoln. Very little of the interior has changed, with rows of wooden shelves housing everything from milk pails to buggy whips. A 2001 photograph (opposite, bottom) shows the staff holding objects for sale in the store. Proprietor Ted Nichols at center was a grandson of the founder.

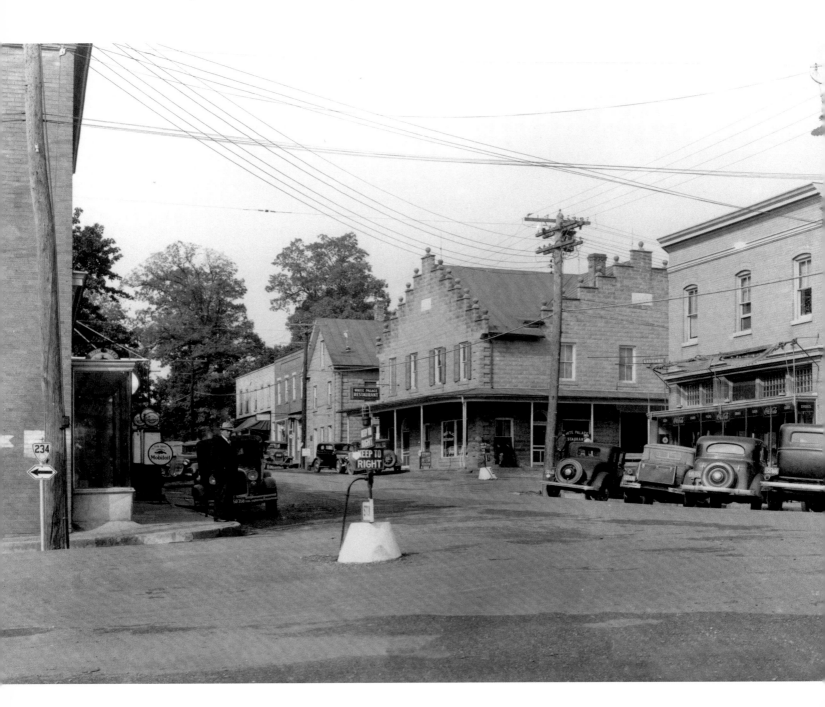

In June 1945 a German prisoner-of-war camp (above) was established on the Moss Farm southwest of Leesburg. Trucks transported a group of 150 prisoners daily to local farmers to help harvest their crops. Many POWs also worked at apple-packing plants where they were paid thirty-seven cents an hour. The war in Europe was already over by the summer of 1945, and the prisoners were returned to Germany that November.

The Red Fox Inn (opposite, top), in Middleburg, was built in 1827 by the aptly named Noble Beveridge. The hotel, which stands at the corner of Washington and Madison Streets, was originally called the Mansion House. It was renamed the Beveridge Inn in 1897, then the Middleburg Inn, and finally the Red Fox Inn after a major renovation in the late 1930s. Colonel Levin Powell, a local plantation owner and veteran of the American Revolution, established Middleburg in 1787 and laid out a hundred half-acre lots. The town was named Middleburg because it was halfway on the road between Alexandria and Winchester.

Shortly after John F. Kennedy was elected president in 1960, his father rented Glen-Ora for JFK and his family. The house stood on a three-hundred-acre estate two miles from Middleburg in Fauquier County. For several years they used it as a retreat—especially Jackie, who loved horses and had been an accomplished rider since childhood. Like Jackie, President Ayub Khan of Pakistan was an avid equestrian. In 1962 he presented her with a fine horse, Sardar, and she became immediately attached to it. Khan and the First Lady are pictured (opposite, bottom) with Sardar at Glen-Ora.

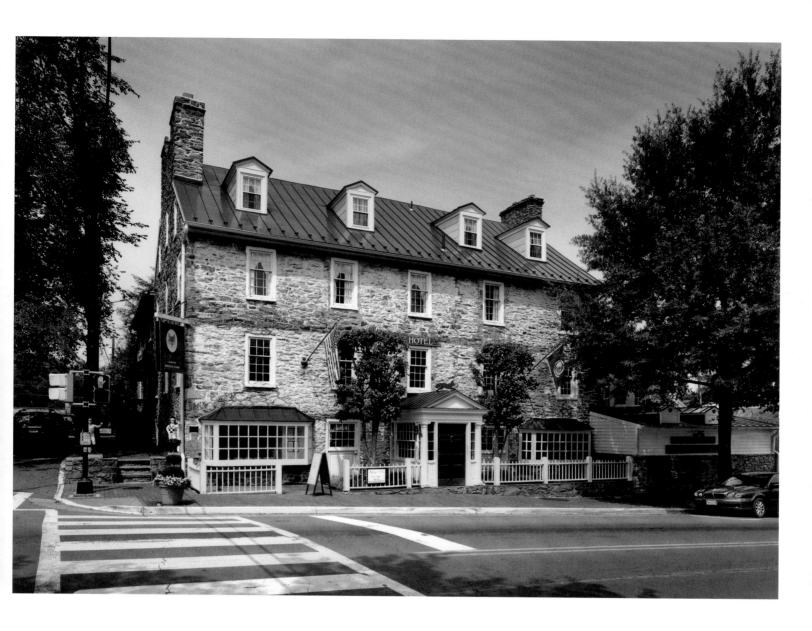

Finnish architect Eero Saarinen (above) died in 1961 at age 51 and didn't live to see the completion of his masterwork, the Washington Dulles International Airport (right). Saarinen, one of the most prominent architects of his time, considered the airport his best work. In the photograph above he appears inside a large model of the terminal, which he compared to "a huge continuous hammock suspended between concrete trees." The airport, located on the eastern edge of Loudoun County, opened in November 1962. It was named for John Foster Dulles, secretary of state under President Dwight D. Eisenhower.

The Loudoun County 4-H Club established an annual fair in 1935 to exhibit livestock, crops, and homemaking skills. Originally located in Purcellville, the fair moved several times before acquiring a permanent facility in 1957 at Clark's Gap. The photograph below from the 1960s shows prize-winning Hampshire sheep. In 2002 half of the land in Loudoun County was still agricultural, with 1,500 farms in operation.

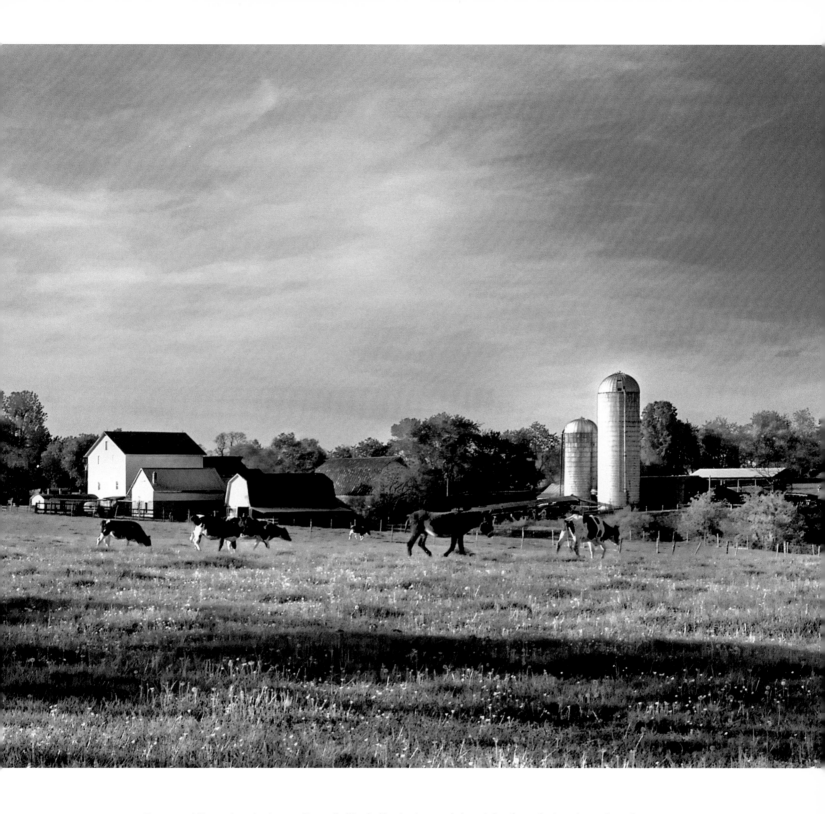

Dogwood Farm, located near Purcellville, is the last remaining dairy farm in Loudoun County. The Potts family has owned and operated the dairy farm for five generations. In 1954, when Loudoun County had 376 dairy farms, it was the largest dairy-producing county in Virginia. The dramatic decline is mostly the result of suburban development.

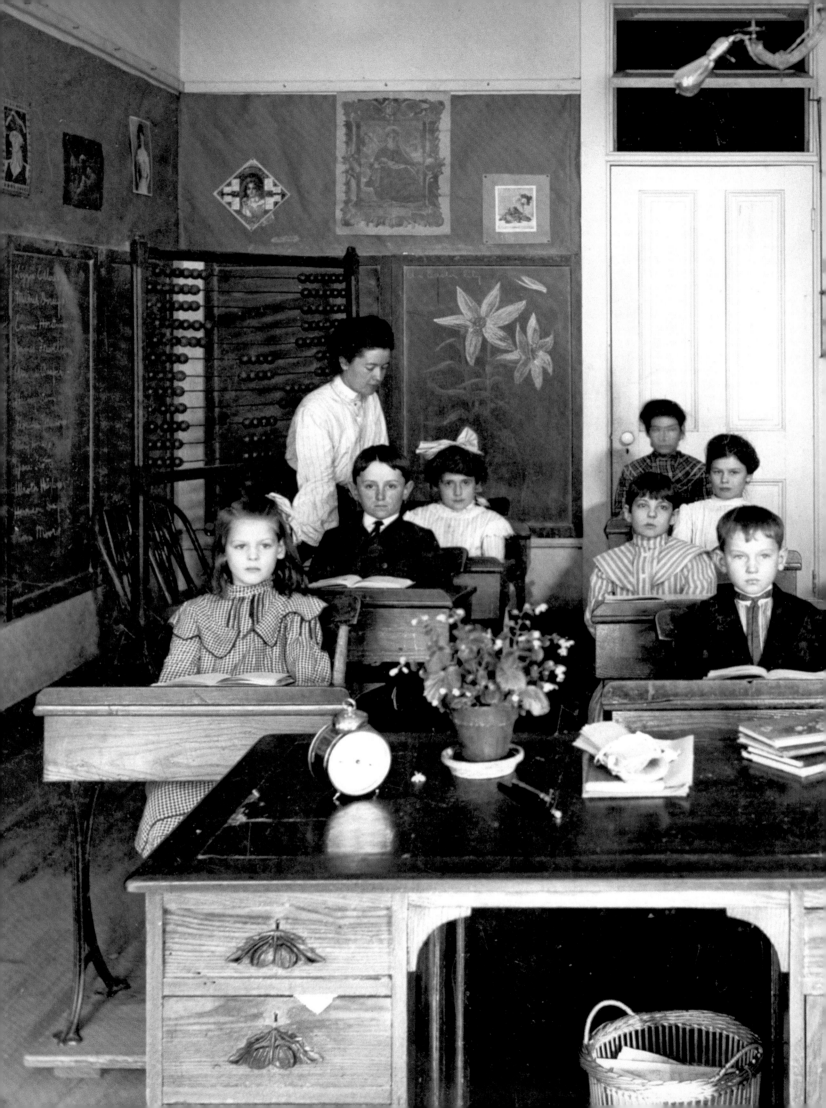

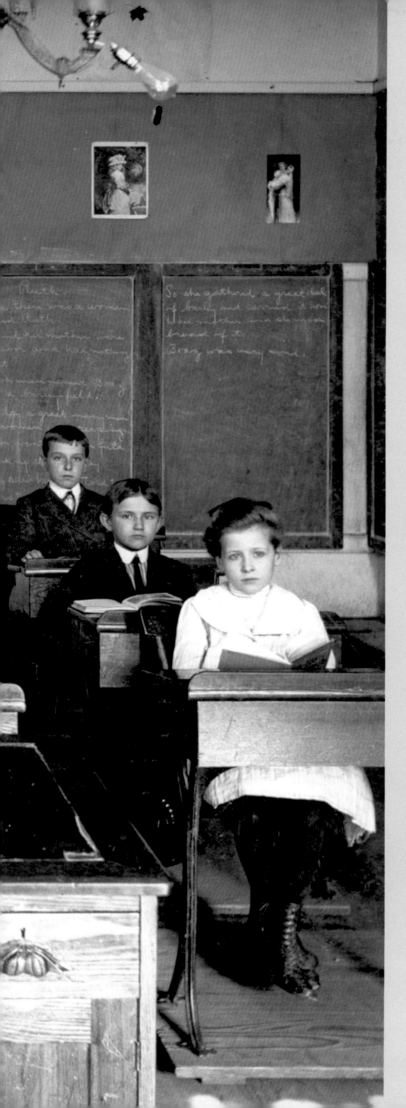

# FREDERICK COUNTY, MARYLAND

The Maryland School for the Deaf opened in 1868 on the east side of Market Street in Frederick. This photograph shows a classroom circa 1902. Today, the school has more than four hundred students from pre-kindergarten through grade 12.

EUROPEANS FIRST SETTLED Frederick County, Maryland, in the 1720s, '30s, and '40s. Many were of English origin from southern Maryland, while others were Germans who migrated down from Pennsylvania. In 1745 Daniel Dulany (1685–1753) established the town of Frederick, laying out 144 lots on Carroll Creek. Dulany was a native of Ireland who emigrated to Maryland in 1703 as an indentured servant, and later became a prominent lawyer and served in the Maryland General Assembly. As a land speculator, in 1744 he acquired a 7,500-acre tract known as Tasker's Chance, which includes the present-day city of Frederick. Dulany then established "Frederick Town," as it was originally known, probably named for Frederick Calvert, sixth Lord Baltimore.

In 1748, Frederick County was formed from part of Prince George's County, and Frederick Town became the county seat. The county originally included most of western Maryland, and as Frederick was the most important town there, it grew rapidly. By 1775, at the start of the American Revolution, Frederick Town had two thousand residents and was the second largest city in Maryland, after Annapolis.

Since its earliest days, Frederick County has been a transportation hub. The National Road, begun in 1811, ran from Cumberland, Maryland, to Vandalia, Illinois. By 1824 private turnpikes connected it to Frederick and on to Baltimore. It was the first federally funded interstate highway and became an important route for western settlement and trade before the rise of railroads. The National Road through Frederick County survives today as Route 144 and Alternate 40, and one of the stone mileposts can still be seen on East Patrick Street in Frederick.

The Potomac River forms the southern boundary of Frederick County and, although it is not navigable, it offered an easy passageway through the mountains from Washington, D.C., to Cumberland, Maryland, for both the Chesapeake & Ohio Canal and the Baltimore & Ohio Railroad. Both the canal and

the railroad were begun on the same day: July 4, 1828. The canal was never a financial success, however, due to competition from the railroad, and it closed in 1924. It remains the best-preserved historic canal in the country and is now a national park.

The Baltimore & Ohio Railroad was one of the nation's first railroads—the freight depot in Frederick, built in 1831, was one of the oldest in the world when it was demolished eighty years later. The town of Brunswick, on the Potomac, grew up as a railroad town where cars and engines were serviced, and there was a vast switching yard. The Baltimore & Ohio was absorbed by the CSX Railroad in 1987, but its tracks are still in use today.

During the Civil War, Maryland remained in the Union, although the loyalties of its citizens were mixed. Confederate troops invaded the county several times, culminating in the battles of Antietam (1862) in adjacent Washington County, Maryland, and Gettysburg (1863), just across the state line in Pennsylvania. Just to the east of the city of Frederick, Union and Confederate forces clashed on July 9, 1864, at the Battle of Monocacy. Although it was a relatively minor battle, Union troops delayed Confederate General Jubal Early's attack on Washington by one day, permitting reinforcements to be gathered, saving the city.

Frederick County has always been largely agricultural, and it is still one of the top dairy-producing counties in the United States. The largest employer in the county is Fort Detrick, an army base best known historically as the home of the United States' biological weapons program. At one time, there was an interurban trolley network joining Frederick with Hagerstown and Thurmont, and railroads connected Frederick County to the wider world. The trolley line shut down when it could not compete with private automobiles and buses in the 1920s and '30s, and nowadays interstate highways have taken its place. Today Frederick County is increasingly becoming a bedroom community to Washington, D.C., and Montgomery County.

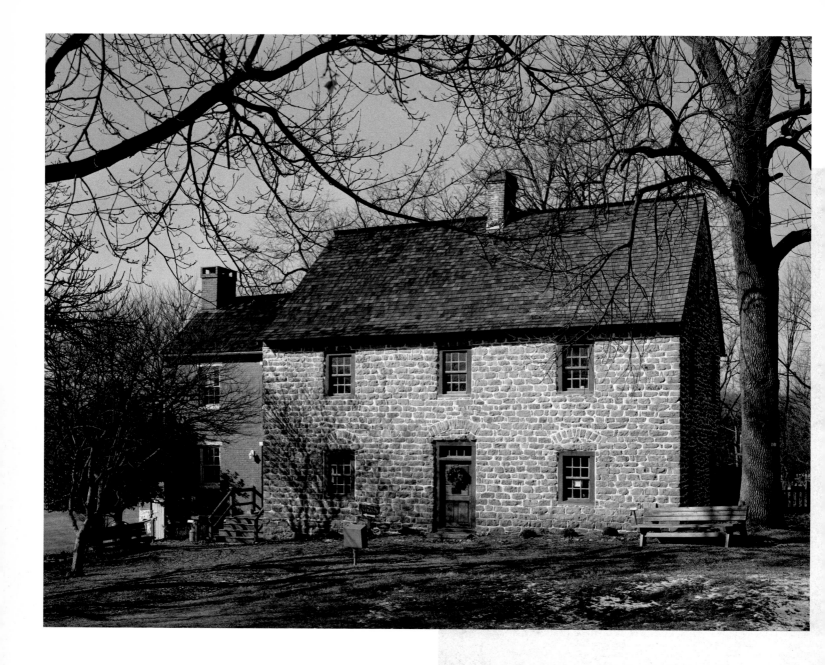

Schifferstadt (above) is the oldest house in Frederick. It was built by Elias Brunner, the son of an immigrant from Germany, and completed around 1756. It is said to be the largest and best-preserved German colonial house in America. Much of the structure is original, including the doors, the elaborate iron hardware, and even the paint in a few places. The house has a five-plate iron stove dated 1756. These stoves were common in colonial America, but the stove in Schifferstadt is the only one in the United States that is still in its original location.

The Hessian Barracks (right), on the campus of the Maryland School for the Deaf in Frederick, were built around 1777 to house American troops during the Revolutionary War; Hessians, German mercenaries who fought for the British, were held there as prisoners of war. The barracks were part of a hospital during the Civil War, and in 1868 became home to the Maryland School for the Deaf (the building with the tower). This photograph, circa 1873, shows a new school building to the right of the barracks; the far left building was demolished in 1874.

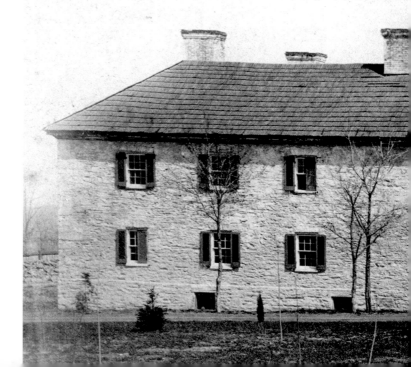

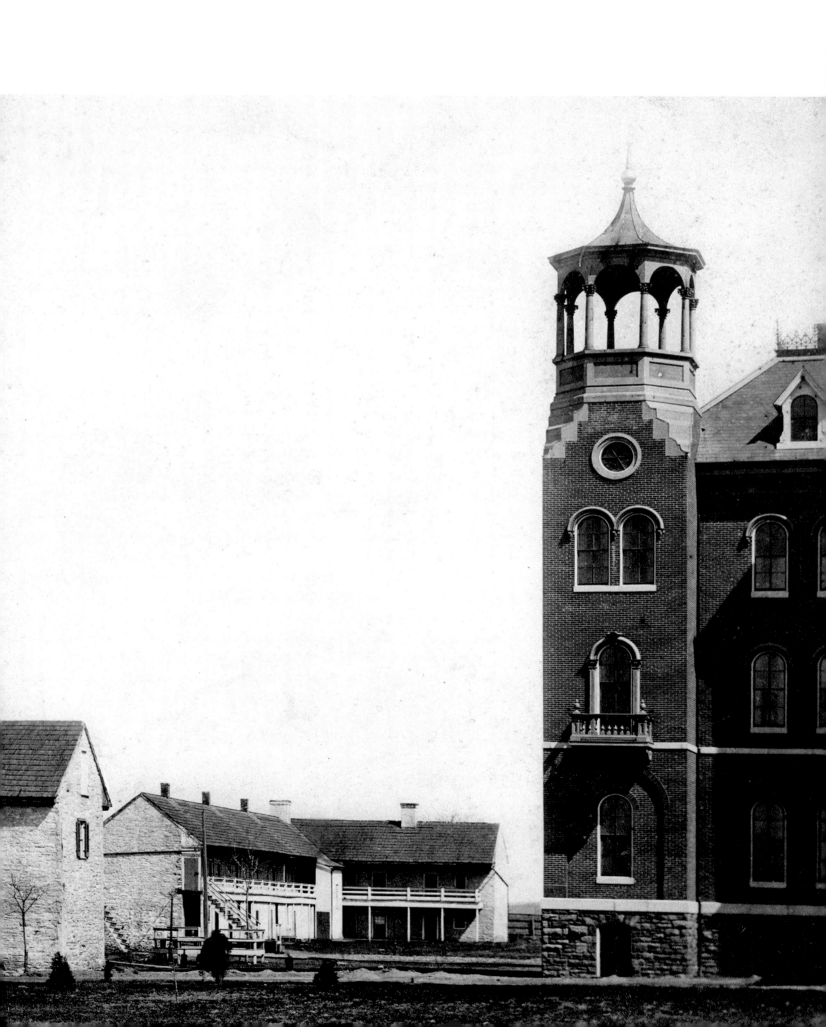

Thomas Johnson (1732–1819) gave Rose Hill, a 225-acre tract near Frederick, to his daughter Ann as a wedding present in 1788. She and her husband, John Grahame, built the manor house at right in the early 1790s. Johnson was one of the nation's Founding Fathers: he served in the Continental Congress and, from 1777 to 1779, as the first governor of Maryland. In 1791 Johnson was appointed to the U.S. Supreme Court but resigned soon after because of poor health. He was also one of the original District of Columbia commissioners appointed by President George Washington to lay out the federal city. Johnson retired to Rose Hill and lived there with his daughter until his death. Today Frederick County operates the house as a children's museum.

Colonel John McPherson built the Federal-style house below at 105 Council Street in Frederick in 1817. McPherson had a financial interest in the Catoctin iron furnace near Thurmont, and the iron fence is said to have been cast there. In 1824, when the Marquis de Lafayette visited Frederick on his triumphant tour of the United States, McPherson entertained him here. In 1835 McPherson's son sold the house to Eleanor Potts. She was a cousin of Francis Scott Key, who was a frequent visitor. The house passed down through her family for 160 years, until Charles W. Ross IV sold it in 1995.

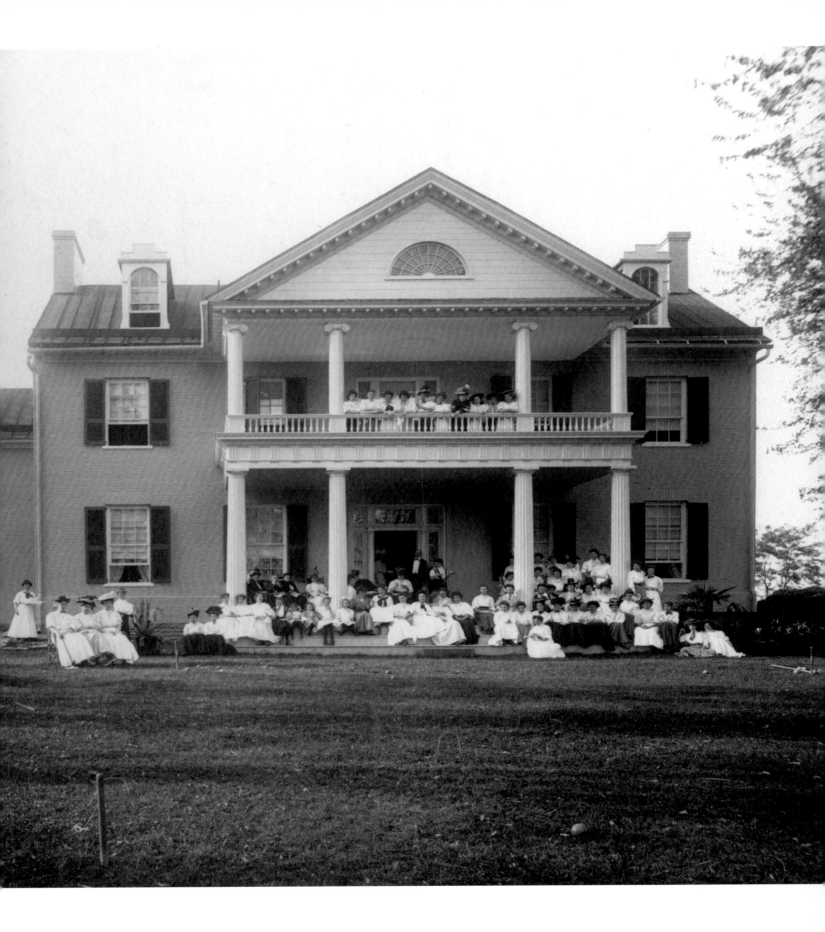

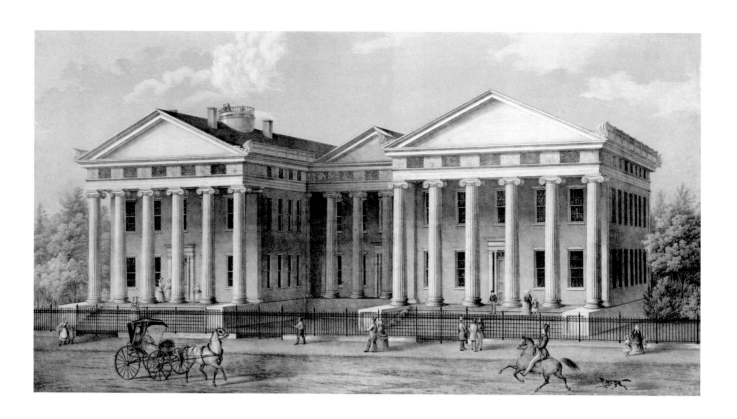

The building on East Church Street that once housed Frederick Female Seminary (opposite, top), seen about 1856, remains an important local landmark. The school opened in 1845 as a college for women. It was defunct by 1897, and the building became home to the Woman's College of Frederick (the present-day Hood College). After Hood moved to a new campus, the Frederick County government acquired the building, and today it is the principal county office building.

The Frederick County Courthouse (opposite, bottom) was constructed in 1862 to replace a previous structure destroyed by fire. After the county built a new courthouse nearby in 1982, the city of Frederick renovated the older building, and it now serves as city hall. Daniel Dulany established Frederick Town, as the city was originally known, in 1745.

The Maryland School for the Deaf (above) opened in 1868 on the east side of Market Street in Frederick. It originally occupied two stone barracks built during the Revolutionary War. This building was completed in 1875 and housed the school for many years. "Old Main," as it was known, was demolished in the 1960s to make room for more modern facilities.

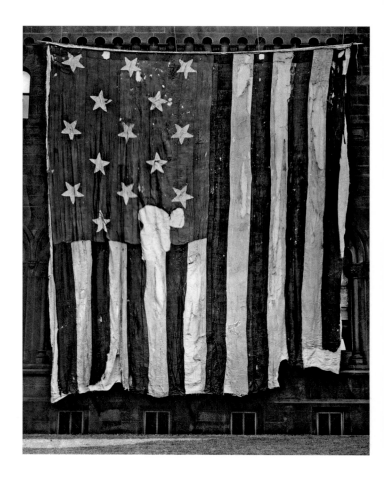

Francis Scott Key (1779–1843) is famous as the author of the poem "The Star-Spangled Banner," which later became the national anthem of the United States. Key was born at Terra Rubra, the family estate near the present Frederick-Carroll county line, and he practiced law in Frederick for a few years before moving to Georgetown, D.C. In 1898 a monument (above) was erected in Mount Olivet Cemetery in Frederick. Key's remains are in the base. The flag that inspired the poem (top right) is shown hanging from the roof of the East Range of the Smithsonian Institution Castle in order to be photographed in 1907.

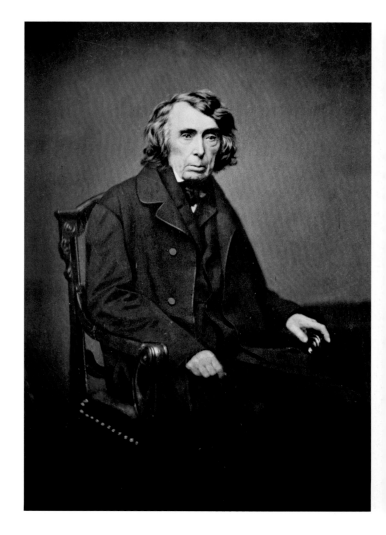

Roger Brooke Taney (1777–1864) (bottom right), a chief justice of the U.S. Supreme Court, lived in Frederick from 1801 to 1823. He married Ann Key, a sister of Francis Scott Key, who also lived in Frederick. Taney was a well-regarded jurist but he damaged his reputation with the Dred Scott decision, which negated the Missouri Compromise and ruled that slaves were not citizens, helping lead the country to the Civil War. Taney's house is long gone, but a house that he owned and rented out still stands in Frederick and is now a museum.

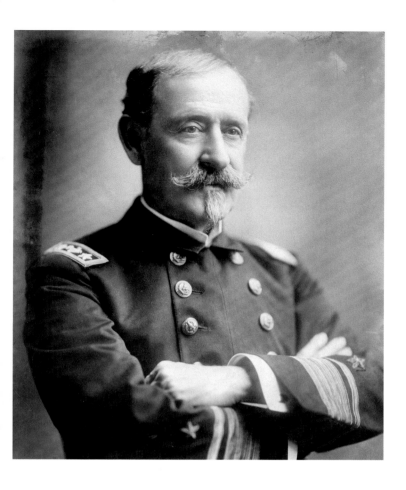

Admiral Winfield Scott Schley (1839–1911) (left) was a naval hero of the Spanish-American War and one of Frederick County's favorite sons. He was born at Richfield, the family home near Frederick, and attended school in the city. Schley graduated from the U.S. Naval Academy in 1860, served in the Civil War, and had a distinguished career. In 1884 he led an expedition that rescued explorer Adolphus Greely in the Arctic. He is most famous for destroying the Spanish fleet at Santiago de Cuba in 1898; his flagship in that battle, the USS *Brooklyn*, is shown below.

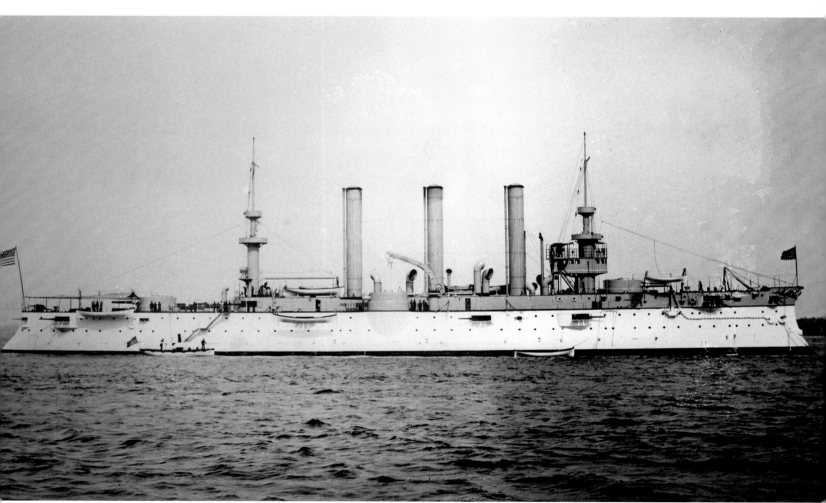

The view below is looking south on Market Street from Second Street. A temporary arch welcomes firemen attending the 1903 Maryland Firemen's Convention, sponsored that year by the Junior Fire Company of Frederick. Today Market Street is the center of a vibrant historic district that draws thousands of visitors with restaurants, cafés, antique stores, and specialty shops.

Hood College was established in Frederick in 1897 and was originally located on East Church Street near the center of town. In 1914 construction began on Alumnae Hall (opposite, top), located on a large tract on the outskirts of the city. In a circa 1950 photograph (opposite, bottom), two young women study in their room in Coblentz Hall. Cadets from the U.S. Naval Academy at Annapolis often visited this women-only college for dances, so the pennant on the doorframe is likely a souvenir from a boyfriend. Men were first admitted to the college in 1971, and today Hood has a fifty-acre campus with 1,500 undergraduate and 1,000 graduate students.

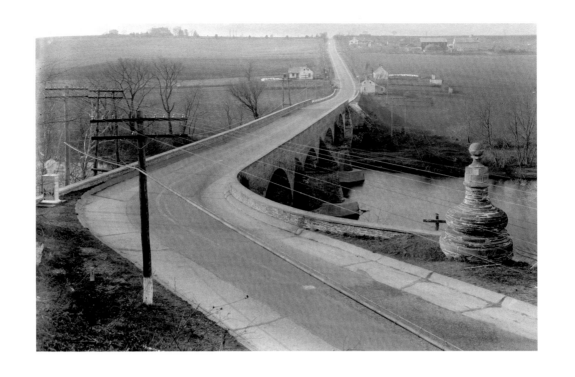

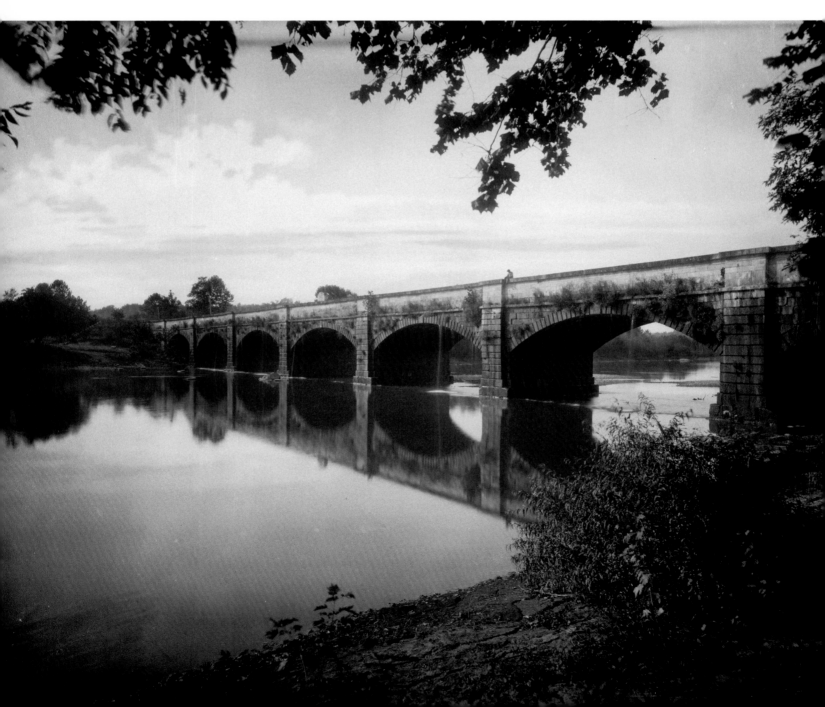

Jug Bridge (opposite, top) was built as a turnpike (now Route 144) over the Monocacy River and connected Frederick to the National Road in Cumberland, Maryland. The federal government built the National Road, starting in 1811, to facilitate commerce and settlement in the era before railroads. Eventually the road stretched from Cumberland to Vandalia, Illinois. Privately financed turnpikes extended the National Road east to Baltimore. The bridge collapsed in 1942 and was replaced with a modern bridge. The large decorative "jug" was moved to a park in Frederick in the 1960s.

The Monocacy Aqueduct (opposite, bottom) once carried the Chesapeake & Ohio Canal across the mouth of the Monocacy River—it held a water-filled trough, now dry, that allowed canal boats to avoid the currents of the river. The aqueduct, completed in 1833, is 516 feet long and one of the most impressive structures on the 184-mile-long canal. In 1924 a flood damaged the canal, and it was abandoned. The federal government bought the waterway during the Great Depression, and in 1971 it became a national park. The Monocacy is the largest river in Frederick County and empties into the Potomac River near Dickerson.

A 1947 photograph (above) shows the construction of the million-liter steel sphere at Fort Detrick (then Camp Detrick) on the north side of Frederick. The "eight ball," as it was known, was used for testing biological weapons, and its vast size allowed the accurate simulation of wind currents. In 1969 President Richard Nixon banned the production of offensive biological weapons, but research into bio-defense continues at Fort Detrick. Today Fort Detrick is the largest employer in Frederick County, and the sphere is on the National Register of Historic Places.

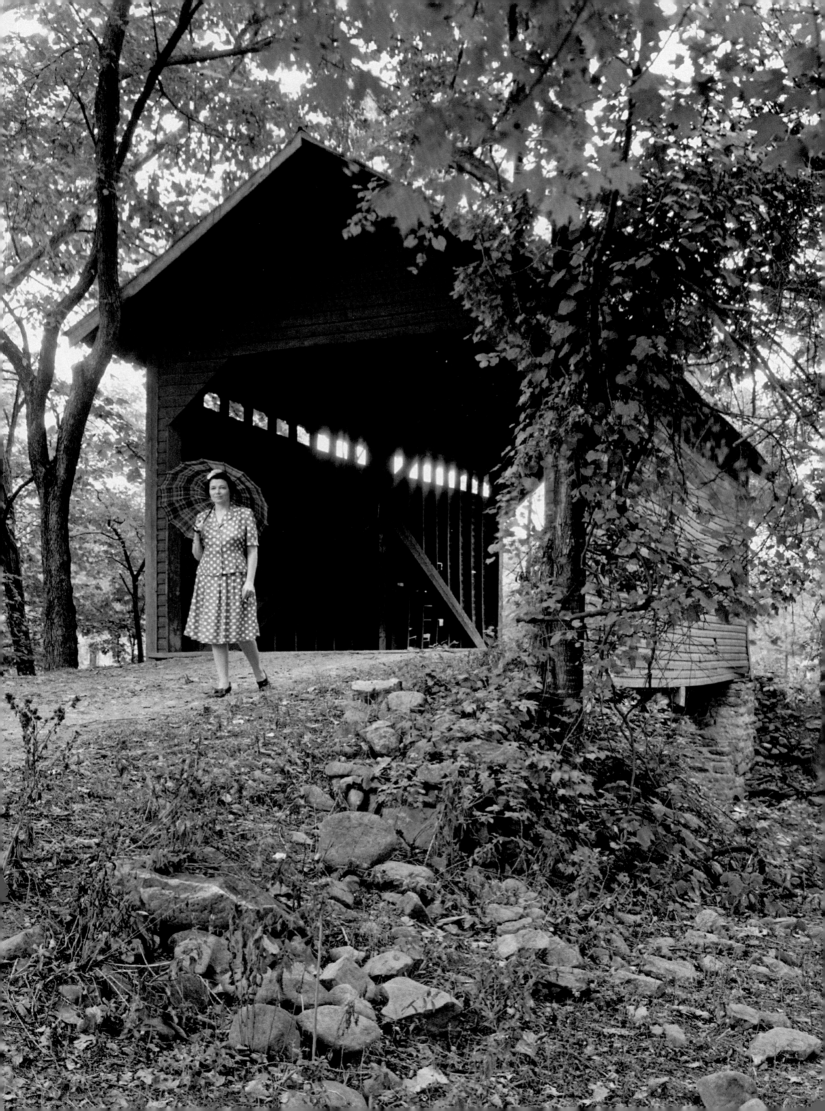

The Roddy Road covered bridge (opposite), built in the 1850s, crosses Owens Creek about a mile north of Thurmont. It is only forty feet long, the shortest of the three remaining covered bridges in Frederick County. There were at least ten others in the county. Some were burned during the Civil War, while the rest were replaced with more modern spans. The shed-like covering protects the supporting timbers from decay, but the bridges are vulnerable to fire.

Madeleine Vinton Dahlgren, a devout Catholic, built Dahlgren Chapel (below) in 1881 for her family. She was the widow of Rear Admiral John A. Dahlgren, who invented the famous Dahlgren gun used on the USS *Monitor* during the Civil War. The Gothic chapel is built of stone quarried nearby and finished with walnut paneling, marble floors, and stained glass. It is located in Turner's Gap on South Mountain, at the western edge of Frederick County. This spot was the site of a fierce battle during Robert E. Lee's 1862 invasion of the North in the Civil War, which led to the Battle of Antietam. The Appalachian Trail, stretching from Maine to Georgia, passes only a few feet from the chapel.

James H. Gambrill erected this seventeen-room mansion (right) around 1872, and it is one of only a few large Second Empire–style houses ever built in Frederick County. Gambrill owned a mill nearby, a large operation that was the source of his wealth. During the Civil War, Union and Confederate troops clashed here at the Battle of Monocacy, and the mill served as a field hospital. The Gambrill tract is now part of the Monocacy National Battlefield Park, and the house is used by the National Park Service as a training center for historic preservation.

The War Correspondents Memorial Arch (below) stands in Crampton's Gap, on South Mountain, at the western edge of Frederick County. George Alfred Townsend erected the arch in 1896, and it bears the names of 157 Civil War correspondents. Townsend, a prominent journalist, owned an estate on this site, which became a state park in 1949. Crampton's Gap figured prominently in General Robert E. Lee's 1862 invasion of Maryland, which led to the Battle of Antietam in nearby Washington County.

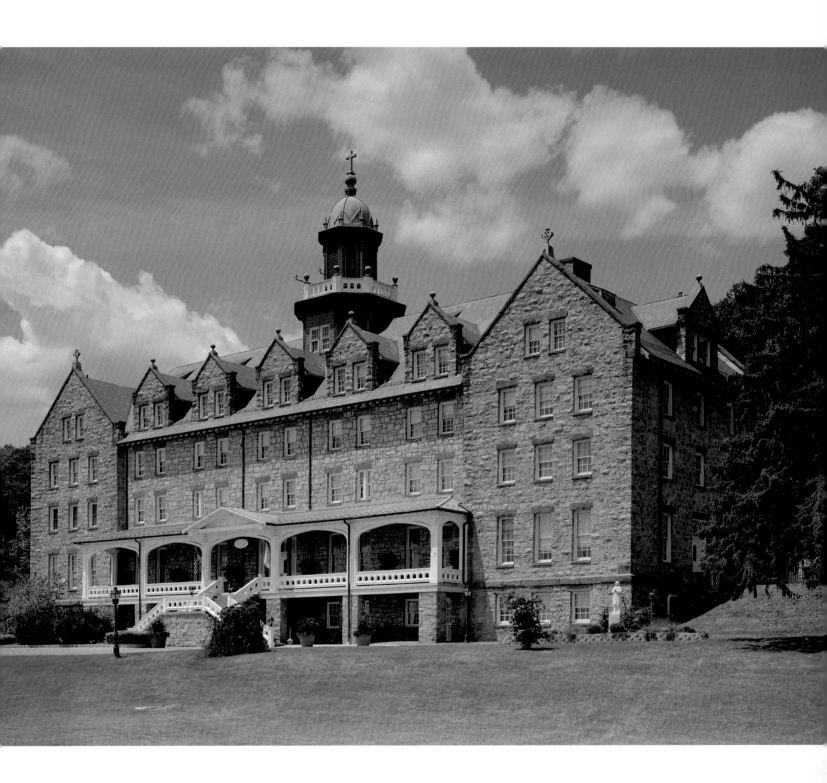

Father John DuBois founded the college and seminary of Mount St. Mary's in 1808, and it is now the second-oldest Catholic university in the United States. "The Mount" is located at the foot of a mountain near Emmitsburg, Maryland, less than three miles from Pennsylvania. The photograph above shows McSweeny Hall, the main building of the seminary, which dates from 1906. Mount St. Mary's is the second-largest Catholic seminary in the country, with 145 seminarians; the university has 1,800 students.

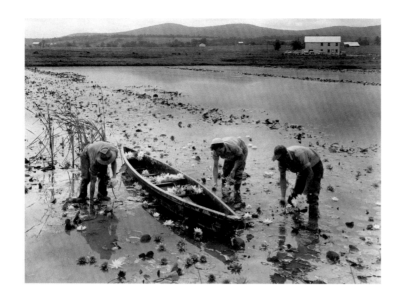

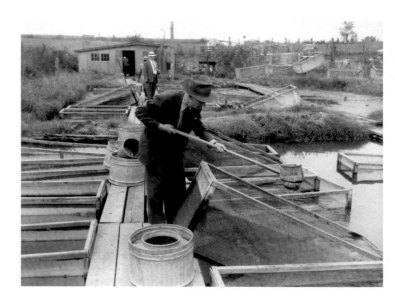

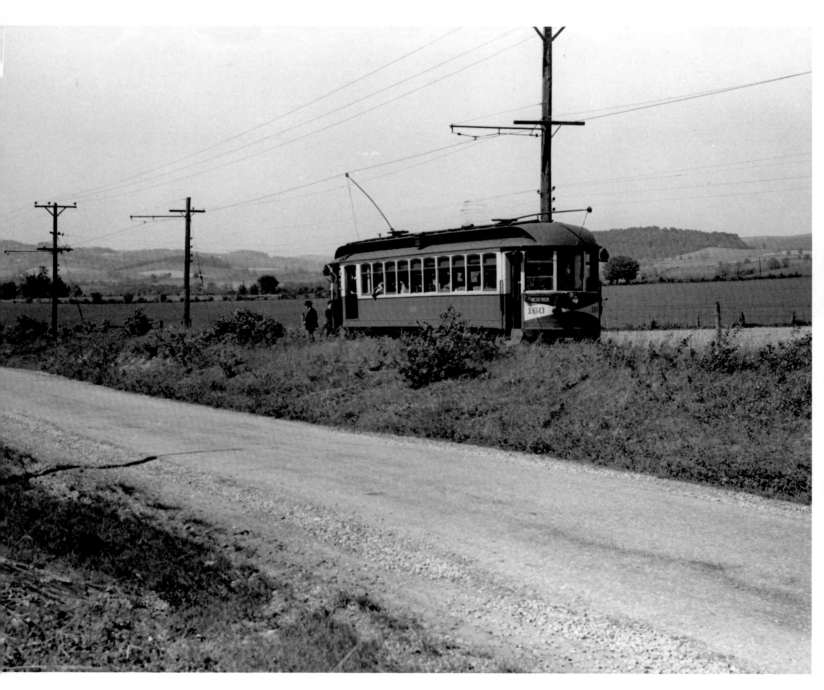

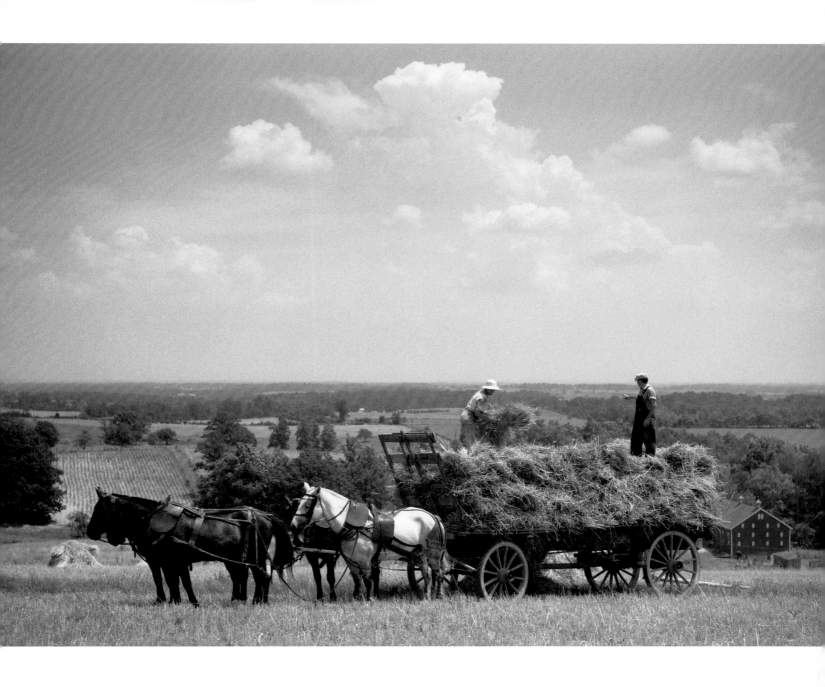

The Lilypons Water Gardens (opposite, top), established in 1917, is a family-owned business that raises aquatic plants and fish. Located three miles south of Buckeystown, it is open daily to the public. By 1936 business was so good that the owner had to establish his own post office. He named it after the opera star Lily Pons, who attended the opening of the post office and mailed her Christmas cards from there for many years. Seen here, workers pick water lilies and move fish.

The Hagerstown & Frederick Railway (opposite, bottom), begun in 1896, was a rural trolley line that connected Frederick with Hagerstown and Thurmont. This 1941 photograph was taken in Middletown Valley, west of Frederick. Competition with buses and automobiles in the 1920s led to the decline of most trolley lines, including this one. Passenger service ended in 1954, but some freight service continued until 1961.

Arthur Rothstein took the photograph above in 1937, as part of a project run by the federal Farm Security Administration. This New Deal program employed such other well-known photographers as Dorothea Lange and Walker Evans and produced some of the most iconic images of the Great Depression. Agriculture remains an important feature of Frederick County. Today the county has more than 1,200 farms and ranks among the nation's top seventy-five dairy producers.

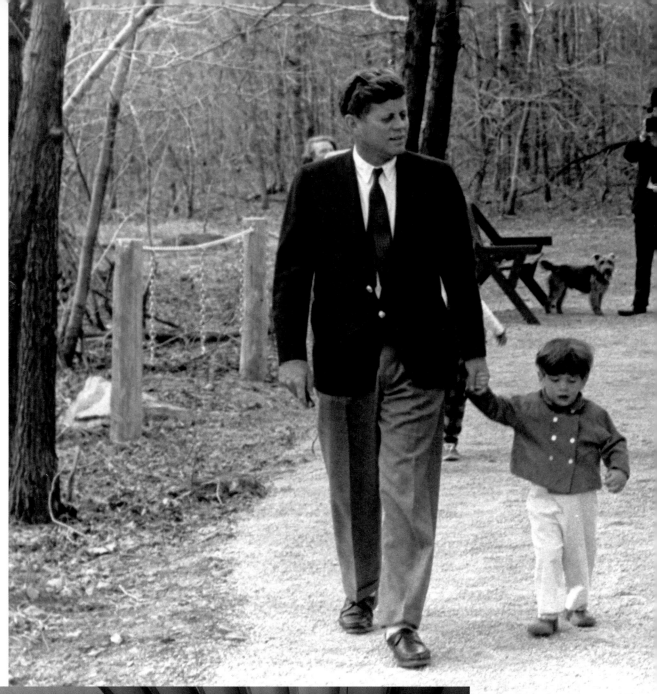

Camp David, a mountain retreat for U.S. presidents, is located in Catoctin Mountain Park in northern Frederick County. The National Park Service built the camp in the 1930s for the public, but President Franklin D. Roosevelt took it over in 1942 and named it Shangri-La. President Dwight D. Eisenhower, who used it extensively, renamed it Camp David in honor of his grandson. In the photograph above, Caroline Kennedy rides her pony Macaroni in March 1963 while her father, President John F. Kennedy, and brother, John Jr., walk alongside. In the the photograph opposite, President Lyndon B. Johnson confers with his advisors at Camp David in 1968.

189

# ACKNOWLEDGMENTS

During the twelve years when I assembled the photographs in this volume and researched their history, dozens of librarians and historians generously gave their time and assistance. Forty-three institutions and eight individual photographers and collectors contributed the photographs that appear here. I am especially grateful to the staff of the Washingtoniana Division of the District of Columbia Public Library for their answers to my many questions. Several authorities on the history of Washington, D.C., read the manuscript and offered suggestions: William Allen, Robert Vogel, and Jerry McCoy. Peter Penczer worked as a consultant in my office two days a week and was very helpful in locating many photographs which had never before been published. He took a number of photographs himself and was responsible for the chapter on Frederick County, Maryland. Ross Heasley read the manuscript and made a valuable contribution as a skillful volunteer editor. My thanks also go to Ginger Hopkins of Framer McGee's Gallery in Bethesda, Maryland, who framed the photographs for the exhibitions and did the calligraphy for the labels, and to Richard Siegman, who installed the exhibitions.

# ILLUSTRATION CREDITS

# INDEX

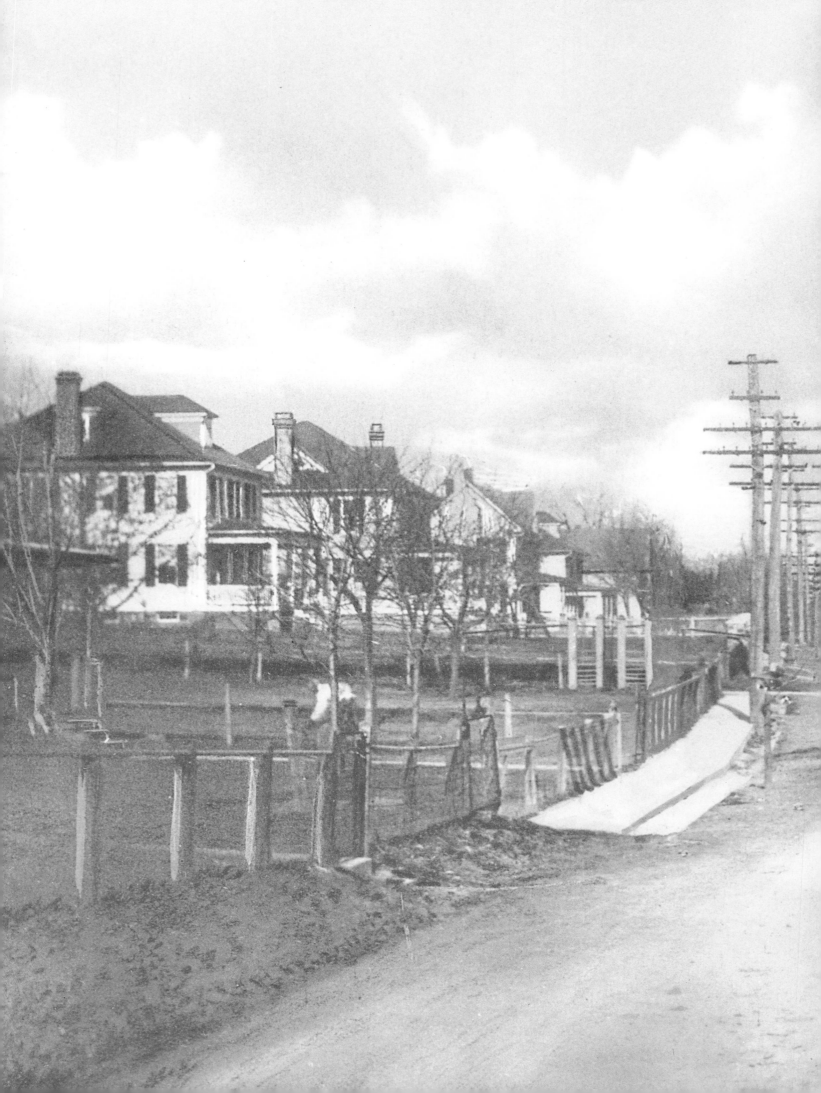